COMPLETE PHOTOGRAPHY MANUAL

AILSA MCWHINNIE

COMPLETE PHOTOGRAPHY MANUAL

THIS IS A CARLTON BOOK Text and Design © copyright Carlton Books Limited, 2000

This paperback edition published by Carlton Books Limited, 2001 20 Mortimer Street London, W1N 7RD

First published by Carlton Books Limited, 2000

This book is sold subject to the condition that it shall not, by way of trade or otherwise, be lent, resold, hired out or otherwise circulated without the publisher's prior written consent in any form or binding other than that in which it is published and without similar condition being imposed upon the subsequent purchaser. All rights reserved.

A CIP catalogue for this book is available from the British Library.

ISBN: 1 84222 388 7

Design and editorial: Andy Jones, Barry Sutcliffe and Deborah Martin Art Editor: Diane Spender Executive Editor: Sarah Larter Picture Research: Alex Pepper Production: Janette Davis

Printed in Dubai

CONTENTS

INTRODUCTION		6
Chapter 1	Know Your Camera	9
CHAPTER 2	Getting the Basics Right	29
CHAPTER 3	Composition	61
CHAPTER 4	Natural Light	85
CHAPTER 5	Using Flash	105
CHAPTER 6	Close-up and Macro Photography	139
CHAPTER 7	Going Digital	161
CHAPTER 8	The Black and White Darkroom	187
Chapter 9	Creative Techniques	209
GLOSSARY		219
USEFUL ADDRESSES		221
Index		223
PICTURE CREDITS		224

-

INTRODUCTION

Portraiture is a challenging area of photography, but also one of the most satisfying.

There's no need to go trekking through the rainforest: stunning nature photographs can be achieved at your local wildlife park or zoo.

There is nothing like the eager anticipation of collecting your photographs from the processing laboratory, whether they are of a particularly memorable birthday party, an exciting holiday abroad, or simply snaps of family and friends. However, there is also nothing as disappointing as the realization that those eagerly anticipated photographs have not turned out the way you thought they would when you released the camera's shutter. Perhaps scenery that looked full of life and colour to your mind's eye has not translated itself on to film in the same way; or prints of the family sitting around the Christmas tree have come out underexposed and with red-eye. Perhaps you simply look at pictures by photographers you admire, or those in the pages of magazines, and despair because you believe yours will never be as good – or maybe you look at all these photographs and think, 'I could do better than that!'

If this sounds like you, then you have come to the right place! Photography is not as complicated as some people would like to make out. A constant learning process it may be, but the basics are not difficult to master. And once those fundamental rules have been learned, the satisfaction of obtaining good pictures, time after time, is so great that for many photography becomes more than just a pastime – it becomes a passion.

While your photography is governed to a great extent by the subjects you choose to capture, the knowledge required to make those photographs successful is the same across all subject areas, whether landscape, wildlife, portraiture or anything else you care to point your camera towards. For this reason, you will not find separate chapters dealing with individual subjects in this manual. Instead, it will aim to draw your attention to such matters as composition, the qualities of natural light, how to master flash lighting, and so on, as well as explaining the basics of macro

photography, the traditional black and white darkroom processes, and other creative techniques.

In recent years, the digital revolution has become a hotly debated topic in the world of photography. Some people believed it would sound the death knell for conventional photography. For others, conversely, the pleasure of being able to enhance and manipulate their images on a computer has rekindled their enjoyment of picture-taking. This manual allows you to make up your own mind, as it includes a comprehensive section on how to go digital, what equipment you will need and some of the things picture-editing software is capable of doing.

Developing an eye for composition is one of the most crucial aspects of photography. The vast majority of the pictures that have been selected to illustrate the techniques explained in this manual can be achieved with a basic SLR camera, an everyday lens and a sound choice of film. The expertise of the photographers whose work we have drawn upon comes from their years of experience in using a camera, not the amount of money they have spent on their kit. Instead, they have spent time developing a photographic eye, which allows them to recognize what in a scene will translate well on to film, and how to be entirely in control of the photographic process so that there are no nasty – or disappointing – surprises when those pictures come back from the lab.

Although expensive camera gear is not the primary requirement, you need to know what equipment is available and what each item does. The book therefore includes advice on what to look for in a basic SLR kit and how those various pieces of gear can be used to achieve the results you are after. It also explains the alternatives to the standard 35mm format which become options once your skills as a photographer develop.

Whatever your reasons for wanting to improve your photography, it is hoped that this manual will provide both the information and the inspiration you will need to build up your confidence in the subject, and to make picking up your camera a pleasure. Enjoy your photography! CHAPTER ONE

KNOW YOUR CAMERA

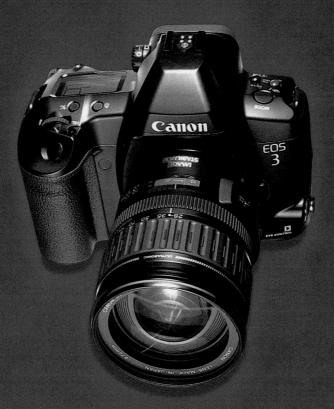

It has never been easier to use a 35mm single lens reflex (SLR) camera. The technology which has gone into the SLR and the features it offers are nothing short of astounding, making the camera no more difficult to use than a simple computer program. What is most remarkable about this technology is the development of the automatic function. What the photographer previously had to assess and consider, is now decided for you by the flick of a switch. This level of automation has made complex photographic science available to the person in the street in the same way that automotives has brought the technology of the racing car to the standard family saloon. However, if you want to take your photography further, you will have to learn what the camera's functions do, and how to apply them in the relevant situations to achieve the desired result.

WHAT TO LOOK FOR IN AN SLR

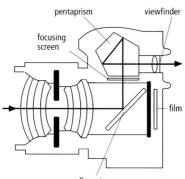

reflex mirror

This diagram demonstrates the fact that what you see through the viewfinder is what you get on film when using an SLR camera. Light travels through the lens and bounces off the mirror into the pentaprism, which in turn bounces it through the viewfinder.

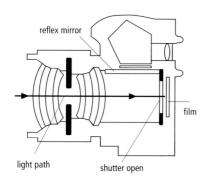

When the shutter is released, the mirror flips up, allowing light to hit the film emulsion. Because, when the shutter is released, light does not hit the pentaprism, the photographer sees only black through the viewfinder for the duration of the shutter speed. When buying an SLR, you need to find a camera that matches your standard of photography – or the standard you hope to attain. If you want only to point and shoot, it is unlikely you will want to buy the most complicated and well-equipped camera since you will not make full use of its potential. If you are keen to learn as much as possible about photography, buy a camera that will allow you to grow in expertise.

Your camera needs to suit you. It needs to fit into your hands comfortably so that you can reach every dial, wheel and button when you need it. Do not buy a camera if it is so heavy you will never bother to take it out with you, or if it is too complicated for your level of interest. If you are just starting out in photography, the most important thing is to buy a camera you can operate yourself – one you can really take control of.

Camera features

There are several main features to take into account when choosing a camera. First, there are its **metering modes** (see Chapter 2, page 43). Most modern SLRs have a choice of up to three metering modes, which will help you obtain the best exposure in a variety of circumstances.

Some cameras feature a built-in **motor drive**, which allows you to shoot two or three frames per second while keeping your finger on the shutter release button. With other cameras you will need to buy a separate unit if you want to have this feature. Although useful for some action photography, a motor drive is not essential.

There needs to be a wide range of **shutter speeds** – from at least one second to 1/1000 second, although a lot of modern SLRs provide an even wider range than this. There should also be a 'B' (or 'bulb') mode, which allows you to lock the shutter open for as long as you need to – this is vital for any kind of low-light or creative photography.

Most modern cameras also feature a built-in pop-up **flash unit**. While useful for a touch of fill flash or for standard portraits, it will not have either the versatility or the range of a separate dedicated flash unit.

Most 35mm SLRs designed nowadays will also automatically set the speed of film that you are using, via a **DX coding system**. However, as you advance in your photography, there may be times when you might want to over-ride this feature, so look for a camera which allows you to do this.

Last, but far from least, the camera's **viewfinder** must be bright and clear, not only so that you can see your subject with utmost clarity and focus on it perfectly, but also so that you can read the exposure markings within the viewfinder.

CAMERA FORMATS

The term 'format' in photography means the size of film a camera takes: this includes 35mm, APS (Advanced Photo System) and 120 - also known as medium format. In addition, there is a type of film called sheet film, which comes in 5 x 4 in. and 10 x 8 in. sizes.

It is not just the size of the film that determines a format, but also the size of the image created on that film. Medium format cameras all use 120 roll film, but negatives of several different sizes can be produced on that film, depending on the camera being used. To confuse the issue, some cameras are able to produce negatives of more than one size. Many medium format cameras also feature interchangeable backs, so that you can swap film speeds and types mid-roll, and also shoot Polaroids to check that the exposure is correct.

Generally speaking, smaller-format cameras are better for fast-moving subjects, such as sport and news photography, while medium and large format cameras are more suitable for stationary subjects, such as landscapes and still life, or for classic studio portraiture. However, fantastic pictures can sometimes be made by breaking these rules.

No film format is more flexible than 35mm. The 35mm negative size is 24 x 36 mm, which, with today's high-quality films, is large enough to produce pinsharp results on a good-sized enlargement. Accompanied by a wide range of lens focal lengths, the 35mm camera body is suitable for almost any subject. Sports

35mm

The 35mm SLR comes in many shapes and sizes, varying in sophistication from the simple point-and-shoot model to the extremely high-tech and complex.

Many basic compact cameras are also 35mm in format, although APS (Advanced Photo System) is quickly catching up.

A 35mm transparency at actual size. Being the smallest of the 'serious' formats, it is the most versatile.

6 x 4.5 cm

A 645 transparency at actual size. A format often used for travel photography, the larger image size means an improvement in quality over 35mm.

When used with its shorter lenses, the 645 system can still be hand-held rather than always having to be tripod mounted. and wildlife photographers use it because the cameras can be hand-held and moved quickly to follow action. The system also has very advanced autofocusing capabilities, with lenses which are long enough to fill the frame with a very distant subject.

Use of 35mm is becoming more common in areas of photography which have traditionally been the reserve of the larger formats. As film quality improves and fashions change, it has become acceptable in certain circumstances to break with convention. A grainy still life, for example, can be very attractive and is more difficult to achieve on a larger film format. While fashion photography has always been a mixture of the studious medium format and the less formal 35mm, increasingly nowadays portraits and weddings are being shot in the latter's more carefree style.

This crossbreed of 35mm and medium format is often dismissed as being of limited use. In fact, the 6 x 4.5 cm (also known as 645) can be very useful. The smallest of the medium format family, it is also the most portable and provides an accessible entry point into the world of the larger negative. For the photographer who likes the flexibility of 35mm, it is a camera that has the appeal of both easy handling and a better quality result.

Some manufacturers are developing 645 cameras which are close to 35mm SLRs in terms of features and functions. For some time, 645 cameras have featured comprehensive exposure metering systems, automatic film advance and exposure program modes. Now there are a number of models on the market which are shaped almost like a 35mm camera, and which also have autofocus systems.

The 645 has always been popular for portrait and fashion photography and the relatively lightweight body, with its 15 exposures per roll, also appeals greatly to travel photographers.

The square negative produced by the 6×6 cm camera is thought wasteful by some photographers and indispensable by others. Capturing 12 exposures per roll, the 6×6 cm camera has a very loyal following amongst portrait and wedding photographers. Users also point out that they can make either a landscape or a portrait format image of the same picture by cropping at the printing stage.

Another advantage of the 6 x 6 cm camera is that it never has to be turned on its side, which is something that has to be done with one providing a rectangular negative. Most medium format cameras use a viewing screen that shows the image laterally reversed: that is, anything on your left will appear in the right-hand side of the viewfinder, while anything on the right will appear in the left. Photographers soon become accustomed to this reversal when shooting landscape format pictures with a waist-level finder, but when the camera has to be turned on its side, life becomes very difficult. The problem can be overcome by the use of a prism finder to turn the image back the right way round, but these are often expensive. 6 x 6 cm

A 6 x 6 cm transparency at actual size. The format generally used by traditional wedding and portrait photographers, it also has an increasing following among landscape photographers.

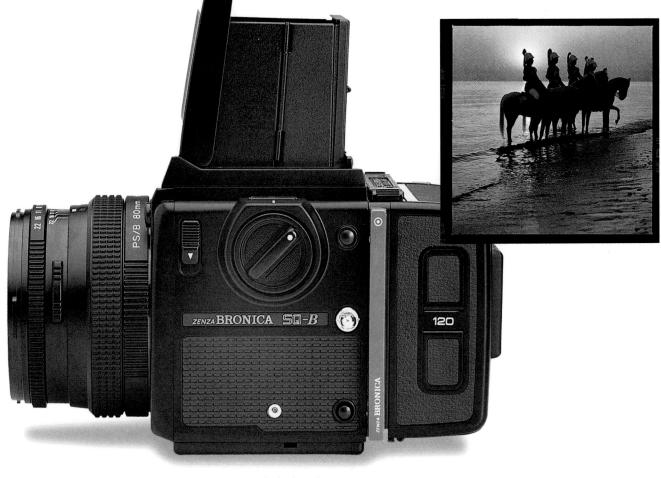

The 6 x 6 cm camera has a waist-level finder which the user looks down into when composing a shot. Here you can also see the interchangeable back.

6 x 7 cm

A 6 x 7 cm transparency at actual size. Also known as the 'ideal' format, the results are perfect when a big enlargement is called for.

Similar in looks to the 6 x 6 cm format, the 6 x 7 cm camera needs to be used with a robust tripod.

6 x 8 cm/6 x 9 cm

6 x 12 cm/6 x 17 cm

With a few exceptions, $6 \ge 7$ cm cameras are truly studio based. They are almost impossible to hold by hand so a sturdy tripod is a must, but the results make the extra trouble worthwhile. The $6 \ge 7$ cm negative is enormous and can be enlarged to poster size with no noticeable grain appearing. The best-known $6 \ge 7$ cm cameras are the Mamiya RB67 and RZ67. These are heavyweight

professional workhorses that feature revolving film backs so you don't have to turn the camera on its side to shoot in portrait format. There are, however, 6 x 7 cm cameras which are more like a 35mm rangefinder in design and are far more portable.

The 6 x 7 cm negative is often described as the 'ideal' format for publication because its ratio means that it can be enlarged to fit perfectly into a full page of the standard magazine size.

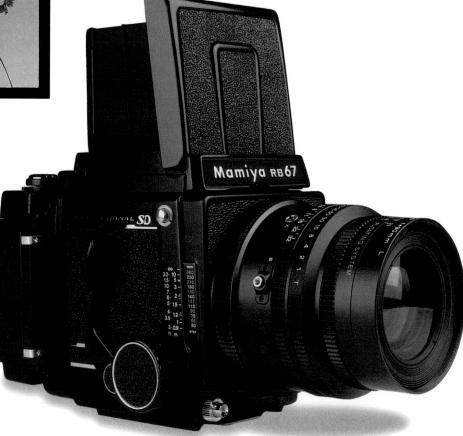

Cameras which produce pictures with these dimensions are quite specialized. Models that deliver a 6×8 cm or 6×9 cm image are either bulky studio machines for product and portrait photography, or compactly designed rangefinders. Images with a long edge of more than 12 cm are classed as panorama cameras and produce a long, thin image which is particularly suited to landscape photography.

Know Your Camera

The 6 x 8 cm and 6 x 9 cm cameras are more specialized formats, used both in the studio and in the landscape.

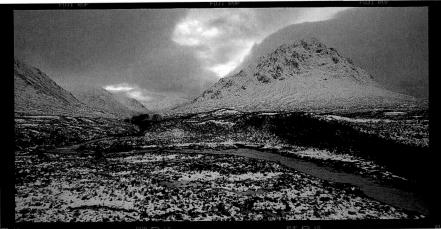

A 6 x 12 cm transparency at actual size. The panorama image perfectly conveys a grand sweep of landscape.

A 6 x 17 cm transparency at actual size. Careful composition is required when using this format.

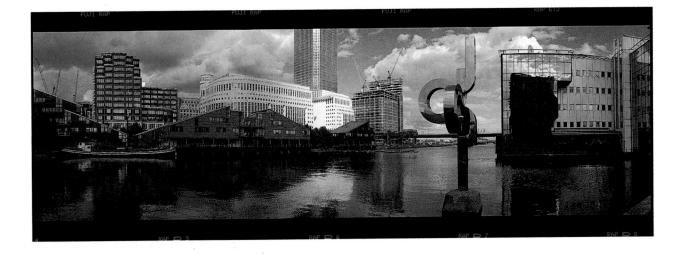

5 x 4 in. and 10 x 8 in.

1)

sinar taa

For the sharpest and most grain-free images you need a large format camera such as the 5×4 in. or the 10×8 in. Very basic, they have none of the automatic functions of a 35mm camera. Most consist simply of a plate to hold the lens and a plate to hold the film, with a light-excluding bellow in between. Strictly for

tripod or studio stand use, these cameras are most often used for images which require maximum sharpness, detail or enlargement – in particular, landscape, architecture and product advertising. One of the greatest landscape photographers ever – Ansel Adams – worked solely with large format cameras, using a 10 x 8 in. plate camera as a matter of course.

Large format cameras also allow the photographer to control converging verticals, perspective and depth of field to a minute degree. This is because they have what are known as 'camera movements', where the lens can be moved up, down or sideways in relation to the film plane.

The 5 x 4 in. camera. Focusing is achieved by adjusting the length of the bellows, rather than turning a ring on the lens.

A 5 x 4 in. transparency at actual size. Complete sharpness from the front to the back of the image can be achieved with this format, thanks to the camera movements which are fundamental to large format photography.

HOW TO CHOOSE THE RIGHT LENS

A lens's focal length will dramatically affect the outcome of a photograph. If you choose one that is too wide your main subject will be lost among a mass of extraneous detail. If you choose one that is too long you could be cutting out the detail which puts your subject into context.

The focal lengths of lenses are split into five categories: ultra wideangle, wideangle, standard, telephoto and ultra telephoto. Wideangle lenses cover the greatest area, allowing you to include a larger expanse of a scene in the picture, while telephoto lenses fill the frame with distant subjects.

A common mistake is to confuse a zoom lens with a telephoto lens. A zoom lens is any lens which can alter its focal length smoothly between one point and another. Thus, an 18–35mm lens is as much of a zoom as a 70–200mm lens; however, only the latter is a telephoto.

It used to be the case that certain lenses were considered suitable only for certain jobs, but nowadays opinions are more flexible. The following is a brief guide to the main uses of each type of lens, but remember, these are just conventional guidelines and you do not have to stick to the rules.

As you can see from the illustration below, an ultra wideangle lens will translate a huge range of information on to film from the scene in front of you, while an ultra telephoto lens has a far narrower angle of view. Overleaf is a sequence of images which demonstrates the narrowing of the angle of view, the longer the lens used.

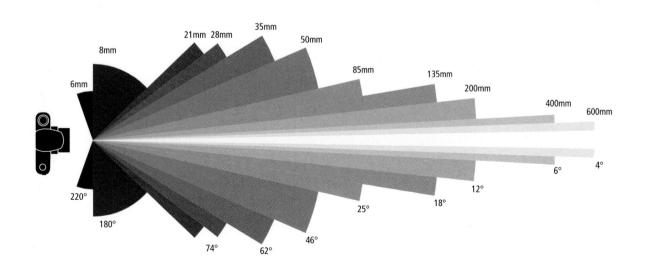

20 mm

24 mm

35 mm

50 mm

400 mm

100 mm

135 mm

200 mm

300 mm

Know Your Camera

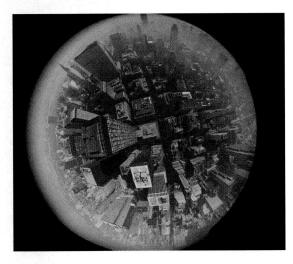

The great things about really wide lenses are the depth of field and the distortion they provide. Even at the widest aperture you are likely to get complete front-to-back sharpness and a sense of exaggerated depth to your pictures. To make anything significantly big in the frame you will have to get quite close to it. This will make anything in the background tiny by comparison.

Objects at the edges of the frame will appear bent and bowed like the sides of a barrel, and the horizon will appear to curve down at the

edges if it is positioned in the top half of the frame.

Used carefully, ultra wideangle lenses can produce unconventional portraits and wacky still-life images. Any wideangle lens which produces a round picture as opposed to a rectangular one is known as a fish-eye lens and, although the effect is eye-catching, it is rarely used and often considered to be a gimmick.

Wideangle lenses allow you to include a lot of detail in your

ALLERS EF 35mm 11.1.4 ALLERS EF 35mm 11.1.4 ALLERS ALLER **shot** – and are especially useful when you cannot move back far enough to use a longer lens. When you are photographing buildings in a street, a large group of people, or a landscape with a lot of foreground interest, the wideangle lens is ideal. Objects or people close to the lens will appear large in the frame, while those further away from the camera will look smaller.

When using a wideangle lens, try to avoid tilting the camera up or down, otherwise you will end up with converging verticals. These occur when you look up or down at an object whose sides are parallel – such as

the sides of a building – instead of

head-on. For example, if you look up at a tall building when you are very close to it, the edges appear to lean in towards each other. This effect is exaggerated with a wideangle lens, although it can be corrected with perspective control – also known as a shift-lens. This lens has a rising front element which allows you to include the top of a building without having to tilt your camera. The only time when converging lines are acceptable is when they are obviously exaggerated, or when they are horizontal and leading the eye into a landscape.

Ultra wideangle lenses – from 6mm to 24mm

A true fish-eye lens will give a circular image which, although dramatic and eyecatching, is of limited use.

Wideangle lenses – from 28mm to 35mm

Converging verticals become a problem when the camera is tilted upwards to take a picture of a straight-sided subject. Architectural photographers can overcome this with specialist perspective control, or 'shift' lenses (left).

Standard lenses – from 35mm to 70mm

The 28–80mm lens is a standard zoom and will cover a lot of photographic needs.

Telephoto lenses – from 70mm to 200mm

The 70–210mm lens is a useful route into telephoto photography, without the expense of fixed-focal-length lenses.

When a telephoto lens is used, the background is thrown out of focus, making your subject stand out very clearly.

Not many photographers use a 50mm lens as a matter of course these days. However, if you were to restrict yourself to it for a whole day, you would find it quite an interesting lens. Standard lenses are said to provide the same angle of view as that of the human eye: that is, the amount of information we see through a 50mm lens (although some would argue more heavily in favour of the 35mm lens) is the same as what we see with the naked eye. The founder of the Magnum photo agency, Henri Cartier-Bresson, uses only a Leica rangefinder camera fitted with a 35mm lens for his photography, for precisely this reason.

The most important characteristic of the telephoto lens is that, as well as appearing to bring your main subject closer to you, it also compresses the image. This makes it ideal for portraiture, as it flatters such features as larger noses. It also works beautifully in the landscape, when mountain ranges which stretch for miles into the horizon suddenly appear almost as 'layers', stacked one behind the other. This compression also allows you to relate a distant object to a closer one – such as two rock formations in a landscape.

Whereas wideangle lenses increase depth of field, telephoto lenses reduce it. This has the effect of making a portrait subject stand out from their background – particularly when the lens is used in conjunction with a wide aperture – because that background is rendered as an attractive blur.

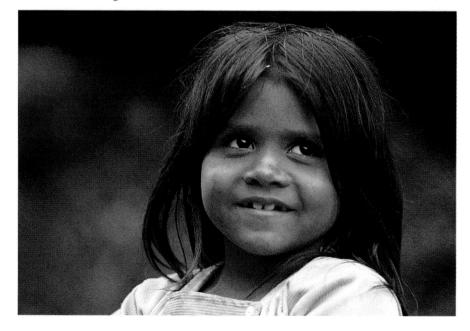

Ultra telephoto lenses tend to be used chiefly by specialist sports and wildlife photographers, allowing them to capture the action while safe in a hide, or from the other side of a football pitch. As these lenses are expensive, many people look for an alternative by investing in a 2x teleconverter, which doubles the focal length of a telephoto lens (so a 200mm lens, for example, would become 400mm). The quality isn't quite so good as that provided by a lens, and you lose a couple of stops of light, but a teleconverter will provide an acceptable result.

Incidentally, it's a myth that the paparazzi use 12,000mm lenses to see inside your bathroom! Not many photographers could hold such a lens still, let alone afford one.

Ultra telephoto lenses – from 300mm upwards

0

Ultra telephoto lenses are extremely heavy, and need to be supported on a tripod or monopod to avoid camera shake.

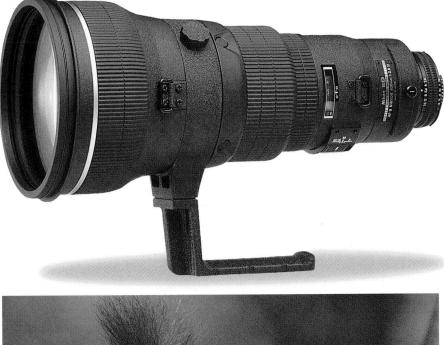

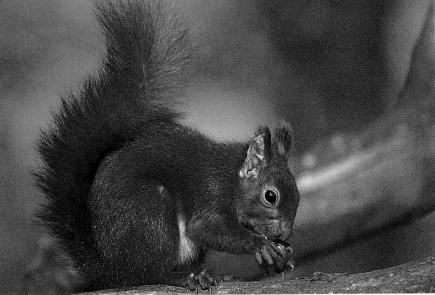

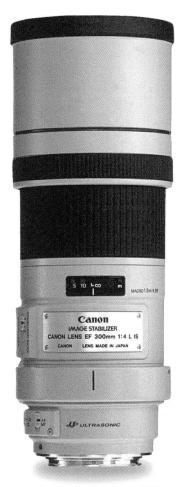

Canon's Image Stabiliser lens has a shifting optical system which reduces the likelihood of camera shake, making it easier to hand-hold. It has the equivalent effect of using a shutter speed of two stops faster.

A long telephoto lens is essential for wildlife photography, allowing the user to fill the frame without frightening away a timid subject. Which brand?

The picture below left was taken on Fujichrome

Velvia, which is an ISO 50 film and is renowned for its contrast and colour saturation.

stop of speed and is less contrasty than Velvia.

The picture below right was shot on

Fujichrome Provia 100, which has an extra

HOW TO CHOOSE THE RIGHT FILM

It cannot be stressed enough how important your choice of film is to the final image. Even if you own the most advanced camera around you will not obtain good results if you use film of inferior quality or film that is simply the wrong type for the job.

There are three principle types of film: colour negative, colour transparency and black and white negative. Your choice depends upon the medium in which you want to see your results. Generally, colour transparency (or slide) film is considered to be of superior quality to colour negative (or print) film. Capable of recording more detail, and with greater colour saturation, slide film has a less obvious grain as it goes through just one stage of processing: the film is developed and is then ready for viewing. Colour negative film, however, has to go through two stages: it is developed, then printed. This results in a slight degradation in quality.

The photographer is spoilt for choice when it comes to brands of film, but such a wide array can make it easier to choose the wrong one. No two films are the same, and no single film can effectively cover every subject in every set of circumstances that you are likely to want to shoot. Some films will produce a warm tone in your pictures and others attempt to boost natural colour. Some films seem cool in tone while others reproduce colours almost exactly as they appear in real life. Some are designed to deliver soft, muted colours to flatter the portrait subject while yet others give contrast and colour saturation for deep blue skies and lush green fields in landscape photography.

It is most important to be prepared to use more than one type of film and to try new ones. One of the best ways to find a film you like – although it is slightly laborious – is to shoot the same subject using several different types, then compare the results to see which one you like best for that subject. But be aware that you will probably prefer one type of film for one subject – landscapes, for example – and another type of film for a different subject, such as portraiture.

Above left: Taken on Kodak Ektachrome, this image has a general yellow cast, while the picture above right was shot on Kodachrome, which has a more magenta cast.

Slide film tends to be more contrasty than print film and more difficult to expose correctly. It also has less exposure latitude (see page 22). The contrast and superior quality of slide film make it a more suitable choice for the reproduction of photos in magazines and books because it produces a

bolder-looking image. However, when shooting something like a portrait, the photographer requires less contrast and less detail in order to flatter the subject's complexion. For this task it is customary to use print film. The latter is grainier and less capable of rendering every blemish in entirely sharp focus, while the reduced contrast smoothes the surface of the skin.

After deciding whether to use print or slide film, you then need to choose the appropriate speed for the photographs you wish to take. Films come in a variety of speeds, which determine how sensitive that film is to light. The speed is expressed as an ISO (International Standards Organization)

number. A fast film, say ISO 800, will provide an image in lower lighting conditions than one shot on a slow film such as ISO 100.

Slide or print?

Film speed

A film which displays low contrast characteristics and renders flesh tones accurately is ideal for portraiture as it is more flattering than a contrasty, saturated film would be.

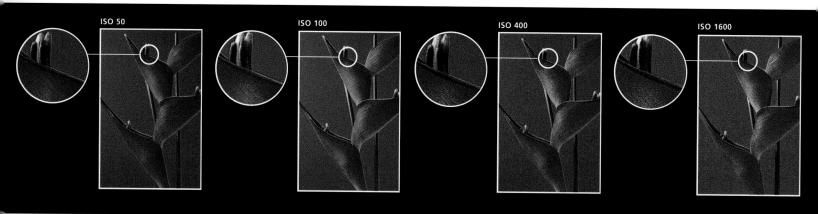

As you can see from this sequence of magnifications, grain size increases with the speed of film.

Slow, fast and faster films

If life were this simple, we would all load ISO 800 film in our cameras for everything. But there is a trade-off: the faster the film, the larger the grain. In the past it has been considered good practice to load with the slowest, finestgrain film possible for the lighting conditions, but there is now slightly less cause for concern since advances in technology have meant that film grain size has been reduced substantially over the years.

Anything between ISO 25 and ISO 100 is considered to be a slow film. The colours will be very saturated and grain will be extremely fine, but it means you will be shooting at very slow shutter speeds so you will need to use a tripod. The resulting slide or negative will be capable of considerable enlargement with very little loss in quality.

Next up you have ISO 200 film, which is fine for general use in a compact camera, but if you really need the extra sensitivity – for example, if the light is fading and you need to record as much detail as possible – you should go for ISO 400. The difference between ISO 200 and ISO 400 in terms of quality and

colour saturation is minimal, but the extra stop provided by ISO 400 could make the difference between getting your shot, or packing up and going home.

After this we reach the realms of the truly fast film. Those of ISO 800, 1600 or 3200 are perfect for low light or indoor situations, or those where flash is not permitted. The grain will be very pronounced, but this can often enhance the atmosphere of the final image and in some cases is more desirable than a completely grain-free result. Do not forget, however, that as a rule the faster the film, the less its colour saturation and sharpness.

What is exposure latitude?

Exposure latitude is nothing to be afraid of! It refers to the ability of a film to produce an acceptable image, even when it has been over- or underexposed. Slide film has less exposure latitude than print film and will only produce an acceptable image up to half a stop either way, whereas print film is more flexible and will provide a decent print even if over- or under-exposed by anything up to three stops either way.

25

Know Your Camera

This is also known as 'pushing' a film. If you find yourself in a position where you only have ISO 100 film in your camera bag, when you could really do with ISO 400, all is not lost. You can simply override your camera's film speed setting, to rerate the film at ISO 400. It is vital, though, to label the film canister if you have uprated it, and to inform the laboratory when you take the film in to be processed. You should also be aware that if you uprate a film on which you have already taken some pictures, and then have it processed according to the new speed at which you have set the camera, you will lose the photographs you took before uprating.

Although it is wise, if you want to be sure of the results, to uprate by only one or two stops, there is no harm in experimenting by pushing a test film up to four stops, just to see how the results turn out. You may like it so much you decide to make it part of your own individual photographic style!

Specialist films

fogging.

If you were to use ordinary, daylight-balanced film under tungsten lights, your result would be a picture with a very strong orange colour cast. Tungstenbalanced film is designed to correct this cast, without the need for filters or flash.

> The defining characteristic of black and white infrared film is that vegetation is rendered as

Tungsten-balanced film

white, while blue skies become very dark.

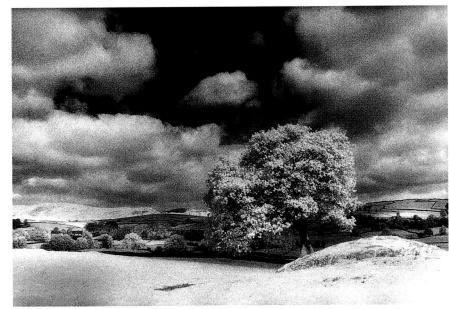

Infrared film is available in both colour and black and white, and is a ready-made special effects film. Greenery and foliage make ideal subjects for black and white infrared film, as they are rendered white in the resulting print. You should use the film in conjunction with a deep-red filter (a Wratten 87) and refocus according to the infrared index marker on the lens barrel. Infrared film also needs to be loaded and unloaded in complete darkness to avoid

Uprating a film

Colour infrared is very unpredictable and it is difficult to repeat its effects – but that is part of the enjoyment of using it. Colour infrared film is altogether less predictable since it can turn the scene into several different colours. These colours vary according to the filter, although a Wratten 12 yellow filter is recommended. Green foliage will be recorded as red or magenta.

It is essential to bracket up to two stops each way with either colour or black and white infrared film, as it is extremely tricky to get the exposure just right. (See 'Bracketing' on page 42.)

The importance of processing

There is another stage in the photographic procedure which it is essential to take into account. All the time, effort and expense spent on selecting the perfect film for your purposes will be worthless if your film is badly processed. Again, shoot several rolls of film of the same subject, but have them processed at a number of different laboratories, avoiding the high street processor or local chemist if at all possible. Instead, choose a professional processor or one that deals with both professionals and the general public. When you have found a company that provides a good service and good results, stay with it. You may end up paying more than you would at a high street store, but it will be worth it.

Know Your Camera

USEFUL ACCESSORIES

Many of us cannot resist any gadget that claims it will change our photographic life, and it would be easy to fill several camera bags with such bits and pieces. However, although we would never quite get round to using many of them, there are a few things you will find genuinely useful.

Almost as essential as the camera body itself, a tripod helps to keep the camera still during long exposures. If you intend to produce anything worthwhile in landscape or architecture photography, you will definitely need one. Get the best and sturdiest model you can possibly afford because – unless you lose it – you will only need to buy it once. There are plenty of low-priced designs available, but when it comes to tripods, you get what you pay for, so be wary of the really cheap models.

When buying a tripod, you will also have to invest in a tripod head. There are two main types – ball and socket, or pan and tilt. There are arguments for and against each type, but essentially the ball and socket has a smooth, seamless movement which is ideal for following moving subjects, while the pan and tilt head is better for general photography and can be positioned very accurately.

Like a tripod but with only one leg, a monopod is ideal for sport or wildlife photography, where you need to brace the camera. A monopod gives you something to lean on without restricting your movements in the way that a tripod does. Tripod

A tripod is essential for stability when using long shutter speeds.

Monopods

Cable release

After spending all that money on a tripod, it would be a shame to jog the camera as you pressed the shutter release button. To avoid this, use a cable release to trigger the shutter.

Not all cameras nowadays have a cable release thread, but a cable release is a vital tool to prevent the camera moving when the shutter is released.

Lightmeter

A lightmeter will ensure that your exposures are accurate at all times.

Spirit level

Lens hood

There are times when the lightmeter in your camera will not provide the result you see in your mind's eye. The camera's meter can only take a reading of light reflected from a scene, although there are times when the incident reading provided by a lightmeter will yield a better result (see page 42). If you tend to shoot with print film and are accustomed to how your camera meter works, you are unlikely to require a lightmeter. Many professionals use one in addition to the camera meter just to be sure that the reading they have is correct.

This may seem to be a surprising addition to the camera bag, but many otherwise delightful pictures suffer from the unintentional sloping of horizontals. A spirit level can make a big difference.

M

Ag

POWER

Flare is one of photography's greatest enemies.

Caused by stray light entering the lens (such as when sunlight falls directly on to the front element), it

bounces around inside the lens, reducing contrast as it goes and sometimes leaving aperture-shaped marks on your pictures. The simple cure is to use a lens hood. It will not provide a perfect solution if you are shooting directly into the light, but it will protect the front element of your lens from extraneous light.

CHAPTER TWO

GETTING THE BASICS RIGHT

For the experienced photographer, picturetaking may be second nature. The beginner who aspires to similar ease with a camera must invest some time in learning the basic skills. These include understanding not only the functions of the camera, which were discussed in the previous chapter, but what those functions do, how versatile they are and how they can be utilized to give you the best possible result – the picture you see in your mind's eye when you release the shutter.

The problem is, the camera's automatic functions are now so sophisticated you could

get away with a lifetime of photography without ever having to think too hard about what you were doing. Switching your camera to auto-everything and making use of modern technology means you will achieve acceptable results nine times out of ten. That's not a bad statistic, of course, but it means you will never have full control of the picture-taking process. Additionally, the one time out of ten where the camera's automatic functions do not provide the result you were after could have been a prize-winning shot if only you had known what settings to use to achieve it.

Take control

Imagine you are shooting a landscape picture where bang in the centre of your frame is a bright, white building. If set to automatic exposure, your camera will assume this is the most important area of your picture, and if set to autofocus, it will also assume this is the area you want to focus on. However, in the foreground of your frame is a large, beautiful and extremely rare black rose, and this is the part of the composition you would prefer to draw attention to. If you went ahead and believed what the camera was telling you, both the exposure and the focusing would be wrong for what you were trying to achieve.

This is why it is important to take control of your camera. Having a good eye for a picture is a very good start, but you will have to master a certain amount of technical detail in order to achieve good pictures every time.

APERTURE AND SHUTTER SPEED

The first step in taking control of your photography is to learn how the aperture and shutter speed relate to one another, and to recognize how they affect the look of the final image. If you have been accustomed to using a compact camera you will find that shutter speed and aperture control give you a whole range of new choices and freedom of creativity.

Exposure is the process of allowing light to pass through a certain-sized hole for a certain length of time. The size of the hole is what we call the aperture, and the time the light is allowed to pass is called the shutter speed. What is important is that the right quantity of light reaches the film. For a particular scene of a certain brightness there will be a variety of apertures and shutter speeds you can use.

When you halve the length of time you allow the shutter to remain open – for example, from 1/250 second down to 1/500 second – you need to double the size of the aperture – for example, from f/16 to f/11. Every time you move a stop either way on either the shutter speed or the aperture dial, you either halve or double the amount of light admitted. If your camera gives you a meter reading of f/8 and 1/125 second, you will get the same exposure on film if you shoot at f/5.6 and 1/250 second, f/4 and 1/500 second or, in the other direction, f/11 and 1/60 second. This is known as the reciprocity law. But shutter speeds and apertures have a far greater impact on your photography than merely getting light on to the film.

Controlling shutter speed

Imagine looking through a window. The window has a set of curtains which you are holding in your hands. Those curtains are closed. You hear a car outside and

you want to see it. If you open and close the curtains very, very quickly you might not be able to tell whether the car is moving or not. You will see there is a car there, but the length of time you were able to spend looking at the car might not have been long enough for you to determine whether it was parked or in motion. If you had kept the curtains open for a little longer, you would have been able to see quite clearly whether the car was moving. This is how shutter speeds work. Shutter speeds determine how long you let the film see the subject. If the film does not get a good long look, how can it know the subject is on the move? If you let it have a long look it will see the subject is moving and will show it in the final image.

Thus we can see how the shutter speed basically determines whether your subject looks as if it is moving or not. You might want to freeze your subject's

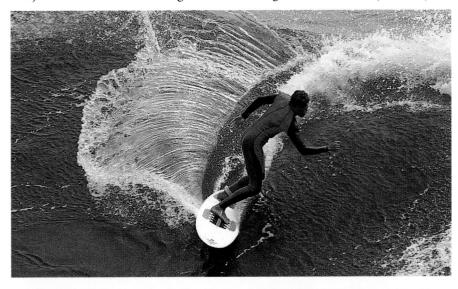

A fast shutter speed captures the surfer crisply, as well as the wave created by his board.

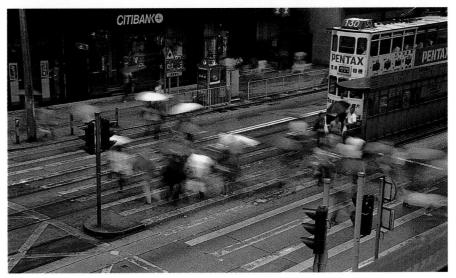

A slow shutter speed renders some of the moving people as a blur, creating a sense of hustle and bustle.

movement with a fast shutter speed or you might want to show that it is moving by using a slower shutter speed. However, do not be trapped into thinking 'fastmoving subject, therefore select fast shutter speed' when showing that the subject is moving might be far more interesting.

Controlling apertures

An aperture is more than just a hole in the lens which lets the light in. The size of that aperture governs the appearance of your final result just as much as a fast or slow shutter speed portrays the movement of your subject. The aperture controls not only the amount of light entering the lens, but also how much of the depth within your picture is rendered sharp and in focus.

When we look at a photograph, what we are seeing is lots of tiny circles of light which build up the image of the subject. The bigger circles, to the human eye, create an out-of-focus subject, while the small ones create a subject that looks sharp. The point on to which the lens has been focused produces the smallest circles, while a certain amount of information in front and behind that point is constructed of circles small enough still to appear sharp to our eyes. This area is called the depth of field.

We can control the depth of this area by using different-sized apertures. A small aperture produces smaller circles of light (called circles of confusion) so that the area that appears sharp to us is larger than when a wider aperture is used. Here we must remember that smaller apertures have larger numbers. Thus f/16 represents a smaller hole than f/5.6.

A simple exercise will soon demonstrate this principle to you. If you have a depth-of-field preview button on your camera, set the aperture on its widest

Below: If you want to render sharp everything in frame – from near to far – you will need to select a small aperture, around f/11 to f/16.

Below right: A large aperture of about f/2.8 allows you to use selective focusing, where you focus on one part of the subject, knowing that the rest of the image will fall out of focus. The viewer's attention is then drawn to the sharper area of the frame.

Depth-of-field preview

Getting the Basics Right

At f/2.8, with the focus on the tree in the foreground, the houses in the background are blurred.

At f/5.6 the houses are sharper ...

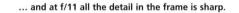

setting and focus on something reasonably close (2 metres or so) using a standard lens. Looking through the viewfinder you will see the amount of focused image available at the maximum aperture of your lens. Now close the lens aperture down to f/8 and use the depth-of-field preview to check the difference. Whatever is in the background of your picture might not be entirely sharp, but objects should be a lot more recognizable than they were before. Now close down to f/16 and check the difference again. By opening and closing the aperture with the depth-of-field preview activated, you will be able to see immediately what difference the aperture makes to the amount of the scene you can render sharply.

There is a little more to depth of field than the aperture, however. The two other elements you need to think about are the focal length of your lens and the distance your subject is from the camera. In basic terms, the longer the focal length of the lens you are using, the shorter your depth of field; and the closer your subject, the shorter your depth of field. Conversely, for the maximum depth of field you should use a short focal length lens (i.e. a wideangle) and focus on a subject that is a long way away.

You can use depth of field either to show the whole scene in front of you in focus or to highlight just a single object as the main subject by rendering it the only sharp point of the picture. It is a powerful tool and one you need to think about every time you look through the lens.

When shooting landscapes, it is usually desirable to have in focus as much of the scene in the viewfinder as possible. For this you cannot rely on your camera's systems, even if you have depth of field mode.

Imagine a scene where you have a few rocks and some vegetation in the foreground, a great lake with a sprinkling of islands in the middle ground and vast snow-capped mountains in the background. You are using a wideangle lens and everything fits into the viewfinder, including plenty of beautiful blue sky and a few puffy white clouds.

If you let the camera's automatic system have its way, it will focus on whatever is in the centre of the frame, which will probably be the base of those mountains. These lie at infinity. Next, to get as much of the scene in focus as possible, you close the lens right down to its smallest aperture. Two problems arise: first, the smallest aperture on your lens will not deliver the best quality or the sharpest image. Secondly, when you are focused at infinity you will need a tiny aperture to make the depth of field stretch far enough forward to get that foreground sharp.

Since the depth of field extends for one-third in front of the focus point and two-thirds behind the focus point, by focusing on infinity we are effectively throwing away two-thirds of our potential sharp area. As far as the lens is concerned, infinity is as far as you can focus and anything at the infinity point or beyond will always be sharp anyway. All we need to do to get those snowcapped mountains into sharp focus is to include them at the extreme of the depth of field.

Maximizing your depth of field

A depth-of-field scale on a lens allows you to adjust your focusing to ensure your pictures are as sharp as possible. **Using the thirds rule,** we can focus one third of the distance into the scene and check with the depth of field preview that the infinity point is still sharp. If your lens has a depth-of-field scale on it, there is an easy way of doing this. Focus the lens at infinity and set the aperture to the second smallest setting. On the

Hyperfocal focusing

depth-of-field scale you will be able to read off the closest focused point for that aperture. This represents a third of the way into the picture. Then adjust the focusing barrel so that it falls at that point. You have just maximized your depth of field. This means that now you have infinity in focus and you have brought the depth of field forward as far as it can go. Using the depth-of-field scale or the preview function on the camera, you can now check how much foreground is in focus.

This technique is called hyperfocal focusing. The focus point which sits one third of the way into the scene is called the hyperfocal point. You should use this

technique for all your photography – not just landscapes. It is relevant to any shot where you want to get as much of the scene in focus as possible, and it can apply to still-life and human-interest pictures just as much as to landscapes.

Hyperfocal focusing is essential for a composition such as this, where there is a distant subject and a lot of foreground.

Camera shake

Camera shake occurs when we are unable to keep the camera completely still, and is not always a result of slow shutter speeds. The first step to avoid it is to ensure you are holding the camera correctly – that is, as firmly as possible and with your elbows tucked tightly into your sides. Camera shake is more likely to occur when using longer telephoto lenses, and often the only option is to resort to a tripod or monopod, which is something you should consider using as a matter of course anyway. However, camera shake can also occur when a camera is tripod-mounted, especially if you do not use a cable release to trip the shutter, as the pressure of your finger on the button could be enough to cause the problem.

There is a basic rule about avoiding camera shake: when hand-holding the camera, never let the number in the shutter speed exceed the number in the focal length of your lens. For example, if you have a 70mm lens attached to your camera, do not use a shutter speed slower than 1/70 second. But of course, you do not have a 1/70 second setting on your camera; therefore you must round the number up. In this case, it would be 1/125 second. By the same theory, if you have a 180mm lens do not use it with a shutter speed slower than 1/250 second, or with a 400mm lens, slower than 1/500 second.

()

PREVISUALIZATION

This is rather an awkward term to use, and sometimes puts people off as it is often perceived as being a little pretentious. Essentially, it simply means anticipating how you want your photograph to look, and knowing how to adjust and control your camera so you obtain that result. Usually photographers have an idea of what they want before they release the shutter, so previsualization is essential to good results.

Rather than allowing the camera to perform a random selection of exposure, aperture, shutter speeds and metering, by taking control of all these elements you have an almost infinite number of different results open to you. You not only need to think about your shutter speed (whether to freeze the movement or let it blur in the picture) and your aperture (whether to use a shallow depth of field to emphasize a single part of the scene or a deeper one to focus on everything), but whether the subject needs to be shown exactly as it is or whether you would prefer it to be reproduced on film lighter or darker than it is.

Anticipating the moment is essential to good photography, as is shooting a lot of film to ensure that at least one of the frames is successful.

Getting the Basics Right

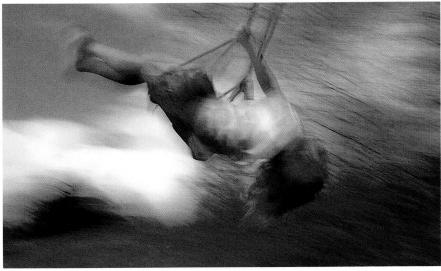

Although this is a colour picture it has a monochrome feel, and the deliberate slight underexposure adds to the ghostly feel.

Panning and using a long shutter speed at the same time increase the sense of carefree movement.

A tool of the trade

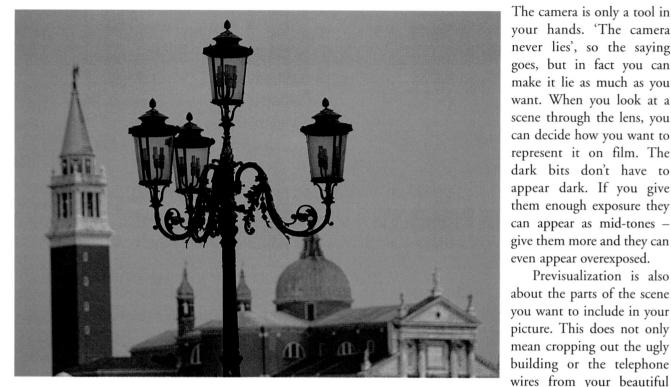

never lies', so the saying goes, but in fact you can make it lie as much as you want. When you look at a scene through the lens, you can decide how you want to represent it on film. The dark bits don't have to appear dark. If you give them enough exposure they can appear as mid-tones give them more and they can even appear overexposed.

Previsualization is also about the parts of the scene you want to include in your picture. This does not only mean cropping out the ugly building or the telephone wires from your beautiful

Using a small aperture draws attention to the ornate lamp-post in the foreground, while giving a blurred impression of the buildings beyond.

The repeatability factor

landscape, it is also about using selective focusing to render 'invisible' elements of the scene you would rather not show. A shallow depth of field can hide all manner of background sins. Dustbins can become vague black shapes and a jumble of vegetation can be transformed into an attractive, non-distracting green patchwork behind a single rose head.

Previsualization is also about knowing how you want your foreground and background to interact. You need to make decisions about such things as how much foreground to include and which lens will make the most of the effect you are looking for. If you want the foreground to have an impact then fit a wideangle lens to give it size and importance. If you just want a hint of foreground in front of a distant subject, use a telephoto lens and drop the foreground out of focus.

Whatever you do, the important thing is that it was intentional; if called upon, you should be able to do it again. Leave nothing to chance and understand how you manage to create every effect you achieve.

It is important to remember that you have control of the pictures you take. Do not feel you have to recreate on film with absolute precision the scene in front of you. True creativity comes when you take what you are given and make something else from it. That requires you to think about how it will look on the light box or in the album – and that in turn requires previsualization. It's just a shame there isn't a better word for it!

Getting the Basics Right

OBTAINING PERFECT EXPOSURES

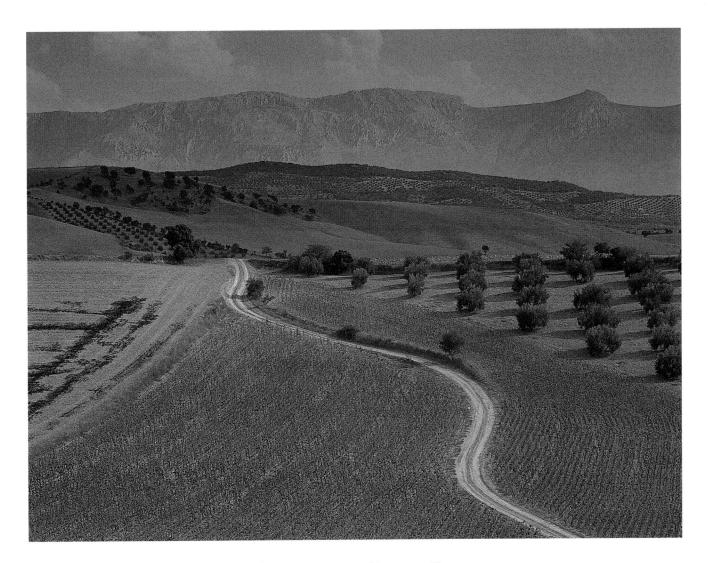

The ability to obtain a perfect exposure is the most important thing you will ever have to learn about photography. And it is not simply about whether a photograph has been overexposed or underexposed, it is about being able to judge what exposure is correct for the circumstances. While most cameras in this age of auto-everything culture will do the job for you, there are still situations where even the most sophisticated automatic metering system will let you down. There is no substitute for reading the handbook and working things out for yourself. Using your own judgement is not as daunting a skill as some people might suggest, and taking some time – and potentially wasting a few frames – will give you the satisfaction of being able to obtain good results every time.

A general scene consisting largely of mid-tones is easy to meter accurately.

Get rid of the greys

Perfect exposures come from understanding the pattern of light and shade in a scene and knowing how you want this to appear in your final image. Achieving the right exposure is not about reading what is there but about interpreting what is there and setting an exposure that will deliver the photograph you are looking for.

You need to be aware that your camera often interprets the scene differently from the way you do. The most important thing to remember is that your camera assumes that, whatever the predominant tone in your scene, it is a midtone grey. So if your scene is predominantly white and you let the camera expose automatically, it will reproduce as a mid-tone grey. If your scene is predominantly black and you let the camera expose automatically, again it will reproduce as a mid-tone grey.

In very simple terms, the answer to these problems is to allow more light to fall upon the film emulsion (by opening the aperture or using a longer shutter speed) if the scene is mainly a bright tone, and to allow less light to fall upon the film emulsion (by closing the aperture or using a shorter shutter speed) if the scene is mainly dark. This may seem illogical, but it is the only way you will reproduce the scene accurately on film.

Purists will insist that you should know exactly where the mid-tone is and what the exposure value of that tone is. Although you need not always adhere to it without exception, it is a sound principle. You need to measure that mid-tone and then decide if you want it still to be a mid-tone in the final print. By opening the aperture or lengthening the shutter speed you can change a midtone to a light tone. Just remember – and it is worth repeating – that your camera meter will look at anything and give you a meter reading which will render that thing as a mid-tone. If your subject is naturally lighter than mid-tone you will need to give additional exposure to the reading from the camera. If your subject is darker than mid-tone you might like to give it less exposure than the camera recommends.

Contrast range

There will, without a doubt, come a time when the contrast range of the scene in front of you far exceeds the ability of the film to record that range. While print film will record detail in a scene with a contrast range of anything up to three or four stops, slide film is far less flexible. Since very bleached-out areas within a photograph can be distracting, it is often best to expose for the highlights – often, but not always.

The classic example is when the sky in a landscape photograph is far brighter than the ground. If you expose for the sky, your foreground will have no detail. But if you expose for the ground, your sky will be completely washed-out in the

Find the mid-tone

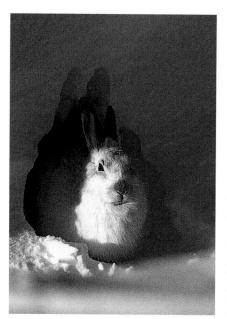

White subjects are tricky to meter. Overexpose slightly and bracket to ensure that the whites are correct and not rendered as a mid-tone grey.

Getting the Basics Right

Above: Dark subjects are also difficult to meter correctly, as they will fool the camera into overexposing. You need to reduce the reflective metered reading by a half to one stop to ensure the blacks are black.

Left: The contrast between the man's dark skin and the white of his clothing is another potentially difficult situation. You will need to decide which is the more important part to reproduce correctly, and meter for that.

Right: Overexposing was essential to make sure the white wall was correctly exposed.

resulting photograph. While this is the perfect time to use a neutral density filter (see page 51), if you do not have such a filter, you will need to decide which part of the scene is more important and meter accordingly. This is when bracketing can prove invaluable (see below). Many photographers also make a point of deliberately underexposing slide film by a third or half a stop, as it can result in deeper, more saturated colours.

Incident and reflected light

Your camera's metering system reads only the light reflected from the subject, not the amount of light falling on to it. An incident meter, however, takes into account only the intensity of the light falling on the subject. Incident-light readings are taken using a hand-held lightmeter, the advantage being that it provides a more accurate reading because it is not affected by the brightness of the subject itself. The exposure will be correct because the subject's colour and the reflectivity of its surface can influence the amount of light reflected to the camera.

Bracketing

Bracketing is the perfect – and sometimes the only – way around a tricky metering situation, but you still need to meter the scene accurately in the first place, otherwise you could end up with a sequence of wasted pictures, all underexposed or overexposed.

Basically bracketing means shooting the scene at the exposure suggested by your camera, then also shooting at third, half or whole stop intervals, both over and under this reading. For example, if your camera suggests a reading of f/8 and 1/125 second, you take an exposure at that reading, then go on to expose at, say, f/8½ and f/11; you then also expose at f/5.6½, and f/5.6. One of this sequence of five pictures should produce an acceptable result. It is a technique really worth using only when you are shooting with slide film, since the latitude of print film will usually allow appropriate exposure.

As an alternative, if you do not want to alter the shutter speed or aperture, you can bracket by using the exposure-compensation dial on your camera. Some cameras have an automatic bracketing facility which does the work for you.

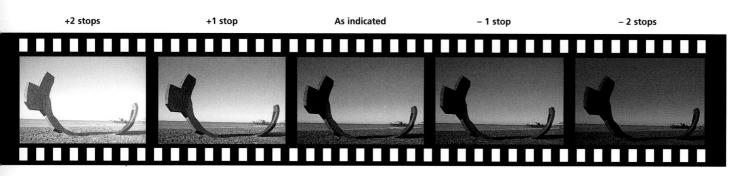

Bracketing was required here as the sky was influential over the scene and there was quite a lot of contrast between shadow and highlight areas.

Using TTL metering

When it comes to an SLR's TTL (through the lens) metering system (as opposed to using a hand-held lightmeter), it is not what you have, it is what you do with it that counts. Some 35mm SLRs have several metering systems, which will cover almost any metering situation you care to think of. Some have only one metering system, but this does not mean you have to be restricted by it. If you know and understand it well enough, it will serve you as well as a camera with several. The main difference between these systems is the way each of them reacts to the light levels in certain parts of the viewfinder.

These are very simple modes to use. You use shutter priority when the shutter speed is more important than the aperture. For example, if you want to capture a fast-moving vehicle, you would set manually the shutter speed – 1/500 second, say – and the camera would automatically set an aperture to give you the correct exposure. Aperture-priority mode is the same in reverse. If you are shooting a landscape where depth of field is of prime importance, you may set an aperture of f/11 or thereabouts and the camera will then select a shutter speed to give you a correct exposure.

This is the most common of the metering systems. It works by measuring light from all over the viewfinder, but pays extra attention to what is going on in the centre of the picture area. The image is split into two parts – the centre circle and the surrounding area. The centre circle influences the exposure slightly more than the surrounding area: the split is usually something like 60:40.

The system works well when your subject is in the centre of the viewfinder. Even if it isn't, in most cases the system will produce an average that won't be far off. However, this system is unsatisfactory when faced with non-average scenes.

Shutter and aperture priority

Centre-weighted metering

As the subject here is fairly large and in the middle of the frame, centreweighted metering is a suitable option. If you have a lot of sky in the picture, your land area will be underexposed, or if your subject is off-centre as well as being unusually light or dark, the system will fail to give the right result. Large expanses of light or dark tones will also throw the metering off course. As you progress in your photography, you will become familiar with the system and learn to recognize situations when it will give you the wrong reading, so you can compensate your exposure to overcome any problems.

This is another averaging metering

system. It has three names because different manufacturers use different words to describe it. (Nikon uses 'matrix', Canon calls it 'evaluative', while Minolta and Pentax call it 'honeycomb pattern'.)

In the simplest terms, the system breaks the scene into a number of parts and reads light information from each. This information is then fed to a central computer which delivers the average reading. Depending on the sophistication of your camera, the scene can be split into anything from four to sixteen parts. Some systems allow for brighter areas at the top of the scene as this is where the sky usually is. Others can also detect when the camera is turned on its side for a portrait-format picture and then adjust for where they expect the sky to be. The more sophisticated systems use information from the autofocus system to detect which area the subject is in. The metering can then be adjusted to give most importance to this area.

For all its clever and sophisticated technology, this is still just an averaging exposure system and it will not work when faced with anything unusual. The white Scottie dog in a bath of milk is still going to be underexposed and the nun driving a black limo will still be overexposed. Too many photographers think matrix metering is the answer to all their prayers, but if this was the case, modern cameras would not feature centre-weighted and spot-metering modes as well. And they do.

Matrix/Evaluative/ Honeycomb metering

Because there is a fair amount of sky in this scene, as well as a lot of contrast between shadow and highlight areas, matrix metering needs to be selected for an accurate exposure.

1

Spot metering is probably the most useful – and the most misunderstood – of all the metering modes. This system allows you to isolate a single part of the scene to take a light reading from only that part. The actual spot is usually in the centre of the viewfinder and varies in size depending on the model of camera – anything from 2 per cent of the image area to about 8 per cent (which is strictly called partial metering because it is hardly a spot!).

The way it works is that you point this spot at anything in the scene and it tells you how much light is being reflected from it. The mistake many people

Spot metering

With a backlit subject, spot metering from the front area, which is in shadow, is essential to make sure the light does not wrongly influence the meter reading, and render the shadow area underexposed.

> make is to believe that the reading given by the spot is the one which will deliver the correct exposure for that object. But as we now know, if you point it at a white object, the meter will tell you what exposure you need to make that object appear as a mid-tone. And if you point it at a black object, it will do the same. The trick is to find the object in the scene in front of you that you want to reproduce as a mid-tone in your final image and point the spot meter at that.

> Once you have learned how to use spot metering correctly, it will prove to be the most accurate of the metering systems. You will have to invest a bit of time in learning how to use it, but it will be time well spent.

The grey card

Many photographers swear by the 18 per cent grey card, but there are equally as many who can live without it. A grey card is exactly what it says, and if you take a meter reading from it, you will get the correct reading to reproduce a mid-tone in your photograph, but only if you meter from it in an area where it reflects exactly the same light as is reflected from your subject. It is a very common error to take a reading from a grey card – or its equivalent – in the shade, despite the fact that the main subject is bathed in bright sunlight, or vice versa.

Apart from the fact that grey cards become worn out or get lost very quickly, it does not take long to learn which other items also reflect an 18 per cent tone of grey. Some camera bags, for instance, are deliberately designed to do so, or, alternatively, a white person's hand – minus one stop – can be used to equal a mid-tone. A grey carpet tile or a lawn are also good standbys.

Getting the Basics Right

FILTERS AND HOW TO USE THEM

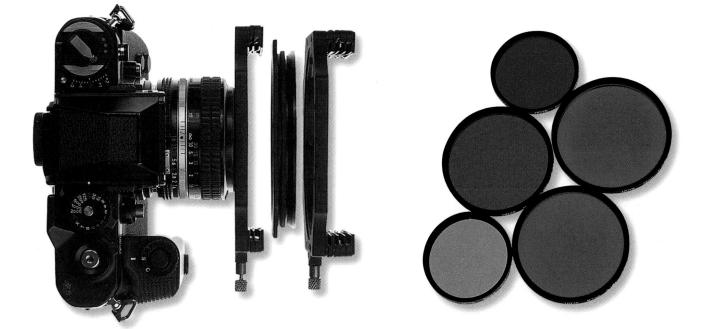

There comes a point in every enthusiast's photography career when they discover filters, and a whole new colourful world is opened up. After a quick skim through the catalogue and a trip to the camera shop, the result is often a nightmare of garish colours and special effects used in an attempt to enhance what is frankly a dull subject. It is probably true for most of us that our first few forays into filter purchasing produced no useful filters at all. There are so many filters on the market and most look tempting in the sales booklets but, in truth, there are not many that are genuinely useful. Those that are useful appear somewhat unglamorous at first glance.

Above left: Square filters require special holders which screw on to the front of your camera. Above right: Round filters can be screwed directly on to the lens itself.

Light filters

Filters, as the name suggests, are in the business of filtering. For the purposes of photography, they filter light. Essentially, they allow certain types of light to pass through, while stopping others. In some subject areas this ability to control the type of light reaching the film is critical to the technical quality of the result, while in other areas the use of a filter can enhance the picture to suggest a

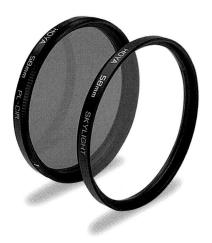

situation that isn't quite true, but which is better than reality. Filters can be used to emphasize certain aspects of the scene, to alter the contrast or to change the way different colours or tones relate to each other. Filters are a very useful aspect of picture taking but they can only enhance or improve what is already there. They do not work miracles, nor should they be the purpose of the photograph. You cannot make a great picture by taking a bad picture and adding a filter. A filter can only help you when you have a good picture already. No amount of special effects or bright colours is going to improve a dull subject or a bad composition.

What are filters and filter systems?

Filters are made from one of three materials: glass, plastic or a tough resin. Generally speaking, those made of glass are of better quality; they are more expensive and the most worthwhile investment.

While filters are undoubtedly useful, the negative side of using them is that they degrade the quality of the image. You may spend a lot of money buying the best lens you can afford and then stick a cheap filter over it. This instantly reduces the quality of the lens, as you have now effectively given it a plastic front element. Plastic filters scratch easily and these scratches disperse the light as it passes through them, giving a soft-focus effect. The difference between plastic filters and glass filters is similar to the difference between plastic sunglasses and glass ones. It doesn't take too long for the plastic lenses to get scratched and then it becomes very difficult to see through them clearly. Glass lenses are far more durable and will deliver a sharper image for much longer.

The tough resin filters are cheaper than the glass types and represent a realistic compromise between cost and quality.

Whatever type of filter you choose, you must keep both sides clean and dustfree at all times. Do not be tempted to keep them loose in your camera bag as any type of filter will become damaged if it is not protected. You should treat your filters with as much care as you would an element of one of your lenses.

Filter shapes

There are two basic shapes of filter. There is the round filter in a metal ring that screws into the front of your lens; then there is the square or rectangular filter that slots into a filter holder that in turn screws to the front of your lens via an adapter. There are pros and cons to each shape, but for the enthusiast there is little to recommend the screw-in filter. Although they tend to be made

The advantage of square filters is that they can be moved up and down in the holder so that the graduated area corresponds with the horizon of your composition. from glass and are therefore of very high quality, what works against them is that you have to acquire a separate filter for each lens thread size. If you have three different-sized lens threads and use a polariser with each of the lenses you will need to buy three polarising filters, which will be an expensive exercise. And you will need three of each of the filters you use with all three lenses. In the end you could end up with a bag full of round filters and no room for the camera!

With the rectangular system, you need only a cheap adapter ring for each size of lens thread. The adapter ring connects the lens with the filter holder, so the same filter can be used with each of your lenses. With the rectangular system you need only one polariser.

Buy big

There are a number of filter manufacturers who offer enthusiast filters in two sizes – generally 'amateur' and 'professional'. If you are likely to use a lens wider than 28mm or a wide-apertured telephoto zoom, it is best to buy the larger 'professional'-sized filters to start with. Many make the mistake of starting with the 'amateur' range, only to find they are not physically big enough to cover the front element or the angle of view of some lenses. It is better to buy big from the outset rather than find that later you have to buy duplicate filters in a larger size for some of your lenses. The big filters fit even small lenses but the small filters have adapter rings for thread only up to 77mm.

There are other reasons to recommend the rectangular system for specific filters and these are dealt with in the sections on those filters. Also some filters are best bought in the round, screw-in version for practical reasons. More on both of these subjects can be found later.

Types of filter

This filter is so useful for all types of photography that most photographers keep one on the lens at all times. Its purpose is to cut out ultra-violet light in the atmosphere to enable us to capture clearer photographs. Often in a landscape situation – and particularly for distant scenes at altitude – there may be an atmospheric haze that partly obscures colour and objects close to the infinity point. A UV filter will reduce this haze to allow the lens to collect sharper detail. Without such a filter, the haze you see with the naked eye will be exaggerated in the resulting picture, because film sees UV light while we do not.

UV (Ultra-violet)

<u>ا_</u>

As these filters appear colourless they have little effect on the pictures where you might not actually need the filter. This means there are no side-effects if you keep the filter on the lens all the time. These filters are not expensive and serve to protect the front element of the lens from dust, dirt and scratching. For this reason, most photographers buy a filter for each of their lenses in the screw-in version and keep it in place constantly. It is cheaper to replace a UV filter after an accident than the front element of a lens.

Polarising filters are used to cut out reflections from non-metallic surfaces. Using a polarising filter, it is possible to see through the reflections on the surface of water, or on a plate of glass.

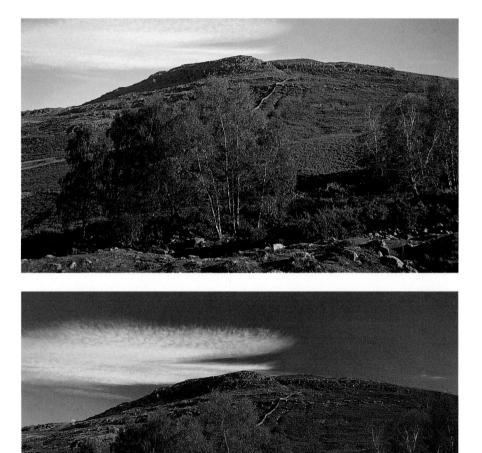

Above: Without the polariser the sky is rather washed out. Right: With the polariser fitted, the blue of the sky is intensified, highlighting its contrast with the white clouds.

Polarisers

Light waves vibrate in all planes at right angles to the direction of travel, while polarised light can vibrate only in one plane. The polarising filter prevents waves vibrating in certain planes from passing to the film, allowing through only those waves vibrating in the plane that is parallel to the lines in the filter. In practice, this is like trying to fit a slice of bread into a toaster. Unless the bread is parallel to the slot, it won't go in and any slices that aren't parallel will bounce off. A polarising filter is like a series of toasters in line that only allow light vibrating in the right plane to pass by.

By turning the filter, you can alter the type of waves you allow past. It is simply a matter of turning the filter while the scene is being viewed through the viewfinder until the desired effect is achieved.

The greatest benefit of the polariser is the deepening of colours by the removal of reflections from their surface, and the emphasizing of a blue sky at right angles to the sun. Polarisers have little effect on the sky when the sun is high, but can create spectacular effects in early morning and late afternoon. For this reason, it is a popular filter with landscape and architectural photographers. These filters are also useful for copying work where the original is covered by a sheet of glass or has a glossy surface.

There are two types of polariser for your camera: linear and circular. It is safer to buy the circular version because the linear type can interfere with the autofocus and autoexposure functions on some SLR cameras.

A neutral-density filter should be completely colourless, but shaded like a pair of sunglasses. The purpose is to reduce the amount of light reaching the sensor (in this case, the camera film) without altering anything else, particularly colour. These filters come in different strengths for controlling exactly how much light can reach the film. They enable the photographer to use slow shutter speeds, wide apertures or fast film in conditions that would not normally be suitable. If, for example, you want a very shallow depth of field and lots of grain, you would use a combination of wide aperture and fast film. However, if it is a very sunny day and your camera is loaded with, say, ISO 3200 film you may not be able to do this. The camera might recommend f/8 at 1/2000 second, but you want to use f/5.6. As 1/2000 second is the fastest shutter speed setting on your camera, you would be unable to open up by one stop and maintain a correct exposure. Fitting a 0.3 ND filter would reduce the amount of light hitting the film emulsion by one stop, so you could set an aperture of f/5.6. The same would apply if your lens did not have a small enough aperture to accommodate a particularly slow shutter speed.

If you buy a neutral-density filter it is worth buying a good one, as cheaper models are not completely neutral. If the dye in the filter is not a true grey or colourless tone, the filter will affect the colour of the shot. Often lower quality ND filters will give your photographs a magenta cast. Filters that can't be classed as neutral in tone are often called 'grey' filters instead of 'neutral'. Grey filters have their uses, but some are better than others.

Depending on the manufacturer, the strength of the ND filter is expressed

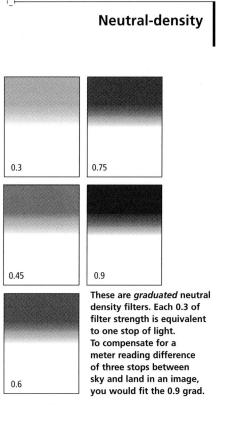

as a decimal. A filter that reduces the light flow by one stop is labelled 0.3, while one which cuts out three stops of light is labelled 0.9. Neutral-density filters also come in graduated form.

Graduates

Top left: **Unfiltered shot.** Top right: **With 0.3 ND grad.** Bottom left: **With 0.6 ND grad.** Bottom right: **With 0.9 ND grad.** A graduated filter is just that – graduated. It has a colour or tone that graduates in strength across the filter. The idea is that you can filter one side of the image while leaving the other untouched. The introduction of the colour or tone does not usually start for some time, so there is often a good-sized section of completely clear filter. These filters, especially the coloured ones, are put to all sorts of questionable uses, such as turning half a building pink while the other side looks normal. However, they can also be very useful.

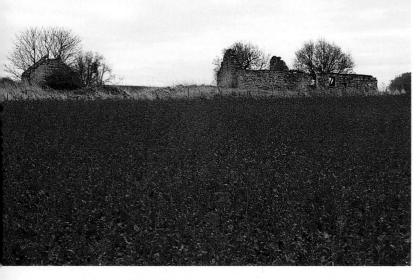

()

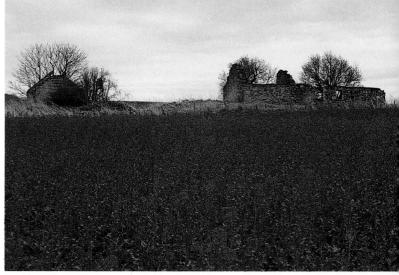

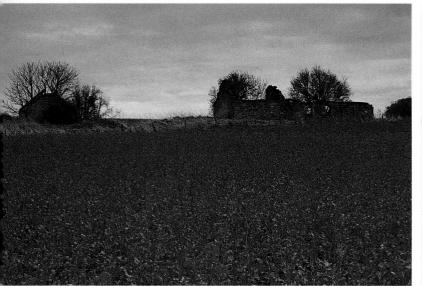

Getting the Basics Right

Graduated filters are popular in landscape photography for controlling the appearance of the sky. If the sky is considerably brighter than the land area in your frame, it is desirable to reduce the sky's brightness so that it will balance with the meter reading from the foreground. To do this, we can use a graduated neutral density filter. The darker area sits over the sky area to darken it, while the land remains unaffected as it is covered only by the clear part of the filter. In this way we can produce a more balanced exposure that shows detail in both land and sky areas of the picture.

Tobacco filters are usually graduated and used to colour the sky in a landscape. They act partly as a neutral density filter, by balancing the exposure for a bright sky and a darker land area, but add a warm brown tone to the sky as well. This can create a stormy feel to the image.

As not all landscapes are composed with the horizon in the centre of the frame, it is useful if the area where the clear glass meets the toned glass can be shifted to cover different horizon positions. For this reason, round graduated filters are not worth buying. As a round filter screws in to a permanent position in the lens, the crossover area, or join, will always be in the same place. If you decided you wanted a lot of sky in the shot, so positioned the horizon close to the bottom of the frame, you would

need to shift that crossover area also to the bottom of the frame. With a rectangular filter you are able to do this by sliding the filter down in its holder.

These filters do not have to be used upright. If you have a scene that has an area of extreme brightness on one side you can swivel a graduated neutral density filter on its side to balance the exposure from one side of the image to the other.

In the studio, graduated filters are useful for producing graduated backgrounds on plain surfaces, and you can choose exactly where the graduate will start.

With all graduated filters you can increase or decrease the abruptness of the join between clear and toned glass using the aperture settings. For a subject at the same distance a smaller aperture will produce a sharper join area than a wider aperture. Also, when shooting close objects with a wideangle lens you will find a harsher join than when shooting distant subjects with a telephoto lens.

Top: Unfiltered shot. Bottom: The same shot, with a tobacco filter fitted. This type of filter is not always everyone's cup of tea! However, used in some circumstances – to intensify the colours of a sunset, for example – it can enhance the atmosphere of an image. Soft-focus

It might seem a little strange to spend money getting the sharpest lens you can afford, only to fit a filter over it that takes that sharpness away, but that is just what many portrait photographers do. The problem is that some lenses are just too sharp and show every line, crease, spot and blemish, and that's not going to make you popular with your subjects! Soft-focus filters just take the edge off the sharpness to hide the bits that portrait sitters want to forget about. There are different strength filters for producing different amounts of softness from just a tiny touch of softness to complete fog. It is always best to avoid extremes, and extreme softness can often look like 1970s glamour.

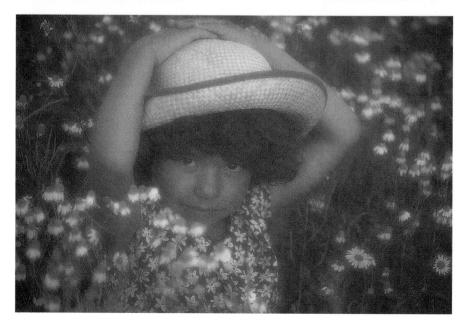

Above: Unfiltered shot. Right: The same shot, with a soft-focus filter fitted. Note how this type of filter makes the highlight areas bleed into the darker areas of the picture. Soft-focus filters are useful in areas of photography other than portraiture, although this remains their staple employment. A still-life shot that requires a soft atmosphere will benefit from a mild filter, as will certain types of landscape. These filters are all very well as a labour-saving device but often the effect is better created through the use of soft lighting rather than a degradation of the lens quality.

When we shoot with normal colour daylight-balanced film in daylight or with flash, we record colours as they appear to our eyes. Whites will appear white. If, however, we want to take pictures using normal household lighting, we will find that whites take on a yellow appearance and every other colour will be influenced by a yellow cast. This is because the light from tungsten (domestic) lighting does not give off the white light with which normal film is designed to be used. To correct this and other colour casts caused by lighting that is not white, we use colour-correction filters. For tungsten lighting you should fit a blue filter over the lens to effectively neutralize the yellow cast. The shade of blue we use depends on the type of tungsten lighting and special filters are produced for different coloured bulbs. This colour depends on the wattage of the bulb.

Fluorescent lighting records as green on daylight-balanced film and this requires the use of a magenta filter to reverse the colour cast. Fluorescent lighting comes in many different forms and many different colour casts, so you will need to check carefully which particular shade of magenta or colour combination you need for each light source.

Rather than use a filter to correct the cast from tungsten lighting, you could instead use a film that is balanced for use in tungsten light. Should you decide, however, to use this film in daylight you will need to compensate for the builtin blue cast of the film. To do this you will need to fit a yellow/orange filter over the lens.

A skylight filter is designed to combat the coolness of the light that comes from a very blue sky. These filters are slightly pink in colour and this pinkness helps to warm up the picture a little. On a bright day, particularly in snow, when there is a large expanse of blue directly overhead, water and reflective objects will pick up some of the blueness of the sky. The sky can act as a large reflector and push cool light over the landscape. The skylight filter helps to correct this colour cast.

Sometimes outdoor light can appear cool. This is especially true on overcast days or when you are photographing in the shade. For landscapes and portraits, particularly, it is often desirable to add a bit of warmth to the image to make the shot or subject more attractive. To help us with this sort of situation, there is a range of warm-up filters on the market. These are basically yellow filters in a variety of strengths from a very pale tone to a quite heavy one. While restraint is the usual watchword with filtration, and just a touch of warm-up is always better than a shot that shows obvious use of a filter, heavy yellow or orange filtration can look very effective with certain subjects. Generally, though, we

Colour-correction

Skylight

Warm-up

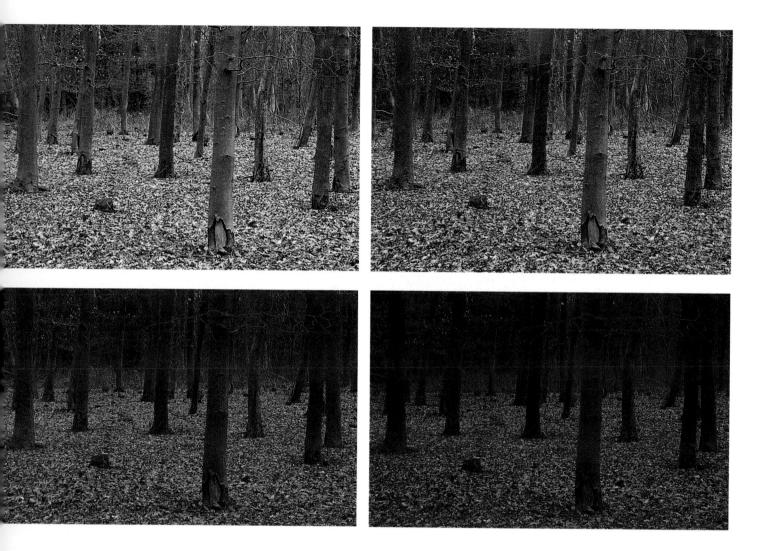

Top left: **Unfiltered shot**. Top right: **With 81A warm-up filter**. Bottom left: **With 81C warm-up filter**. Bottom right: **With 85EF warm-up filter**.

Intensifiers

should try to apply a quantity of warm-up that looks natural and not false. Like fake tanning, it is too easy to turn a subject's face yellow instead of a healthy gold.

It is worth having a strong orange filter, like the one used to correct daylight for use with tungsten film, to add a sepia-style aged look to landscapes or architectural shots. In the right circumstances this will look very attractive.

Sometimes we want to make a certain colour brighter and deeper than it really is, but without affecting the qualities of the other colours in the shot. Intensifiers are designed to do just that. Usually available for reds or greens, they highlight the chosen colour, adding extra density on top of what is already there. The success of these filters varies, and you might find that whites in the scene also take on a shade of the intensified colour. In truth they are not perfect, but can work well if you do not have much in the way of light or white tones in your shot.

Getting the Basics Right

Not strictly filters

There is a group of attachments for the end of your lens which are often labelled 'filters', despite the fact that they are more accurately light or image modifiers. Filters in this category include prism attachments, which produce the subject repeated a number of times all round the screen, and split-screen filters, which allow two focus points through the use of different dioptre sections in the same filter. Also sometimes classed as filters are the magnifying lenses that allow close-up work with your normal lens.

If you want a rainbow in the shot you can buy a clear filter with a rainbow painted on to it – but it is not advisable! There are many other special-effects filters that produce, for instance, a star-burst on lights and bright spots, filters that leave motion trails behind the subject and hundreds that turn the subject a range of different revolting colours. Most are best avoided.

Above: Unfiltered shot. Below: With sunset filter fitted.

Top: Unfiltered shot. Bottom: With sunset and blue graduated filters fitted.

Filters for black and white photography

It might seem a little odd that coloured filters should have a place in black and white photography, but they do. To understand this we need to remember that coloured filters do not so much add colour to an image as prevent certain other types of light from passing through them.

There are five principal filters that are regularly used with black and white films. These are red, yellow, orange, green and blue.

Light skies in a landscape will often reproduce as a plain blank white or grey in a black and white image. This is because the film cannot see much difference between the white of the clouds and the blue of the sky. A red filter can inject a certain amount of drama, creating strong contrast between the two. On the colour wheel, red and blue appear as opposite colours, thus a red filter will hold back the blue. As hardly any blue can reach the film, any areas that appear blue before your eyes will appear black in the final image. By using a red filter on a sky you can create white clouds against a black background.

The disadvantage of the red filter is that sometimes the contrast it creates is too great. Green is also opposite red on the colour wheel and thus returns darker tones under a red filter. In a landscape picture you could easily end up with a dramatic sky and dark land and trees, which might be too much in the way of dark tone for your liking. Also, patches of water that reflect the blue of the sky will appear dark. So you can see that a red filter, while very useful, can become a problem in itself.

Often the answer to the heavy contrast issue is to use a weaker filter. Both orange and yellow will do the trick, as the effect on greens and blues is not quite so extreme. You will still get the detail in the sky of white against blue, but without such a marked contrast. Of the two filters, orange is the stronger, while yellow makes just a small difference.

Yellow and orange filters have other uses apart from in the landscape. When copying old pictures it is often difficult to attain a decent level of contrast because of the absence of real whites from faded or sepia prints. By matching the base colour of the print with the filter colour as much as possible, you will allow more light from the should-be-white areas to pass, creating a better white on the final print.

There is a favourite trick performed in colleges all over the world, where red wine is spilt on to an important document. The document is then copied using a red filter to allow extra light to pass from that area so that the stain disappears in the final print. As a practical exercise it is remarkably pointless but it does demonstrate the magical power of the filter in black and white image-making.

Red

Yellow and orange

Facing page

Top left: Unfiltered shot. Top right: With yellow filter fitted. Bottom left: With orange filter fitted. Bottom right: With red filter fitted. It is easy to get carried away with the extreme contrast between sky and foreground created by the red filter. However, often a little more restraint is called for, so use a yellow or orange one too, then make up your mind!

Getting the Basics Right

Green and blue filters

1

Green filters obviously make greens lighter and reds darker, as do blue filters with blues and reds. The uses for these two colours are rather more limited in general photography than the warmer colours, but are most useful if you wish to render grass or skies lighter than they actually are.

Filters in infrared photography

In black and white infrared photography the red, yellow and orange filters have a similar effect to that which they have on ordinary black and white film – blues and greens become darker. But the filters also serve to promote the effect of infrared radiation so that things that reflect it will appear white. You will end up with some greens (those of living foliage) appearing much lighter than other greens (a green car, for example).

When we take pictures with colour infrared slide film, filters again have an important part to play. While not actually controlling the quantity of infrared reaching the film in the same way as with black and white film, red, yellow and orange filters will alter the colours used to represent colours and brightness in the scene. There is also a special infrared filter that can be used with either black and white or colour slide film. This filter is not particularly popular since it is difficult to use owing to the fact that it lets no visible light through. Therefore, when it is fitted over the lens, your viewfinder will be black. In black and white photography this filter produces excellent results and a great infrared effect. In colour the effect is a monochromatic version of the black and white film but in black and red. This is also very effective.

Filters, factors and metering

Depending on the filter you are using, there are two different ways of metering. For plain coloured filters and effects that cover the whole image area, you should fit the filter and then meter in the usual way. With graduated filters there are two schools of thought. One says that you should take a meter reading first from the area which will be covered by the clear part of the filter, set that reading manually, fit the filter and take your picture. The other suggests that you just fit the filter and take an average reading. Both work, but the latter will be accurate only if you balance the light and dark areas perfectly (e.g. by fitting a 0.6 ND grad to compensate for a sky which is two stops lighter than the land). If there is still a discrepancy between the filtered and unfiltered parts of the frame, you should use the first method.

If you do not have a built-in exposure meter, you will have to read off the 'filter factor' on the filter case. The factor tells you how many stops to adjust the exposure by when the filter is fitted. A filter with a factor of 4 requires an extra four stops of exposure above the non-filtered reading. The alternative is to hold the filter over the sensor of your hand-held lightmeter.

CHAPTER THREE

COMPOSITION

Ask any photographer what they believe to be the most important aspect of any landscape photograph, and the chances are the answer will be 'light'. And they'd be partly right. However, even when presented with the most aweinspiring combination of light, shadow, texture and colour, your resulting image will amount to little more than a satisfactory snap for the holiday album if the composition isn't working.

It raises a vital question, too. When faced with a breathtaking view, a family group at a wedding, or a giraffe munching leaves on a tree, how do we know what to include and what not to include in our picture? How can we best convey the drama, humour or serenity – or any other emotion we choose – to whoever is looking at the photograph?

The thought process that takes place when we lift the camera to our eye can take seconds, minutes, hours, or even days, but it is the key to a successful composition. When a scene unfolds in front of us, it is up to us to decide whether each element contributes to or detracts from the photograph we are trying to make. It is this combination of elements and their coherence within the frame that dictates the success – or otherwise – of a photograph.

LANDSCAPES

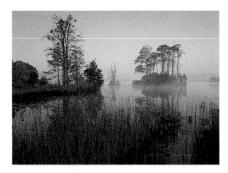

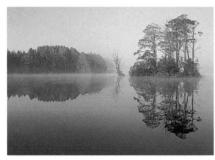

Lenses in the landscape The type of lens you choose will alter dramatically the outcome of your pictures

(see Chapter 1, page 17). If you were to use too wide a lens in the landscape, you might end up with a mass of bland, uninspiring foreground, while the true focal point of your composition is a pinprick on the horizon. On the other hand, if you combine a wideangle lens with a low viewpoint, you will convey all the drama of the landscape.

Using too long a telephoto lens risks cutting out all foreground interest and other elements which set your landscape image in context. However, its advantage is that it can also compress the 'layers' of, for example, a mountainous landscape, to make them seem closer to each other than they would otherwise appear. As ever, it is a question of experimentation and practice, and eventually you could find it becomes second nature to select the right lens for the type of image you have previsualized.

Exploring the landscape

One of the most common mistakes a photographer can make is to turn up at a wonderful spot, take a couple of quick snaps, then hop back into the car and drive away, assuming the job's well done. While he or she may well have made a decent photograph, nine times out of ten that photograph could have been improved with a little time and exploration.

The way to achieve a photograph which stands out from the rest is to explore the landscape you are in. This might mean walking for a few hours, circumnavigating mountains, climbing hills or fording rivers – but it could also mean simply moving a few steps to the left or right, moving forward or

backwards a few feet (assuming you will not fall into a ravine as a result), or raising or lowering your tripod by a few inches.

Experiment with both horizontally and vertically framed images and consider the difference this makes to the scene in front of you. You might find that framing a sweeping panorama

This sequence demonstrates how varying your viewpoint and moving just a short distance one way or another can transform a picture. The top picture was taken with a 28–70mm zoom at the 28mm end, and shows a lot of foreground, which some might feel is a little distracting. By moving further around the edge of the lake, the photographer was able to exclude the reeds in the foreground, but still use a relatively wide setting – around 35mm. Only a few paces to the left, a log protruded from the water, giving a focal point to the bottom third of the frame. Then, turning the camera on its side, and again moving in one direction or the other, the photographer was able to choose between the simplicity of a log as foreground interest, or the texture of reeds.

Composition

vertically gives an added sense of depth from foreground to background. Alternatively, you might decide that the lake in the foreground which initially appeared essential to the composition is worth sacrificing in order to convey the sense of a 180° view.

If you have a focal point you want to include in your frame – a church, a tree or an interesting rock formation, say – move your camera around to decide whether that focal point looks best in the top right-hand corner of the frame, the bottom left, or even smack in the middle. And don't just shoot it from the first angle at which you come upon it. Walk all around it, studying the foreground and background which will be included in the frame.

The decision about whether to shoot a landscape in horizontal or vertical format can drastically change the emphasis of a composition.

The rule of thirds

The rule of thirds is central to all types of photography – not just landscapes. And although some argue it is a cliché, it works almost without fail. Imagine a grid placed over your composition – three vertical lines and three horizontal lines. The theory goes – if you are taking a landscape shot, for example – that your sky should take up approximately the top third, the middle distance the middle third and the foreground the bottom third. Then you might have a nice little rustic barn nestled in one of the four bisecting lines created by this imaginary grid. It's all very pleasing to the eye, and nine times out of ten your result will be a satisfying image. However, after a while you may find that the rule of thirds feels just a little too safe, and the maverick inside you is just dying to take a crowbar to rules like this. Well, go ahead!

If your instincts tell you to plonk your focal point slap bang in the middle of your frame, then follow them. If your instincts tell you to cut out the sky altogether and simply reveal the shapes and undulations in the landscape, then that is worth trying, too. Composition is such a subjective craft that it is often impossible to say what is right and what is wrong. However, it is not just whether or not to adhere to the rule of thirds which makes a landscape photograph. It also comes down to the type of viewpoint you take.

Breaking the rule of thirds

Above: Adhering to the rule of thirds is almost guaranteed to produce a pleasing result. Left: However, breaking the rule of thirds – perhaps by placing the subject in the centre of the frame – can sometimes produce a more dynamic composition.

By getting right down low to the ground, you can produce a composition not normally seen by the average viewer.

The plume of smoke from the factory provides the main emphasis of this picture, with the varying textures of the wet roofs in the foreground adding an interesting contrast.

Change your viewpoint

Taking a low viewpoint can dramatically increase the impact of a photograph, especially when combined with a wideangle lens. By crouching down low, you suddenly find you have a strong foreground interest with which to draw the observer into the picture. If shooting from a low viewpoint, look out for strong shapes and texture and, in particular, diagonal lines that start from the outer edges of the frame and extend to a point within the frame. Completely still conditions are vital when shooting low down – unless you specifically want a hint of movement in your picture – because you'll need a very small aperture to ensure everything in frame is sharp from the foreground to the background.

The other advantage of a low viewpoint is that it discourages the photographer from including too much sky in the frame, which is a common mistake. Even when faced with spectacular cloud formations, for example, don't be tempted to include too much, as it will lessen the impact of the land. By having just a little of the sky in frame, your photograph will still show the spectacular light, but will have more of a feeling of balance.

Taking the other extreme, you could find a spot which allows you to look down on the landscape unfolding in front of you. This will give an immense feeling of space and will allow you to include the many features – both natural and man-made – which are characteristic of the modern landscape.

Landscape styles

Aside from following the rule of thirds, there are numerous ways of making the composition of your landscape effective.

Although landscapes usually need to have a strong focal point, this is the perfect contradiction to that rule. A landscape which is almost entirely without stark features can have just as much effect as one where the viewer's eye is drawn

straight to a particular object. You might concentrate on the textures of sand, for example, or the shape defined by a curving river with the sun glinting off it.

Both sunrise and sunset are wonderful times to photograph a featureless landscape, because the shapes and colours alone which are seen at these times of

day can be enough to create a stunning photograph. It's also a composition which often works particularly well in the panorama format, as the eye is encouraged to sweep from left to right, almost 'reading' the image in the way we would read a book. Empty landscapes

Above left: The impression of an empty landscape can be created with a telephoto lens. These isolated-looking rocks are actually part of a very busy bay!

Above: Sometimes only minimal detail is required, and subtle light forms the basis of the composition.

Left: The feeling of dunes stretching to infinity is enhanced by the low viewpoint and the ripples in the sand rushing away from the lens.

Movement

(_)

The stillest conditions often occur just as the sun rises. By 8 o'clock on a summer morning a breeze is usually blowing, putting paid to anything which requires a small aperture and slow film. For those souls who prefer a few extra hours in bed, do not be afraid to have a touch of movement in your pictures.

It pays, once again, to shoot plenty of film using a variety of longer shutter speeds so you can be sure of getting the best effect. If you find you are unable to

A windy day need not spell doom for photography. Often the feeling of movement created by a long shutter speed will add to a composition. Do not be afraid to experiment.

Rushing water can sometimes be made to seem very peaceful, when a long shutter speed is used. Often, too, it is only on seeing the photograph that the route of a waterfall is revealed. get a sufficiently slow shutter-speed reading, even when you stop down to an aperture of, say, f/22, there are other ways of getting there. For a start, you could change the speed of film you are using. An ISO 400 film used in bright conditions is never going to give you a really slow shutter speed, no matter how hard you try. Load an ISO 100, ISO 50 or even ISO 25 film instead. Also,

neutral-density filters can cut out up to four or five stops of light – depending on the strength of the filter – thus reducing your shutter speed dramatically (see Chapter 2, page 51).

If you want to convey the merest hint of a breeze in a golden cornfield, you'll need a slightly faster shutter speed than if you want to convey a gale rushing through the treetops. When it comes to water, however, it's a little more subjective. Some people prefer a very fast shutter speed which captures every last droplet of a crashing wave, while others prefer a shutter speed of half a second – or longer – which turns wild waves into nothing more than fluffy cotton wool. Who says the camera never lies!

Composition

There's no rulebook which states that a landscape photograph has to show a wide, open vista, with miles of countryside rolling off into the far horizon. A close-up can say just as much about our environment and can create a very pleasing, almost abstract image of shape and texture. The

natural geometry of leaves makes a perfect subject, as do icicles, grasses and, of course, flowers. Think carefully about the colour of your subject when shooting abstracts - one uniform colour can work just as well as an image which has a backdrop of colour and a focal point in a contrasting shade.

One of the most pleasing ways to lead your viewer into a landscape photograph is by framing a distant focal point with an object in the foreground. Boughs of trees do this perfectly, as do gateways, arches and other architectural features. They can also hide a multitude of sins, including dull, featureless skies or other objects which would otherwise be an unsightly intrusion into the frame. If you find a tree which provides a perfect frame to a feature, take care not to have just a few branches incongruously dangling into the top sliver of your frame. Instead, include the branches and, if possible, the curve of the trunk. It will bring the composition together a lot more coherently. A small aperture is vital in these circumstances so that your frame and your background are both sharp.

Making a final check

Once you are happy with your composition, take a few moments to study the viewfinder. This could prove invaluable. It is at this point that you might notice the foil sweet wrapper which is perfectly placed for the sun to glint off it, or the unattractive dried-up grasses straying into the bottom of your frame.

The other extremely important thing to look at is your horizon. Is it completely straight? When taking pictures, many people concentrate so hard on what is in the foreground of the frame they completely forget to check the horizon, leaving it to appear as if it is sloping off to one side instead of being perfectly straight. If you find this is happening a lot in your pictures, it is worth investing in a small spirit level to ensure your camera is completely balanced. This final check does not take long, and it could save a lot of disappointment when you get your pictures back from the processing lab.

Abstracts

Always keep your eyes open for unusual compositions. Here, the strongly contrasting colours - and the fact that there are only two of them – emphasize the sharp, diagonal lines.

Framing

Look for different ways in which to photograph well-known subjects. This composition works particularly effectively because the shape of the frame echoes the dome of the Taj Mahal beyond.

A question of format

So far throughout this chapter we have assumed that all landscapes are shot on a 35mm-format negative or transparency. However, you do not have to look far to see that some of the best landscape photographers working today do not by any means always use a rectangular format. It is important to be aware that if you change format, you also have to alter the way you compose your picture.

6 x 6 cm

To many people, this is an unnatural format for landscape photography, as the square shape does not lend itself to the wide sweeping vistas we normally associate with the great outdoors. However, it is the chosen format for some renowned landscape photographers such as Charlie Waite. The rule of thirds was not written for this format, either, but when using a 6 x 6 cm format, you should look out for a strong, sizeable focal point, preferably towards the foreground of your picture. Avoid dividing the image precisely in half, especially if the sky is uninteresting, as this sort of symmetry works less well in the square format.

6 x 7 cm

Although there is only a centimetre's difference between this and a square format camera, they are worlds apart in terms of composition. This format is similar to the rectangular format that 35mm users are accustomed to, but allows the cropping out of too much bland sky or dull foreground. A format that works particularly well when the camera is turned on its side, it is an ideal route to a pleasing composition.

5 x 4 in.

This is the one format that sticks resolutely to the imperial measurement system! While the cameras are extremely heavy (you might want to hire a pack pony for particularly inaccessible locations), you may find that the huge leap in quality from 35mm makes the weight worthwhile. Compositionally, you would need to think in a similar way to when using 6 x 7 cm, but the main point in this format's favour is that the camera will considerably reduce the speed at which you work. That is because it is a fiddly camera to use, and the whole process is enjoyably laborious. However, so is landscape photography, so the two are perfectly suited!

6 x 12 cm and 6 x 17 cm

The panorama format is perfect for use in the landscape. It is a difficult format to master, as the long frame needs to be filled with visual interest across its whole area. However, the effort is worthwhile as the results often provide the most dramatic visions of space. The 6 x 17 cm format, in particular, is immensely tricky, as its letterbox format is a demanding one to work with, but it is worth it for the novelty of turning it on its side from time to time for an upright panorama picture.

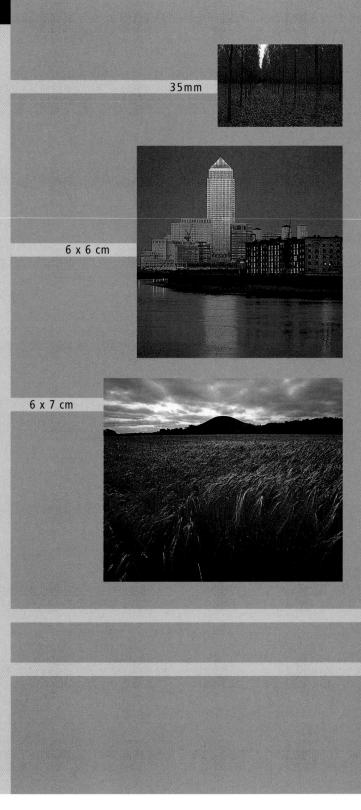

Composition

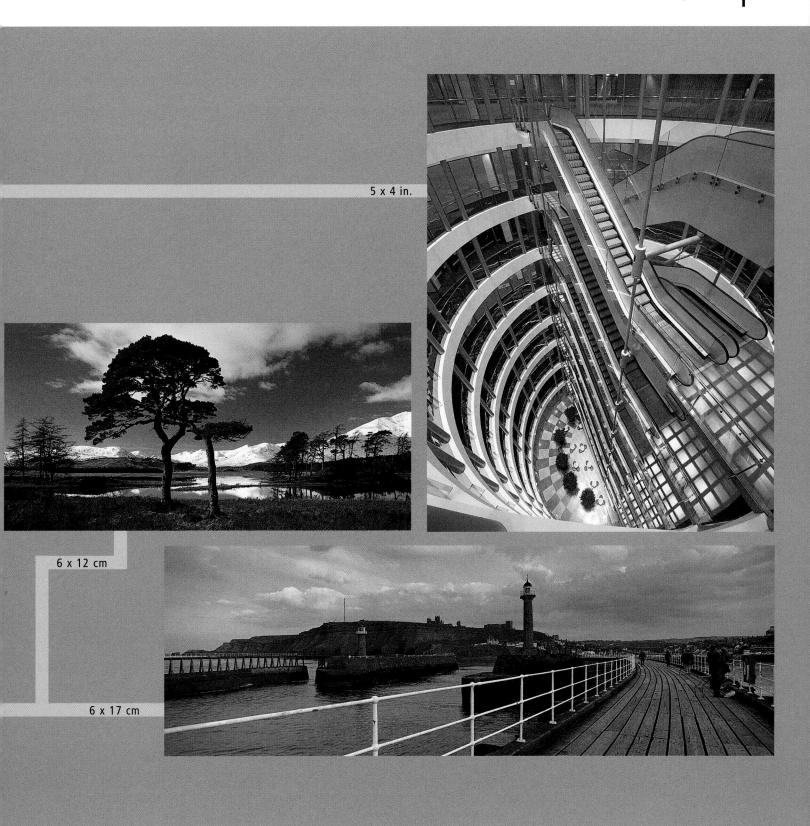

ANIMALS AND NATURE

This characterful animal portrait works for several reasons: the cat has been placed slightly off-centre, its languid expression has been captured, and the backlighting draws attention to the texture of its fur.

Start at home

Go down to their level

Composing nature photography is something you cannot rush. A photographer might wait an hour, a week or even a year for the right conditions in which to photograph a wildlife or botanical subject. But when the moment arrives, it does not tend to last long. Once you have the perfect conditions, they might last just a few minutes – for example, a bird of prey flying down to some bait which you have placed. Or they may last a few hours – such as a stage in the life-cycle of a butterfly. Some may last only a few days - for example, bluebells at their best.

If you have patience on your side, the subject of nature and wildlife is an extremely satisfying – and vast – area of photography.

You do not have to go on safari to Africa to get outstanding and characterful photographs of animals. If you have a pet – whether it's a humble hamster or an aristocratic afghan – home is often the best place to start. You know the behaviour of your pet, what it reacts to and any tricks it might perform for the camera.

If you don't keep pets, just head for your back garden. A wealth of wildlife photographic opportunities exist in even the smallest, simplest outdoor space: a dew-laden spider's web with a spider lurking in the centre, waiting for its next prey; a close-up of your prize roses, the red, velvety petals filling the frame – with or without a photogenic bumblebee gathering pollen; or simply a group of boisterous sparrows feeding from a bird tray. Slightly further afield, zoos, safari parks, wildfowl sanctuaries and rare-breed farms are just some of the places where opportunities for great animal photography exist.

Whether you take most of your pictures through the bars of a rabbit hutch, or out in the Serengeti, the rules are fairly similar. First and foremost, the majority of the animals you will be photographing are likely to be much smaller than you, and you will not normally get a good picture by standing over the creature and photographing it from above. (The obvious exception to this is when you are in a helicopter hovering above the Florida Keys as several thousand pink flamingoes take flight!) Therefore, you must be prepared to get dirty in your pursuit of the perfect picture, because when you photograph animals you will

Composition

The simplicity of a dew-laden web is best photographed with a shallow depth of field, so that the background is out of focus and does not distract from the composition.

Above: By filling the frame with the poppy, the impression of size – and the petals continuing out beyond the edges of the picture – is created, while attention is drawn to the detail in the centre of the flower.

Getting right down to eye level cannot be beaten with animal portraits: all the impact of this seal's doleful eyes would have been lost if the photographer had been standing up to take the picture.

spend a great deal of your time either crouching down very low or even lying flat on your chest in the mud.

Ideally, you should shoot with your lens looking up at the animal's eyes, rather than down at them. Obviously, this is not always possible, but if you can manage it your pictures will have more impact as a result.

Fill the frame

-1

Whether closing in on a beautiful flower or a monkey at the zoo, if you frame your subject very tightly, the resulting picture will be far more dramatic than one which has a lot of extraneous background. Think of it as a classic animal portrait, where you want the viewer to concentrate on its features, the texture of its fur or feathers and to have eye-to-eye contact with it.

This is where a long telephoto lens will prove invaluable, and if animal photography is something you plan to do a lot of, it is worth the investment. Alternatively, teleconverters are of reasonable quality these days, and will provide more than satisfactory results. Using a longer lens will also throw the background out of focus, which helps to concentrate attention on the main subject and can help to disguise the fact that you photographed the animal at the zoo, and not in its natural environment.

Above: Close in on a subject to give your viewer a different perspective on a creature. Here, attention is drawn to the colour and texture of the fur of a Highland bullock.

Most people are wary of caiman, and their crocodilian relatives – and with good reason, as demonstrated when a telephoto lens is used to zoom in on a specimen's teeth.

Composition

On the other hand, you could ignore all the advice about filling the frame. The result might turn out to be a photograph which is much more striking and dramatic than an ordinary animal portrait. Look at your subject's surroundings. If they would add to rather than detract from your final image, wi think about including them.

Simple is still best, however, so try to isolate your subject against a plain background, whether or not you intend to include its surroundings.

Look at the shapes created by the animal's environment. The more stark and graphic the shapes are, the more they are likely to enhance the picture. For example, your result will be much more successful if you photograph a bird sitting in the branches of a dead tree, isolated against a plain blue sky, than if you photograph a creature which is partly camouflaged by its environment.

Give it some space

Looking at these poppies from a low viewpoint gives the impression of the flowers growing up towards the deep blue sky.

This composition says something very different from the seal portrait on page 71. Here, its surroundings are emphasized, showing how the animal tones in with the colours, while its raised head echoes the shape of the rocks in the top half of the frame.

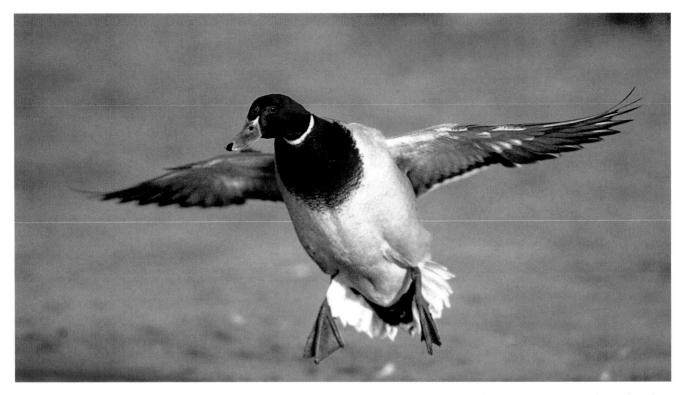

Animals in action

Quick focusing skills and a motor drive are helpful with any type of action photography. The duck's outstretched wings add dynamism to the composition. This is where the fun really begins. Animals are not instinctively inclined to remain in one place for any length of time (apart from sloths), so some stylish action shots are ready to be captured when your subject takes flight, takes to its heels or takes a dislike to you!

For a successful action shot you need to have your camera and lens braced firmly, with enough room to pan along with your subject as it moves (see 'Perfect your panning technique' below). Experiment with shutter speeds either to capture the animal completely crisply, or else to get an effective smidgeon of blur to convey the sense of movement. Bear in mind the advice on composition mentioned already – that is, you must decide whether to fill the frame with one animal – or, indeed, a group of animals – or to show the animal within its natural context.

Perfect your panning technique

Panning is a vital technique to learn if you want to take action shots of any subject. It involves releasing the shutter while you follow the animal or bird with your camera, which should be moving at the same speed as that of your subject. The subject will appear sharp or slightly blurred, depending on the shutter speed you choose. The slower your subject, the slower the shutter speed you can get away with. One of the advantages of panning is that it will blur the background, and intrusions which would otherwise have been a distraction are rendered as streaks of colour.

Keeping camouflaged

If you are serious about photographing wild animals in their natural habitat, be prepared to work hard for it. Perfect your skills on more common subjects which are easier to come across, so that when you are camouflaged up to the eyeballs in your hide at 5 o'clock in the morning, with nothing but a flask of coffee for company, the technique of photographing the animal you have been stalking for the past few weeks is second nature. The last thing you want to be worrying about when the badger, red squirrel or peregrine falcon finally arrives is whether you turn the aperture ring left or right in order to get f/5.6.

Natural colours and shapes, as well as foliage, help break up the outline of a hide or a lens, making it less noticeable.

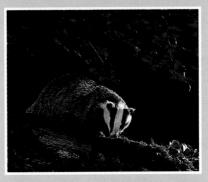

A creature as timid as a badger can only be photographed from a hide, to which the animal must first become accustomed, and in which the photographer must be in place at least an hour before the animal ventures out to forage.

Hides

Portable hides are available nowadays at quite reasonable prices. Once you have found the spot where you will be working, set up the hide and leave it in place for a few days so that any animals or birds become accustomed to it. Although a hide is made from camouflage fabric, it will also pay to 'decorate' it with foliage from surrounding trees. Learn the times at which your subject is in the vicinity, and arrive at the hide at least an hour beforehand, so that you are ready when the action takes place. Most important, wear plenty of layers to keep warm, and take food and drink with you.

Clothing

If you need to stalk your subject, you will need camouflage clothing to break up your outline and make you stand out less against the background. Coats, trousers and baseball caps are all available in camouflage prints, as are simple pieces of cloth, which can prove useful for covering long lenses. If you are stalking a particularly sensitive animal, do not wash this clothing after wearing it, because the creature will be able to smell the washing powder you use!

The car

Believe it or not, this is one of the best forms of camouflage around! Many animals have become so accustomed to roads and vehicles that they now take no notice of them. So if you know that a particular animal hangs around the roadside, simply park your car and wait. Shoot by resting your lens on the top of the open window.

PORTRAITURE

Theoretically, people should be one of the simplest subjects to photograph as they are by far the most prevalent. We are surrounded by them every day, we know how to interact with them and we can tell instinctively in a lot of cases what will annoy them and what will entertain them. Why, then, do so many portraits turn out differently from how we intended them to? Very often it is because the photographer is ill-prepared, with little idea of what he or she wants from the portrait session. Therefore, the answer is to make decisions and have everything in place well before bringing the subject into the equation. If the person is unaccustomed to being photographed, it is likely that they will be slightly nervous or feel awkward, so the last thing they need is to be made to hang around while the photographer fiddles with lights and backdrops, unable to decide where the person should sit, what they should wear and how they should pose.

A perfect starting point is to prepare by studying portrait photography in books and, in particular, magazines. There's no harm at all in trying to replicate pictures you like in order to learn about how people look and act in front of the camera. Then, once you have acquired the necessary techniques, you can allow your imagination to run wild. However, do not be misled into thinking that portraiture has to involve a studio, with complex lighting arrangements and a professional model. Portraiture is just as much about real people in real surroundings as it is about a formal studio set-up. The main aim should be that you and your subject enjoy the session – at least that way they will be more likely to come back again another time!

Posing techniques

The secret of a successful portrait lies in the pose. If the person looks awkward and unhappy in front of the camera, it is probably because of the pose you have chosen for them. And unless the person you are photographing is a politician or

If your subject stands straight on to the camera, it does not produce an interesting portrait. Slight changes in the angle at which this model faces the camera, as well as relaxed hands and arms, make all the difference, as this sequence shows. a model, they will not be able simply to turn on the charm for your camera. They will need a bit of guidance. First, make them feel relaxed by chatting with them. As soon as they are talking about a subject that interests them, they will be less aware of the camera pointed at them. Some photographers suggest you should not even load a film for the first dozen or so shots, while your subject relaxes and learns to become accustomed to the camera.

A close-up of your sitter's face is a very strong form of portraiture. As there are no distractions from the backdrop, their expression is vital and will say a lot about the person. A composition which shows them looking directly at the camera will have a great deal of impact, while one where they have turned their head very slightly one way or the other will send out an altogether different message. Experiment with high and low angles, but always concentrate on the eyes, making sure they are in pin-sharp focus – you will not get away with anything less when you crop as tightly as this. Cropping in

this way will show up every flaw in a person's skin, so it is ideally suited to character portraits.

Because a head-and-shoulders portrait reveals more about the person and the backdrop, there are more factors to take into consideration. This includes what they are wearing and the position of their hands (see 'You need hands', page 80). A good starting point is to angle your model's body and shoulders at 45° to the

The face

Closing in on a person's face is a very effective way of making character portraits.

Head and shoulders

Be aware of where your subjects' eyes are in the frame: notice here how both girls' eyes are almost on the same plane. camera. This is more attractive and visually interesting than if they were square to the camera, and also allows you to try numerous different poses, simply by altering the position of their head and eyes. The rule of thirds also applies in portraiture, so you should frame your shot so that the person's eyes are in the top third of the picture. Experiment by tilting your camera at a slight angle, being aware that diagonals create a more dynamic composition than straight lines.

There's nothing more awkward-looking than a picture of a person standing ramrod straight, square on to the camera, in front of an irrelevant backdrop. If you want to take a full-length portrait of someone, there are numerous ways to go about achieving a successful picture. Should you want the person to be standing, then give them something to lean against. This might mean framing them in a

doorway, or behind a gate, for example, so they can lean against it in a relaxed fashion.

The other option is to have them sitting at ease on a chair or some steps. Something for them to rest their elbows on would be helpful. Again, bear in mind the advice about the body being turned 45° to the camera, mentioned above, and shoot at around shoulder level to avoid any apparent distortion.

Above: A photographer should always make sure that colours and textures complement one another. Simplicity is often the key to a successful portrait. Left: If the person feels awkward standing up, place them in a relaxed sitting pose instead – a full-length portrait does not have to mean the person stays on their feet.

Full length

Composition

Backgrounds

The backdrop you choose for a portrait is almost as important as the person you are photographing. Keep it simple, as anything too complex or colourful is going to be a distraction. Try to relate the backdrop to the subject and think about what you are trying to say about that person. For example, a character portrait of a manual worker, such as a miner, could look very striking set against a backdrop of the machinery operating the mine in which he works. However, equally effective could be a completely plain white background

- this would draw attention entirely to his features and clothing, which would reflect his work.

Classic portraits can be complemented by fabric backdrops. A huge range of colours and patterns can be bought ready-made nowadays, a muted, mottled effect being the most versatile. But there is nothing wrong with using a wall or even the sky as a backdrop, if it relates to your subject and results in the kind of picture you are looking for. If you want the background to be as unobtrusive as possible, use a telephoto lens, which will throw it out of focus, or set your lens to its widest possible aperture.

The background of a wooden building suggests something about the accordion player's environment.

A plain, uniform backdrop draws attention only to the subject, with no distractions.

Do not underestimate the power of the sky above as a backdrop.

A person's hands can say as much about them as their eyes or face, suggesting age, work and even personality.

Right: A strong, firm position of the hands makes the subject appear confident.

Far right: If your subject's hands seem awkward, ask them to do something which occupies their hands.

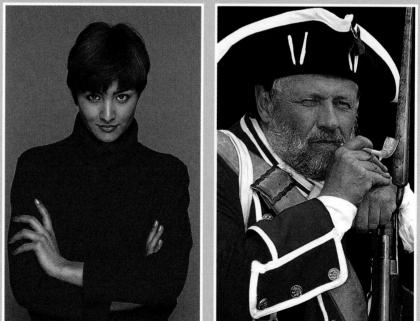

You can tell a lot about a person by their hands, the saying goes. In a photograph, you can certainly tell how relaxed a person is by the position and tension in their fingers. The fingers should not be bent too tightly, and if your model is resting their chin on the hand, ask them not to lean too heavily on it. Avoid resting the chin on a fist as it is too similar a size to the face, and will be very distracting.

Composition

If you are faced with a group of people, the task of posing them becomes altogether more complicated. Try to position them so they fill your frame, and make sure they are all placed at different heights. This is most easily achieved by having at least one person sitting on the floor or ground, one on a chair or other

object, and one standing. Vary the angles of their bodies to the camera, and keep arms and legs discreet so that they do not form a distraction. Try to have some sort of interaction between the people, whether it involves linking arms, or resting a hand on the back of a chair. The most important thing is to make it appear as if they all belong in the photograph together, rather than each person being an individual standing next to another individual.

Posing more than one person

Above: The father and daughter facing each other makes a more intimate portrait than if they had been looking at the camera. Left: Make sure your subjects have fun when you photograph them!

Candid portraits

Spontaneous, candid portraits of people are one of the best ways of summing up a person's character. The only problem is, because of the nature of this kind of portrait, you might not make the most of the opportunity. Building up the nerve to approach someone and persuade them to pose for you can often mean that all thought of composition flies out of your head in your hurry to take the picture and allow the person to go on their way.

Avoid just 'snatching' a picture without asking first, as it will irritate them – at the very least! In these circumstances it is often a good idea to work backwards. First, find a spot which provides an interesting backdrop, then wait for someone to come along. If you ask politely – even if you do not speak the same language – more often than not the person will agree to being photographed. If you cannot quite work up the nerve, wait for a group of children to come along. They are usually more than willing to ham it up for your camera, and can be a relaxed and fun subject for a portrait.

Flattery will get you everywhere

Let's face it, none of us likes an unflattering photograph of ourselves, and you are more likely to please your model and make them willing to be photographed again if you take a few points into consideration. The first is your choice of lens. If using a 35mm camera, the classic portrait lens is the 105 mm. If you have a zoom lens, set it at around this focal length, or slightly longer. Bear in mind that the wider the lens you use, the more distorted your model's features will be.

A double chin can be minimized in a photograph if you ask your model to lift their chin very slightly and look up at the camera when shooting just their face, or head and shoulders. If your subject is sensitive about a bald patch, shoot at a slightly lower angle and have them looking down towards the camera. To avoid chunky upper arms, do not let your model squash them close to his or her body. Instead, keep a distance of a few inches between the arm and the side of the body.

STILL LIFE

As with many subjects, simplicity is often the key to a successful still life. Muted colours can combine to reflect the different props, while the shape of the apple echoes that of the plate. If it is pouring with rain outside and there is no chance of taking any landscape pictures, or if you cannot find a subject willing to let you take their portrait, then take a look around you. Seemingly everyday objects can take on a whole new meaning when turned into a still-life photograph. It is a precise skill, which above all requires patience and experimentation.

Often it is the most ordinary subjects that can provide interest in a still-life composition, especially if several items are brought together which conjure up a mood or feeling. Even a simple flower or piece of fruit is a perfect subject for a subtly lit still life. It is also a photographic subject which is perfect for hoarders, as collections of old and bizarre objects gathered from junk shops and car boot sales are ideal items to bring together in a still-life picture. And now, if you discover a liking for still-life photography, you have an excuse for collecting even more!

Composition

Keep it simple

Never has simplicity been more of a watchword than with still-life photography. Whatever you include in your composition, it has to have a reason for being there. A selection of random objects which bear no relation to each other will just look incoherent and confusing in the final picture. Avoid cluttering the picture with too many objects as, again, this will simply become confusing. Instead, start with one object, adding another, then another, until you have a composition that works. Think about the shapes and colours created by the objects you have chosen, and try to make them work harmoniously with each other. For example, contrast curved edges with harder straight lines.

Left: This is a particularly clever composition, as it suggests the chicken has left a feather as its calling card, instead of a sixth egg.

Conjure up the impression of bygone times with a selection of nostalgic objects.

Natural subjects also make good still-life compositions. In this case, the white space created in between the leaves'edges is as important and eye-catching as the leaves themselves. The stunning velvety texture and rich colours of the opium poppy are emphasized fully by the use of a plain, black background.

Backgrounds and textures

As with portraiture, the background used in a still-life composition is equally important as the objects you are photographing. It can complement or contrast, but again, you need to consider why you are using a certain type of background and what relevance it has to the photograph. Anything goes, whether it's a plain piece of white card to emphasize a black object, a strip of tin foil for a hi-tech, futuristic appearance, or a piece of hessian sack for a rustic feel. It is also very easy to paint your own backdrops, but one of the best solutions is to raid your local toy shop for some Plasticine. It comes in a range of colours, you can mould it into any shape or texture, and when you've taken your shot, you can simply roll it into a ball and store it indefinitely – assuming your kids don't get hold of it first!

Think about the feeling you are trying to conjure up when you are composing a still life. If you have a pile of rusty nails, for example, they might work well against a backdrop of peeling paint, to emphasize the idea of decay. On the other hand, a completely plain, smooth background would draw your viewer's attention to the shape and texture of the nails themselves.

CHAPTER FOUR

NATURAL LIGHT

Without light, photography would, quite literally, not exist. After all, it is the action of light on the film emulsion that makes a photograph. However, its effect on an image goes much further than that. The type of light that pervades a photograph can make the difference between success and failure. A portrait taken in harsh, bright, overhead sun will be unflattering as it will have black shadows under the nose and, more often than not, the eyes will be blocked out altogether. And a composition that relies heavily on sky will come to nothing if that sky is merely a drab grey instead of a backdrop of dramatic cloud shapes.

UNDERSTANDING NATURAL LIGHT

A successful photograph depends very much on the quality of light. And the quality of light is determined chiefly by four factors, all of which work in harmony (or otherwise) with each other to influence your resulting photograph.

Early in the morning and late in the afternoon, when the sun is low in the sky, it produces long, raking shadows which are perfect for landscape photography. These shadows mould and shape the land, revealing textures and outlines within the scene. When the sun is at its peak –

around midday – highlights tend to be washed out, while shadows are much darker, but it is a good time of day for the light to reveal bold, graphic shapes.

One of the earliest rules photographers learn is to keep the sun behind them when shooting. Although this is reasonable enough for basic photography, it is a theory that soon runs into problems. If you are shooting a portrait and your subject is facing the sun, they will squint - and that is not too attractive. However, frontal lighting can be useful – if slightly bland - when you simply want to record detail, as the shadows will fall behind the subject. When the sun shines into your camera it can cause flare and - far more serious - damage your eyes. But it can also be a wonderful device for anything from dramatic silhouettes (see page 99) to subtly backlit flower pictures. If the light comes from the side to shine across your picture, the shadows formed help create depth.

Height

With the sun low in the sky, long, raking shadows are thrown.

Direction

Strong overhead lighting is unsuitable for many subjects, but in this case it emphasizes the whiteness of the statue and the Leaning Tower of Pisa beyond.

Natural Light

The colour of light also changes throughout the day (see 'Colour temperature', page 92). At the beginning and end of the day, light tends to be warmer because less white light can penetrate the thicker layer of the earth's atmosphere at these times. There can be variations even within this warmth, making them excellent times of day for photography. As the sun rises higher in the sky, more white light comes through and this makes the warmth of earlier in the day disappear.

Intense sunlight produces the highest contrast between bright and shadow areas. While this is great for very bold, graphic images, photographers often make the mistake of assuming it is the best light to shoot in. However, highly contrasting scenes can be difficult to meter, and some of the detail usually has to be sacrificed because no camera film – despite the wonders of modern

technology – can cope with a very extreme contrast range. If you find yourself in a situation where you can photograph a particular scene only in highly contrasting light, you must decide which part of your photograph is the most important, and meter for that.

A beautiful palette of intense colours can often be created at the end of the day – even if it is the result of pollution!

Colour

Contrast

Directional side-lighting reveals a strong contrast between highlight and shadow areas.

The elements

It goes without saying that none of the factors which determines quality of light is a constant; each one is independent of the other, and can change many times throughout the day – sometimes very rapidly. This is due, in part, to the bugbear of all photographers – the weather. It can be our greatest ally or our worst enemy, and comes and goes as it pleases, often thwarting our best photographic intentions. But do not be put off. Good results can be had from most types of weather – you just have to be prepared.

Plain, blue skies do not make the most exciting complement to a landscape, nor is direct sunshine ideal for portraiture, so sunny conditions are often best for photography when combined with another element: shafts of sunlight breaking through a cloud, or backlighting a scene, for example.

This brings out the coward in the hardiest of us! But do not automatically abandon your camera if it is pouring. Rain is wonderful for cleansing the atmosphere and intensifying the colours of nature. It can also be fun to photograph people as they try to go about their everyday business while wielding umbrellas and fighting the elements. And it is hard to beat gathering stormclouds on the horizon, while sunlight bathes the foreground, for a dramatic backdrop. You might even be lucky enough to end up with a rainbow to add the finishing touch to your shot.

While perfectly still conditions are desirable for many types of photography – especially if you want to photograph anything involving reflections – the wind can add a dynamic twist to a picture. Use a range of long shutter speeds to capture its effect.

Sunshine

Rain

Rain not only adds an extra dimension to many natural subjects, but also intensifies their colours. If no rain is forthcoming, cheat by using a plant spray!

Wind

Natural Light

Early-morning mist or fog is wonderfully atmospheric, and often has the added advantage of cutting out clutter or background detail which would spoil the photograph under clearer weather conditions. It is particularly photogenic when complemented by a rising sun to backlight the scene. Just be prepared to rise early to catch it!

Mist

Rising mist early on a frosty winter's morning might mean dragging yourself out of bed before dawn – and enduring cold feet – but the results are worth it.

Cloud formations are often essential to a landscape photograph, since a plain, blue sky is rarely inspiring from a compositional viewpoint. Some landscape photographers are on a constant quest for the perfect cloud formation which echoes the shape of the land below. Do not underestimate the importance of bright cloud cover, either. It provides an immaculately even spread of light which cannot be beaten for portraits, or for lighting still-life compositions. And remember also that diffused light from a north-facing window can give just the even dispersal you need.

1

Clouds can form a fundamental part of a composition, particularly if they echo the main subject.

Cloud

Frost

A scene such as this would be quite ordinary without the crisp, sparkling frost that adorns the grasses in the foreground. A low, backlighting sun brings out the detail.

Some subjects look good throughout the seasons. To make a sequence such as this, you must mark exactly where the legs of your tripod were placed, and make a note of its height. Take the previous season's picture with you each time for reference. The sparkle of winter frost on leaves and grasses is a compelling reason for braving the cold, armed with your camera. Ordinary dried-up leaves take on a whole new appearance, and the best thing is that it can all be found in your own back garden!

The time of year

Not only does the quality of natural light vary throughout the day, it also varies throughout the year, so a picture taken in winter can look very different from one taken in spring – even after taking into account the seasonal changes in the environment. One of the advantages of shooting during the winter is that the sun is never directly overhead, unlike in the summer. Therefore, on a sunny winter's day, you do not have to get up quite so early as you would in the summer, because shadows stay long throughout the day, and the light is not as harsh as it can be during the summer months.

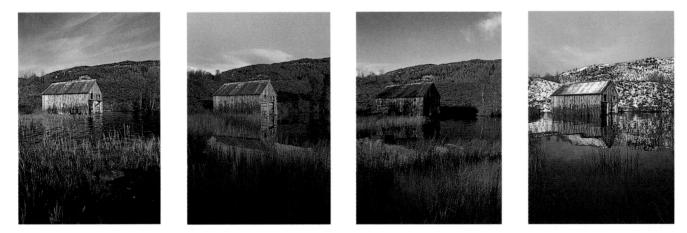

Natural Light

THE TIME OF DAY

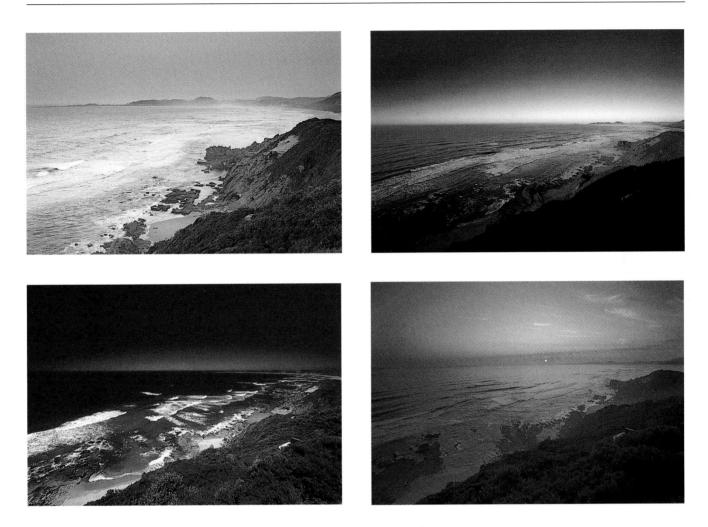

As we have just seen, the time of day at which you choose to take your photograph is crucial to the result, since the quality of light varies enormously over the period between sunrise and sunset. In fact, it can even change quite profoundly within the space of a few minutes.

This sequence shows how the colour of light changes in hue and intensity throughout the day, resulting in an entirely different picture each time. Top left: Before sunrise. Top right: Sunrise, 6.30 a.m. Bottom left: Midday. Bottom right: Sunset.

Plan ahead

Relying on natural light to give you the perfect result is, to say the least, a hitand-miss affair. It can also be infuriatingly frustrating. However, there are certain plans you can make to ensure the time you spend taking a picture is worthwhile. First, you should make the most of the weather. You may have found the perfect location, and have set your alarm clock for 4 a.m. to be there in plenty of time for the first rays of light to be creeping over the horizon, only to wake up to a relentless drizzle. Unless you are sure it will be completely worthless to visit your location, resist the temptation to go back to sleep. You may find that the scene has benefited from the rainfall because its natural colours have become saturated as a result. Or you may arrive just as the first rays of sunlight break through the cloud. Or the rain may have created a subtle, ghostly mist which is floating over a pond.

Conversely, it would be disastrous to turn up at your location at sunrise, only to discover it has no light to speak of in the morning, but is absolutely glorious as the sun begins to set in the evening. When you find a place you know you want to revisit with your camera, use a compass to determine the direction of the light, and to work out what time of day will be best to bring out the qualities of that place. It may be that the scene – particularly if it is a wide, sweeping landscape – is photogenic both early and late in the day, but has very different qualities at both those times. For example, the view down on to a meandering river in a valley could look fantastic both lit from the front – when every detail in the landscape stands out – and when backlit at sunsets – with the river rendered as a silver strip flowing from a silhouette of hills beyond.

Colour temperature

This is one of those technical terms that tends to scare off photographers who are less keen on the scientific side of the craft. However, it is not something to be afraid of, and can be understood quite easily.

Imagine a piece of dull, black metal being heated in a furnace. As it warms, its colour will begin to glow a dark red. After a longer period in the heat, it will

Overcast, misty conditions bring down the colour temperature, resulting in a cooler image. This can often be atmospheric, but if you prefer to correct it, you can use a warm-up filter.

Natural Light

go through a brighter red stage, then yellow, then white. The colour temperature scale works in the same way. Expressed as degrees Kelvin (K), colour temperature is based on the standard of midday sunlight, which is 5500K. The standard film used by photographers is daylight balanced, which means it is designed to reproduce colours completely accurately in this standard daylight of 5500K, or with flash. Anything cooler or warmer than this will produce a colour cast. Although colour casts can be filtered out at the printing stage if you are using colour-negative film, the only way round them when shooting on slide film is to

correct the cast with filters. However, it should be remembered that sometimes the filter-free results can be very pleasing. It is unlikely, after all, that you would want to filter out the effects of a glorious sunset so it appeared less dramatic on

film. You need to be aware none the less of the effect of colour temperature on your results.

Shooting on daylight film in light C with a colour temperature below 5500K will result in a warm, orange colour cast, while a colder, blue cast is the result of shooting in conditions where the colour temperature is higher than 5500K. Rather than correcting these casts every time, you might prefer to leave them as they are, or even emphasize them further. This can be done by adding one of the blue 80 series filters to an already cold scene, or by using a warm-up 81 series filter on a warm, evening scene. But use them with restraint - you don't want to overdo it!

A clear blue sky such as this can have a colour temperature of more than 10,000K.

Colour casts

The warm, orange light which characterizes the end of the day is perfect for atmospheric and flattering portraits.

Outdoor temperature

--)

Natural light is surprising in its wide range of colour temperatures. Early morning and evening light has a colour temperature of between 3000K and 4000K. Average noon daylight has the standard colour temperature of 5500K, but this figure alters according to the cloud cover – or lack of it – in the sky. It is a surprise to learn that skylight (which is blue) has a higher colour temperature than sunlight (which is white). The overwhelming strength of the sun is what brings the temperature down to 5500K, although a clear, cloudless sky can have a colour temperature of more than 10,000K.

Clouds also affect colour temperature drastically. A blue sky combined with a scattering of clouds will have a temperature of around 9000K, because the clouds can block the sun, so the blue sky dominates. It is for this reason that shadow areas on a bright day will often display a blue cast. An overcast sky actually combines skylight and sunlight more evenly, thus reducing the colour temperature to 7000K or thereabouts.

The chart below gives some general guidance on the types of filters to use for correcting excessive colour casts.

Light source	Colour temperature	Correction filter required
Clear blue sky	10,000–15,000K	Orange 85B
Open shade in summer sun	7500K	81B or 81C warm-up
Overcast sky	6500–7500K	81C warm-up
Noon sunlight	6500K	81C warm-up
Average noon daylight	5500K	none
Electronic flash	5500K	none
Early a.m./late p.m.	4000K	82C blue
One hour before sunset	3500К	80C blue
Sunset	3000K	80A blue
Fungsten photopearl	3400K	80B blue
Tungsten photoflood	3200K	80A blue
100W household lamp	2900K	80A + 82C blue
Candle flame	2000K	80A + 80C blue

Natural Light

LOW-LIGHT PHOTOGRAPHY

Just because the sun has set over the horizon, it does not mean you have to pack up your camera and head for home. The magical period of twilight – sometimes all too brief – between sunset and nightfall, when the sky is inky blue-black and street and house lights begin to shine, can provide some wonderful opportunities for truly creative photography. The resulting photographs, as the last fragments of light disappear over the sea, or as bright neon lights reflect in a puddle, can convey a tremendous sense of atmosphere. While low-light photography brings with it a certain number of specific considerations, once you have tried it a few times you might well find yourself hooked. For successful low-light photography, there are several factors you must take into account.

Without a doubt, cities and towns are the best subjects for low-light photography. The huge variety and quantity of artificial light sources which are found in the average town balance perfectly with the pinky-blue sky which is characteristic of the hour before nightfall. Anything from a wide hilltop view looking down over a town, or a closer composition of a bridge over a river with reflections in the water and trails from car headlights (see page 210), to a close-up of a neon light will be a suitable subject for your camera. And do not be put off if the weather during the day has been dull or rainy. Even on the worst days, there is usually a hint of colour in the sky at twilight, and the reflections of streetlamps off rain-soaked pavings or in puddles can be very photogenic.

Although successful photographs can be made right into the darkness of night, the backdrop of a sky with a hint of colour in it is far more photogenic than large blacked-out areas of the sky after nightfall.

Look for buildings which are floodlit at night, to contrast with fading light in the sky.

Subject

Give yourself time

Reflections in rain-soaked pavements are clearer at the end of the day, during twilight.

Exposure

Film

Bracketing

The most important aspect of low-light

photography is to get to your spot in plenty of time – certainly well before sunset. This will give you the chance to set up your camera and tripod properly, and to tweak your composition until it is just right. The longest you will ever get during twilight is about an hour, so the last thing you want to do is to turn up just after sunset and rush the job so that you only get a couple of decent shots – especially given that your pictures may run into exposures of several minutes, depending on the light levels and the speed of film you are using.

With the huge variety of light sources and light levels you find in the average town, your camera's meter is likely to get

a little confused. So don't place all your faith in your camera's automatic TTL meter. As with any metering you do, you need to decide what you would like to be the mid-tone and meter for that. If you can, take a meter reading from close up, then manually set your exposure on the camera and move back to your spot to take the picture. By taking a reading in this way and setting it manually, you will avoid the camera's meter being distracted by the large areas of dark sky and exposing for that, instead of the lights. The extreme brightness of some city lights means they will burn out during a long exposure, but most people can live with this as it often enhances the picture.

Just because you are shooting in low light, do not assume you need a faster film in order to get a good result. In this case, in fact, the opposite is true. Low-light photographs taken on slow film of ISO 50 or 100 will display far more richness, saturation of colour and clarity than those taken using a faster film. Whatever speed of film you use, you will need to have your camera on a sturdy tripod anyway, so you might as well expose for a little longer and achieve the superior quality given by the slower films.

As the varying light sources at this time of day are so unpredictable, and because the natural light changes constantly and rapidly, it is essential to take meter readings as often as possible so you can alter your shutter speed or aperture accordingly. It also means sometimes that the only way to guarantee a satisfactory result is to bracket as much as possible. While bracketing is normally associated with both underexposing and overexposing around the recommended meter reading, in low-light photography it is only necessary gradually to overexpose. Therefore, if your meter reading suggests f/11 and 15 seconds, you

should expose for that reading, then take bracketed pictures. However, because of reciprocity law failure (explained below), it is advisable to bracket by opening the aperture, rather than lengthening the shutter speed. Try not to use a shutter speed of more than 30 seconds as anything longer than this will make your results more difficult to predict.

The New York skyline is brought out to perfection just after sunset, when its sea of artificial lights balances with the colour of the sky.

Reciprocity law failure

As we already know, the reciprocity law dictates that the exposure given by f/5.6 and 1/250 second is the same as f/8 and 1/125 second, which in turn is the same as f/16 and 1/60 second, and so forth. The majority of daylight-balanced colour films will not have any problem coping with shutter speeds of 1/1000 second

At the initial exposure setting of 1/8 second at f5.6, the depth of field was insufficient, so the photographer stopped down to f/32. According to the reciprocity law, this should have required a shutter speed of 2 seconds. However, as this law breaks down at shutter speeds longer than 1 second, compensation of one stop was required.

Film characteristics

Bracketing with the aperture

down to one second. Beyond one second, however, this relationship between shutter speed and aperture becomes unreliable and can result in underexposure. This is known as reciprocity law failure.

The point at which an emulsion fails varies from one manufacturer to another, and from film to film. However, all manufacturers will be able to inform you of the characteristics of their films, and – best of all – new films are being launched on to the market all the time which are less susceptible to reciprocity law failure. The best advice is to stick closely to the guidelines

recommended by the manufacturers, but of course this is not always possible.

If you head into the realms of long shutter speeds, therefore, be prepared to bracket extensively. But be aware that you cannot rely on this entirely. Because reciprocity law failure is associated with low light, that light will be fading even as your shutter is open, so you may get the chance for only three or four exposures at the most. Therefore, you need to be certain that your initial exposure is at least within acceptable bounds, otherwise you will just end up with a sequence of wrong, and wasted, exposures. But be bold. Do not bracket by a measly 10 seconds or so. If your indicated exposure is 30 seconds, and the manufacturer of the film you are using recommends compensating by one stop extra, bracket to include exposures of one minute, 90 seconds and even two minutes.

The other problem is that extending the shutter speed results in further reciprocity law failure and therefore makes your results even more difficult to predict than they already were! To be on the safe side, it is often a better idea to bracket by opening up the aperture, from f/11 to f/8, for example – if you can bear to sacrifice some of the depth of field, that is.

Bear in mind that it is not just in low light that reciprocity law failure can occur. If you are using very slow film, as well as a filter such as a neutral-density graduated filter – which can cut out several stops of light – and a small aperture to maximize your depth of field, your exposures will lengthen and reciprocity law failure will come into play. Once again, bracket accordingly to compensate for this.

One final point. Do not be too put off if your meter reading suggests an exposure far longer than that recommended by the film manufacturers. They are naturally cautious, despite the fact that most films tend to be slightly more robust than the published reciprocity characteristics might suggest.

SHOOTING INTO THE LIGHT

Exploiting the qualities of frontal and side lighting are fundamental to good photography. We can see how light wraps around a subject to reveal its texture and enhance its shape so it stands out from the background in sharp relief. However, it is when we shoot into the sun that a whole new host of creative, yet controllable possibilities opens up to us. This is known as backlighting, and it can be exploited to produce just a subtle rim of light around a delicate flower, for example, right through to a bold, graphic silhouette of a building. The advantage of shooting into the light is that it is a technique you can use throughout the day, so you do not need to restrict yourself to the early morning or late afternoon light which is preferable for many other subjects.

Silhouettes

The best thing about silhouettes is that they are very straightforward to take. It is the one time you can set your camera to automatic exposure and rely on it to produce the result you foresaw when releasing the shutter. If you want to set it manually, simply take a meter reading from the sky, and set that.

The best subjects for silhouettes are those with strong outlines since no other detail will be recorded on film. Hence the reason why so many silhouettes tend to be architectural subjects – especially older buildings, as these often have more elaborate features than those built more recently. When composing your picture, you should try to isolate your subject against the sky since every detail will record as a silhouette, and too much of it can become confusing. In the same

way as you should avoid the proverbial tree trunk growing out of a person's head, you should watch out for branches sprouting from the top of your building. It is true that on the one hand they might enhance your composition, but on the other they might intrude, making it advisable to crop them out if at all possible. As with many photographic subjects, the best advice is to keep it simple.

Of course trees on their own often make excellent subjects for silhouettes, but you should bear in mind that it is best either to go for dead ones, or to photograph them in autumn or winter after their leaves have fallen. The sharp shapes of the branches and twigs provide more interest visually than the leaves.

Bold, graphic shapes work particularly well as silhouettes. Here, a meter reading from a bright area of the sky was taken, and set manually on the camera.

A memorable picture does not always reveal every detail in a scene. In this photograph, low light and silhouetted figures create an atmosphere that is evocative of long summer days.

Frontal lighting would have failed to draw attention to the 'furriness' of this plant's leaves and stem, while backlighting brings out its delicacy. Metering for backlighting

Backlighting – also known as *contre-jour* – does not only produce silhouettes. You can also control your use of it for a much more subtle result. If you want to retain detail in your subject, as well as backlighting it, you will need to take a spotmeter reading from an area outside of the backlit rim. For example, if you are taking a backlit portrait, you should take a meter reading close up from the person's face, and expose for that. Do not let the light shining into your camera fool you into underexposing their face. Backlighting is very flattering for portraits as it highlights the person's hair – especially if it is blonde – and softens their features, too. Don't worry too much if the backlit area burns out quite noticeably. As long as you have retained detail, it should not be too much of a distraction.

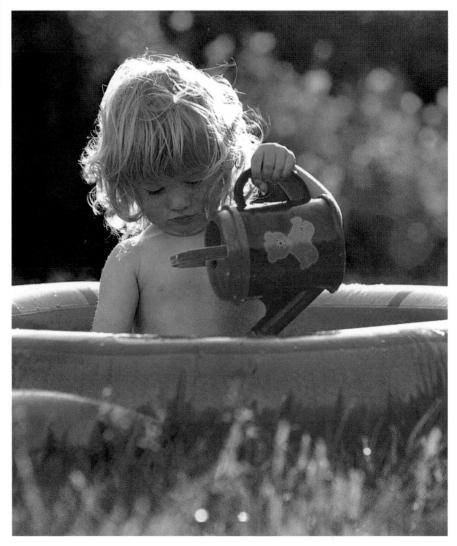

Blonde hair is perfectly suited to backlighting, giving it the effect of spun gold. In this

If you do not have a spotmeter facility, take a meter reading from the light shining into your camera and compensate by bracketing and opening up your aperture to at least two, if not three, stops more than the one your meter is indicating. The other options are to use a reflector (see page 102) or a burst of fill-in flash (see page 116).

Avoiding flare

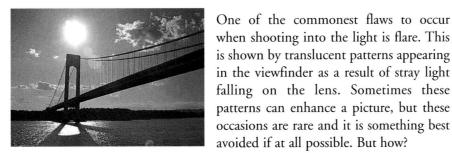

This helps to shield the front element from a certain amount of unwanted light. However, you will need to be on your guard to avoid vignetting - a darkening at the edges of the photograph caused by the lens hood encroaching into the frame. This is a particularly common problem when using wideangle lenses.

One of the commonest flaws to occur

In this case, the flare is rather atmospheric, but there are ways of avoiding it if you want to.

Vignetting – the dark areas at the corners of the frame here - is a problem that occurs when the lens is too wide for the lens hood.

If your subject is movable, position it so that it is between your camera and the sun, blocking out the sun as much as possible. You will still have all the effect of backlighting, even if the subject stands directly in front of it.

A reading from a lightmeter will meter for the light falling on the subject, not the light reflected by that subject, so it is more accurate in the slightly unpredictable conditions caused by backlighting.

This can be done simply by shielding the top of your lens with a piece of \bigcirc card, altering your viewpoint or moving your subject.

Important note

When shooting into the sun, never look directly at it through your viewfinder. You could cause serious damage to your eyesight or even, in extreme circumstances, blind yourself.

Position your subject

Use a lens hood

Take an incident reading

Cut the sun out of the frame

MODIFYING NATURAL LIGHT

Left: Natural light. Right: A foil reflector bounces enough light back into the composition to make it a viable photograph. In our enthusiasm to take a picture, it is often all too easy to forget that a film emulsion is nowhere near as sensitive as the human eye. We can never assume that the camera film will record every minute detail we see through the viewfinder when we take the picture. It takes trial, error and a few wasted frames before we realize that the shady area in our frame is not going to display much detail if we have metered for the brightly sunlit area. But how can we get around this? There are a few options. We can take a meter reading for the brightest area, and another for the shadiest area, then set our exposure at a halfway point between the two; we can use a burst of fill-in flash (see page 116); or we can use a reflector.

What is a reflector?

One of the most useful accessories in your photographic armoury, a reflector can be anything from a length of white fabric to a sheet of tin foil or a piece of gold card. Collapsible reflectors are stocked by most photographic retailers and – once you've got the hang of folding it up to go back into its case – these are well worth the investment. There is a huge range of sizes on the market, with the most common surfaces being white, silver or gold. Some reflectors have a different-coloured surface on either side for extra versatility, and there is also a choice between shiny and matt surfaces. A shinier reflector can sometimes bounce back as much as a whole stop more light than its matt counterpart.

- White This bounces a soft, subtle light into the shadow areas. It is a useful standard for a natural result.
- Silver A much harder, cooler light is reflected by a silver surface, and this is useful for both fashion and nature work.
- **Gold** This reflects a similar quality of light to a silver reflector, but the light has a distinctly warmer tone, and it can alter slightly the colour of your subject. It is particularly flattering for portraits.

Using reflectors

When you first buy or make a reflector, find a subject and experiment for a while. Notice how the quality of the reflected light alters according to the angle of the reflector and how close it is to your subject. Where you place a reflector depends on the direction of the light.

Natural Light

Top left: Without a reflector the shadows are slightly unflattering and there is no life to the model's eyes.

Top right: A white reflector evens out the shadows, but gives a natural looking result.

Bottom left: A silver reflector bounces back a much harder light which, in this case, suits the model's pale skin tones less well.

Bottom right: A gold reflector significantly warms the model's skin tones and, as with the other reflectors, produces a catchlight in her eyes.

Overhead light

Left: With the sun directly overhead, ugly shadows fall under the eye sockets and beneath the man's baseball cap. Right: Moving the couple slightly so that the sun is behind them, and using a white reflector, makes a huge difference to this portrait. If you are shooting a portrait and the sun is directly overhead, your subject will have harsh shadows under their nose and chin. Their eyes will probably also be in deep shadow. In these cases, you should hold the reflector flat, and as close to the person's face as possible – but take care that it doesn't creep into the frame! If you are shooting just a head and shoulders portrait, your subject can hold the reflector in their lap and adjust its height according to your instructions. Otherwise, you may find it useful to recruit a friend to assist you by holding the reflector and altering its position, while you concentrate on taking the photograph.

Side light

Back light

You will be able to get variable effects from your reflector when shooting a sidelit subject. Again, it is of most use when you need to balance a very contrasty scene, but it can also squeeze a bit more brightness out of overcast conditions. If you are shooting a sidelit still-life composition, you may need only a small reflector – a piece of silver foil wrapped around a piece of card could suffice. To obtain consistent results, you should clamp it in place so that you can go back to the set-up another day if necessary. If you would like to retain a hint of the shadows being cast, place your reflector further away from the composition. If you want to get rid of the shadows as much as possible, then move it as close as you can.

As we saw on page 100, there will be some circumstances where you want to expose detail in the shadow area, while retaining the backlit effect. A reflector allows you to do this perfectly. The translucent petals of a flower will respond very well to the backlight and reflector treatment, as will a portrait – the latter will result in an attractive, reflector-shaped catchlight in the eyes. This combination is an ideal solution to the problem that arises when your subject faces the sun – that is, squinting eyes. It also means you will never have the problem of your own shadow encroaching into the photograph, which can happen if you keep the sun behind you all the time!

CHAPTER FIVE

USING FLASH

There are many situations where natural light is insufficient to take a picture – such as on very dull days, at night or, of course, indoors. The first and most obvious remedy is to open the camera's aperture or extend the shutter time, but this isn't always possible or desirable. Your camera may be set to the maximum aperture already, or perhaps you need the depth of field that a smaller aperture provides. A longer shutter speed may require a tripod and you may not have one with you – and in any case, if your subject is a living one their movement during a long exposure would almost certainly render them a blur.

Using Flash

A second option is to increase the sensitivity of your film, either by uprating it (see Chapter 1, page 25) or by switching to a faster one. This too brings its own complications. Uprating would adversely affect normally exposed frames which you've already taken, but removing it in favour of a faster film (assuming you have one on you) would be wasteful, especially if you only want to take a couple of shots rather than a whole roll.

This brings us to the third option: increasing the brightness level by introducing an artificial light source. Indoors this could in theory be the room lights or a table lamp, though in practice these are unlikely to be of sufficient power to raise the light level enough to take a picture. Outdoors not even these options are available, so there must be an alternative. Thankfully there is a quick, effective and powerful light source already at our fingertips, just waiting for us to switch it on – flash.

The invention of flash has revolutionized photography in low light. Beforehand, photographers risked life and limb with explosive powders, or cooked their subjects under hot floodlights in their quest for adequate lighting. The earliest types of flash were bulbs that could only be fired once before being discarded. In fact, disposable flash cubes or bars are still available for the thousands of old instamatic cameras still in circulation. Today, however, most compact cameras and many SLRs include built-in flashguns, and there are dozens of accessory flashguns available, which can be fitted to the latter when extra power or features are required. Flash has some unique qualities – some advantageous, some not. It is important to know about them in order to obtain the best results.

Facing page: Obtaining photographs such as this requires an extremely specialized and sophisticated flash-lighting set-up in a controlled environment.

The world of flash photography can open up all sorts of creative possibilities. In this case, the photographer has made the most of the lovely ambient light and achieved an unusual result by using flash combined with a long exposure.

The advantages of flash

- It is bright: because flashguns emit a lot of power for their size, you can use them with relatively fast shutter speeds and apertures.
- It is adjustable: its brightness level can be adjusted according to the distance of the subject and the lens aperture required.
- It is brief: a burst of flash lasts only a fraction of a second in some cases less than 1/1000 second – so it can 'freeze' the motion of fast-moving subjects.
- It is versatile: its qualities can be varied by changing its angle or position, or by bouncing it off a nearby surface.
- It is daylight balanced: flash produces a colour temperature similar to daylight, so with normal colour films you do not have to mess about with filters in order to avoid colour casts.
- It is portable: flashguns are small and can be carried in a pocket or a corner of your camera bag. The smallest models would fit inside a cigarette packet.

The disadvantages of flash

It has a limited range: flash has a useful range of only a few metres. Its intensity diminishes
as it travels, until it eventually peters out altogether. This effect is called 'fall-off' and is bad
news for the millions of people around the world who waste time and film taking flash
pictures from the back rows of stadiums, concert halls and so forth. (The average flashgun
would struggle to reach beyond about 10 metres.)

The rate of fall-off is steep but linear, and can be calculated by using the inverse square law. In simple terms, this states that a single-point light source will, for every doubling of distance, diminish not by a half but by a factor of four. So, if a flash gives a working aperture of f/16 at two metres, at four metres it will be only a quarter as bright and will require an aperture of f/8 – two stops wider.

- It has limited coverage: while flash brightness diminishes as it travels forward, the same applies as it travels outwards, creating a circle of light which gradually fades to nothing. This angle of coverage is matched to that of a 35mm wideangle lens on an SLR or a compact camera. This means that if, for example, you tried to photograph a building at night using a lens wider than this, you would get a 'hot spot' in the middle, while areas just a few feet on either side would remain unlit. However, some flashguns can adjust the breadth of coverage (see 'Choosing a flashgun' on page 109).
- Its duration is short: because flash is so brief you cannot see the effect it is having until you
 get your pictures back. Potential problems such as reflections (from spectacles, for example)
 will not be spotted, so they must be anticipated. Its brief duration also limits the range of
 shutter speeds that you can use with it.
- Its battery consumption is heavy: flash exerts a considerable drain on your batteries, compared with other camera functions. If you use flash a lot it would be prudent to invest in a flashgun which can take rechargeable batteries or power packs.

CHOOSING A FLASHGUN

No well-stocked camera bag is complete without a flashgun, but choosing the right one for you from the hundreds on offer can be a daunting task. Here we will look at the main types of flashgun available and the most important features and specifications you need to consider.

Types of flashgun

ITT

SUNPAK

auto 2000 DZ

Most accessory flashguns are designed to be slotted into the camera's hot-shoe which, in most cases, is fitted to top of the prism. The hot-shoe is so called because it contains an electrical contact in the centre which triggers the flashgun at the right moment. Some older cameras have a more basic, contact-free shoe which simply holds the flashgun, and synchronization is achieved by plugging a short PC lead from the flash into a socket elsewhere on the camera. Few modern flashguns have a PC lead so, if you have such a camera, you will need to fit a

hot-shoe adaptor between the shoe and the flashgun.

Bouncing the flash off a nearby white surface produces softer, more naturallooking illumination than direct flash (see page 122). In order to do this, though, you must be able to tilt the flashgun's head upwards (to bounce off the ceiling) or rotate it sideways (for a wall). Most of the larger hot-shoe

mounted flashguns can achieve at least the former.

are designed for Hammerhead flashguns professional use and comprise a large head mounted on a long stem, which doubles as a handle. In general they are much more powerful than hot-shoe mounted models, recycle faster and boast a wider range of

accessories - especially when it comes to the choice of power sources. Many offer a choice between alkaline or rechargeable batteries (which fit either in the handle or in the head), or mains power. Some models can also be attached to shoulder-mounted battery packs for heavy usage on the move. Hammerheads are used mainly by press, PR, wedding and other branches of professional photography where portable flash is used. Like shoe-mounted models they offer varying degrees of sophistication and automation, depending on budget and needs.

Hot-shoe mounted flash

Bounce flash

An adjustable bounce flash head gives more flexibility than a flash gun with a fixed head.

Hammerhead flash

Ringflash

Ring flash creates a distinctive 'halo' effect around the subject, with a circular catchlight in the eyes. It is also widely used in macro photography as it illuminates the subject completely evenly. -0

These highly specialized flashguns are designed for macro photography. Their characteristic doughnut shape enables them to fit over the front of the camera lens, which pokes through the hole in the middle. Because the light they produce comes from all sides of the lens axis rather than just one side, the resulting illumination is virtually shadowless and quite distinctive. Larger, mainspowered versions are available and are commonly used by fashion photographers.

SUNPAK

auto DX 12R

Slave flash

These, usually pocket-sized, devices are not attached to the camera at all. Instead they contain a sensor that triggers them when they see another flash – most likely the one on your camera. Consequently they are secondary flashguns, used to give the main one a

helping hand (or produce a particular lighting effect). The idea is that you place one or more of these somewhere in front of

somewhere in front of you – either just out of shot or hidden within it. When you take a picture they all go off simultaneously. Slave flashes have no means of exposure control, but since they are intended only to provide fill-in and are not very powerful, this is rarely an issue.

A useful addition to any flash kit, a slave flash provides a touch of extra fill-in lighting.

Important features

All other things being equal, the more powerful your flashgun, the better. With more power, your flash will have a longer range and, at a given subject distance, will allow you to select a smaller aperture than a less powerful gun would. Of course, all things are not equal, and there are a couple of reasons why you may opt for a less powerful model. The most obvious of these is cost: as a rule, extra power comes at a price. But there is also the portability factor to consider. The more powerful models tend to be physically larger and heavier, and if you use that extra power a lot you will find you also get through a lot more batteries. That said, if you have the budget and the space in your bag, a more powerful flashgun is a lot more versatile.

A flashgun's power is measured by its **guide number**. This figure is usually quoted in metres, based upon use with an ISO 100 film. The higher the guide number, the more powerful the flashgun.

This figure is the equivalent of the 0–60 time quoted for cars. It tells you how long it takes to recharge the flashgun once it has been fully discharged. When you want to take several flash pictures in relatively quick succession it can be frustrating having to wait for the flash to recharge. If this factor is particularly important to you, it may be advisable to buy one of the more expensive professional flashguns.

Recycling time

Power

Coverage

Automation

Most flashguns are designed to cover an area equivalent to what you see through a 50mm or 35mm lens. If you are using a more wideangle lens than this you will get a hot-spot in the middle and a dark vignette around the edges of the frame where the flash has not reached. Conversely, when you use a telephoto lens, some of the flash is wasted in lighting areas that are not in the shot. Some flashguns overcome the wideangle problem by including a plastic diffuser which you can clip over the front to widen the angle of coverage. The best answer to both problems is a flash with a zoom head. This features a fresnel lens in front of the tube, which, by moving back and forth, adjusts the angle of coverage to match the lens. Some expensive models do this automatically as you zoom the lens, others offer a push-pull mechanism which you adjust yourself.

With a straightforward, manual flashgun, you have to work out the required aperture by studying a chart on the back of the gun. To avoid the tedium of having to do this before every flash picture, it is worth investing in an automatic model. An auto flashgun measures the distance to the subject and cuts off the power when your film has had enough exposure. It does this after a brief exchange of information, whereby you tell the flashgun what film speed you are using and the gun tells you what aperture to set on the lens. As long as you stick to the same film and aperture, the flashgun will do the rest. Some more advanced models offer you a choice of apertures, and tell you the maximum range of the flash with each. Of course, if you forget to set the right aperture (or shutter speed) the flash has no way of knowing, and will carry on regardless. For a flashgun that does the thinking on your behalf, you need a dedicated model ...

If you want your flashgun to communicate with your camera without your intervention then you need a dedicated model. Dedicated flashguns

automatically set your camera to the correct shutter speed, and adjust their output according to the aperture you are using. This is achieved by the inclusion of additional pins on the base of the flash-shoe which correspond to extra contacts on the camera's hot-shoe. Since each camera manufacturer uses a different array of contacts, the positioning of these pins varies. If you are buying a dedicated flashgun, make sure you get the correct mount for your camera.

If you have an autofocus camera, you may want a flashgun which will take over the focusing when the light is too low for your camera to do it. In order to do this it will need to have an AF illuminator (which looks like a dark-red translucent panel) on the front.

Autofocus

Dedication

Look out for a red panel on the front of your flash if you intend to use it in conjunction with an autofocus camera.

FLASH EXPOSURE

With modern, computer-controlled cameras and flashguns you could happily go through life with no understanding of flash exposure at all, because your equipment does all the calculating for you. But your resulting pictures are unlikely to rise above the merely adequate.

An understanding of flash exposure is a good grounding for a host of more creative techniques and will give you the confidence to experiment and perhaps even establish your own visual style. Unfortunately, many photographers find the subject intimidating, so they never make the creative leap. Flash exposure is determined by factors governed by both the camera and the flashgun itself.

The camera

The first thing to know about using flash is that the camera's shutter speed has no influence on the flash exposure, only on the parts of the picture *not* lit by the flash. The speed of the flash burst itself is effectively the shutter speed and it is very brief – sometimes less than 1/1000 second. But that is not to say

the shutter-speed dial is unimportant. Quite the reverse: with the focal-plane shutters used by most cameras, flash will work only at certain shutter speeds. This is because these shutters are comprised of two 'curtains', which travel horizontally or vertically across the film. The first one opens to begin the exposure, and the second follows behind to end it. At fast shutter speeds, the second curtain starts to close the shutter before the first has completed its journey across the frame, effectively forming a travelling slit. If the flash is fired at these higher speeds, only that narrow slit is exposed on film. So the fastest shutter speed at which flash can be

The sync speed

Watch your shutter speed settings when using flash! If you set your camera to a shutter speed faster than your flash sync speed, not all of your frame will be exposed. used is the highest speed at which the *whole* frame is momentarily exposed. This is called the flash synchronization speed, and every 35mm SLR has one. The precise speed varies from model to model, but it is usually between 1/60 second and 1/250 second. (One or two recent cameras have managed to achieve much higher sync speeds when used with specially matched flashguns, but these are in a minority.) Most modern cameras automatically set the shutter to the flash sync speed as soon as a dedicated flashgun is attached and switched on, but by overriding this and choosing a slower speed more interesting pictures can often be achieved (see page 119).

The brightness level of the flash in your pictures is determined by two variables: the intensity of light emitted by the flash itself, and the aperture selected on the lens. Exposure can be controlled either by keeping the flash output constant and varying the f-stop, or by choosing a particular aperture and adjusting the flash power to suit it. The former is achieved via the flashgun's manual mode, the latter by using the flash on automatic.

The major difference between these two methods is that, because the aperture controls all the light entering the lens, it affects the density of not only the flash-lit areas but also the surroundings – and of course it alters the depth of field. So if you take a lot of flash pictures you will produce more consistent results if you adjust the flash output rather than the f-stop between shots. Whichever method you choose, though, your working aperture is determined to a great extent by the power of the flashgun. The lower the power, the wider the aperture will have to be. Your working distance is also a factor – the closer your subject, the smaller the aperture you are able to use.

The flashgun

Automatic flashguns work by measuring – via a sensor on the front of the gun – the amount of light hitting your subject, then cutting off the flash when the on-board computer has decided the subject has had enough. The further away the subject, the more flash will be needed to reach this point. In order for the auto mode to work, you must tell the flash what aperture you have set, or use one suggested by the flashgun itself.

While these methods work well most of the time, there are exceptions. All exposure-measuring systems, including those found in flashguns, assume the subject is of average density, so when you are shooting very light or very dark subjects, the exposure-measuring system is likely to get things wrong. This applies also with subjects photographed against very dark or light backgrounds, since these can influence the reading. (That is why the faces in portraits taken at night or in dimly lit venues are often very washed-out – the dark background has caused the flash to overexpose the subject.) With experience you will come to recognize situations which may cause the flash exposure to err and you can compensate accordingly.

The aperture

Autoflash

In the auto mode this is easy – simply use a larger or smaller aperture than that suggested on the back of the gun. (If it tells you to use f/8, for example, you can set f/5.6 on the lens to effectively double the flash power, or f/11 to halve it.)

The exposure sensors in dedicated flashguns follow broadly the same principles as auto models, but measure the light coming through the lens (TTL), which is more accurate. Because dedicated flashguns know which aperture you're using, they reduce the risk of error caused by the photographer forgetting to set the lens to the right f-stop. They simply adjust their output to match the aperture you're using – as long as it is within the maximum range.

Like auto models, dedicated flashguns can be fooled by dark or light subjects or backgrounds, but overcoming this is less straightforward. Altering the lens aperture won't work because the flash will simply adjust its power to compensate. More sophisticated flashguns feature a flash-exposure-compensation button which allows you to increase or reduce the metered flash exposure by up to three stops in either direction. In the absence of this feature you'll have to resort to deception to fool the flash into doing what you want it to. The easiest way is to override your camera's DX film-speed sensor and set a higher or lower ISO than the film you are actually using. If you are using ISO 100 film, setting the ISO to 50 will delude the flash into thinking your film is slower than it really is, so it will give one stop more power. At ISO 200 it will do the opposite.

Manual flash and the guide number

The manual mode is the best one to use when you are shooting multiple photographs at a fixed distance and you want your exposures to be consistent. This is because manual flash emits a fixed and constant output, irrespective of any changes in ambient-light level or subject distance. With some more sophisticated units, this output can be adjusted from full power to a half, a quarter and in some cases down to 1/64 power.

Exposure must be calculated manually, too. Some flashguns provide a table on the back which tells you what aperture to set for a given film speed and subject distance. Others use a sliding scale to achieve the same result. Another method is to use the flashgun's guide number (GN).

The GN is a useful method of comparing the relative power of different models when you are shopping for a new flashgun, but it is also the best way to calculate the correct flash exposure when in manual mode. You can use it in one of two ways: either to determine what aperture you should set for a particular subject distance, or to calculate how far away your subject should be for a given aperture. Dividing the GN by the distance between you and your subject will tell you what aperture you need to set. Therefore, if your subject is 5 metres away and your guide number is 40, your correct aperture is f/8. However, if you would prefer to be using f/11 in this situation, then you would divide the GN by the aperture you want to use. This will then tell you what distance your subject must be in order to expose it correctly at that aperture. In this case it would be 3.6 metres: 40 (the guide number) divided by 11 (the aperture).

Dedicated flash

USING FLASH IN DAYLIGHT

The idea of using flash outdoors on a sunny day, when there is more than enough natural light to take a picture without it, may seem rather strange. The purpose of flash, surely, is to enable photography in conditions which would otherwise be too dark.

This may be true, but in photography it is not just the quantity of light that is important – the quality of the light is also crucial. Light quality is determined by several key factors: direction, height, contrast and colour being the most significant. There is no set right or wrong combination of these qualities, it all depends on what you are photographing and the effect you want. But if you find that the light quality is wrong for your particular subject at the time and place you want to photograph it, then at times like this your flashgun can be a great ally.

Flash in bright sun

The most common example is outdoor portraiture in bright sun. The high sun of a summer's day produces ugly shadows under the subject's nose and chin, and even their eye sockets can take on a panda-like appearance. Turning the subject to face away from the sun may help, but then they will be in shadow. A correct exposure for the face will overexpose the more brightly lit background. It is a conundrum best solved by using a small amount of flash. (A white reflector could also be used, but is less versatile in use and more cumbersome to carry around.) A controlled burst of flash can reduce or even eliminate these unwanted shadows, but it has to be the right amount. Too little flash will be ineffectual. Too much will look obtrusive and, with print films, cause the background to darken. Signposting your use of flash in this way distracts the viewer, drawing their attention to your technique rather than the subject matter of the picture.

There are exceptions of course, and in some quarters a few fashionable photographers have made a trademark out of heavily flashed 'in-your-face' outdoor portraits, which work especially well with wideangle lenses. As a norm, though, it is generally accepted that the sun, rather than the flashgun, should be the main light source. The aim of the flash is to 'fill in' (hence the name) shadows cast by the sun and it should therefore appear no brighter than the natural light in the final image.

One of the most effective ways to use fill-in flash is to shoot into the light, with the sun behind your subject, then use flash to light the face. This not only produces an attractive rim-light around the subject but also reduces the risk of them squinting. A subtle blip of fill-in flash can even be used in dull weather when there are no shadows at all, to brighten the face slightly and put a flattering catchlight in the eyes. Of course, the technique is suitable for more than just portraiture. It can also be used with animals, flowers and other non-human subjects, and exactly the same principles apply.

Balancing the exposure

Achieving a harmonious flash balance requires careful calculation – unless you are lucky enough to have a modern dedicated flashgun which does the maths for you. But even these are not always ideal, because they are programmed to provide flash of equal brightness to the ambient light – what is known as a 1:1 lighting ratio. This produces brash results in which it is still fairly apparent that flash has been used. A more subtle, natural-looking effect can be achieved by halving the flash power so that its output is one stop less bright than the prevailing conditions (a 1:2 ratio) or even quartering it so that it is two stops less (a 1:4 ratio).

Some sophisticated flashguns feature a 'flash ratio' or 'flash-exposurecompensation' control which lets you alter the daylight to flash ratio as required. Simply key in 'minus two stops' or whatever ratio you require and the flashgun's on-board computer will do the rest (as long as you are in range). The camera will play its part, too, keeping the shutter set to the sync speed (although, as far as the flash exposure is concerned, it does not matter what shutter speed you use as long as it is no higher than the sync speed).

A variety of effects can be achieved by altering the output of a flashgun. On the far left, use of flash is obvious, while the result on the far right is less so, and creates only a subtle catchlight in the model's eves.

1:2

1:1

Left: Flash output is too low, resulting in underexposure. Centre: Correct flash output. Right: Flash output is too high, resulting in overexposure and washed-out features.

Non-dedicated fill-in flash

With non-dedicated automatic guns there are a few more steps. If your flashgun offers a choice of shooting apertures, select one and set this on your lens. Next, take an ambient-light reading of the scene (or from your subject's highlight) to determine the shutter speed which will provide the right general exposure at this aperture. Setting this shutter speed (as long as it is no higher than the sync speed) will, in theory, provide a 1:1 fill-in. In practice, however, your subject will be slightly overexposed because the ambient meter reading did not take account of the flash. The result will be a harshly lit subject. A more natural look would be achieved by using a 1:2 ratio. To do this, the lens aperture should be one stop smaller than the one indicated on the flashgun. For a 1:4 ratio it should be two stops smaller. In order to maintain the correct ambient exposure, any decrease in the aperture should be matched by a corresponding slowing in shutter speed. If your auto gun offers only one aperture, you will have to work around this one and hope that the shutter speed is within range.

Manual flashguns work in a similar way: your aperture will be determined by your subject distance (unless you have a variable-power model) and this should be your starting point. From here, simply follow the same steps as for auto flash.

Example of fill-in flash with non-TTL flashgun

Let's imagine that you want to use fill-in flash for an outdoor portrait. Your flashgun tells you that, with the ISO 100 film you are using, and the subject at a distance of 3 metres, you must set an aperture of f/5.6. An ambient reading from the subject's face tells you that, at f/5.6, you need to set a shutter speed of 1/125 second for a correct exposure. Your flash sync speed is 1/250 second so this is all right. However, you do not want a 1:1 flash ratio, and decide to plump for a more subtle 1:2. The flash power must be decreased by one stop. Setting the lens to f/8 will underexpose the flash by the required stop, but will also underexpose the ambient light. This is corrected by reducing the shutter speed to 1/60 second. This will not affect the flash exposure but it will increase the ambient exposure by one stop, back to what it was before you changed the aperture.

Using Flash

SLOW-SYNC FLASH

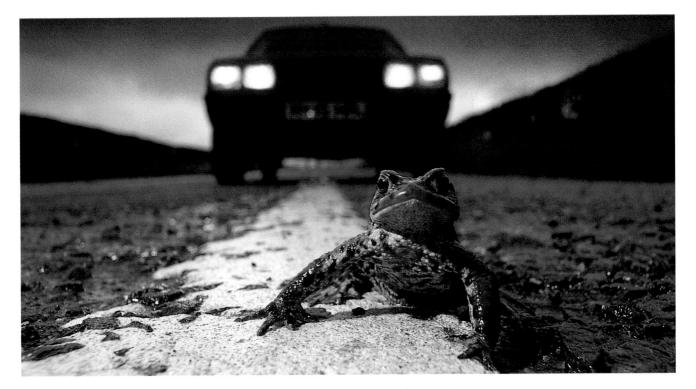

The majority of flash pictures are shot in low light, mostly indoors. The typical result is stark, white faces set against a virtually black background. Any natural atmosphere that existed at the time is lost in the gloom. While pictures like this provide a useful record of the moment, artistically they leave a lot to be desired.

There are numerous situations when you might want to record not only the moment, but the ambience of your surroundings. Perhaps you're gathered round the Christmas tree, which is festooned with fairy lights; or you're in a cosy, candlelit restaurant; or you find yourself amid the bright lights of Piccadilly Circus at night. With your camera and flash set to automatic, you are unlikely to capture any of the atmosphere which made you want to take the photograph in the first place. This is because the flash sync speed which most cameras select with flash is usually between 1/60 second and 1/250 second, and these speeds are much too brief to record any of the dimly lit background. The simplest way to rectify this problem is to use a much slower shutter speed. Most modern compact cameras recognize the demand for atmospheric flash pictures by offering a slow-sync mode, which combines flash with a much lower shutter speed. With SLR cameras you can easily do this yourself. You will have to check with your instruction manual to discover which modes you can do this in. Some, such as program, usually insist that you stick to the sync speed. Shutter priority or manual are generally the best modes to use.

By balancing flash output with ambient light, detail is retained in the background, while the foreground is correctly exposed.

The ideal shutter speed

There's no lower limit on the shutter speed you can set. Indeed, it could be for minutes or even hours, but obviously you would not be able to hand-hold the camera at these speeds without causing camera shake - though in most cases this would only really affect the background, as the subject would be frozen by the flash. The ideal setting depends on how dim the ambient illumination is, whether there is any movement and whether or not you are using a tripod. If your aim is to expose the surroundings perfectly, you will have to take an ambient exposure reading, then set an aperture and shutter speed combination which offers the best compromise between depth of field and exposure time. If perfect background exposure is less important than simply recording the atmosphere of the occasion, a speed of around 1/15 second is a good place to start. You can hand-hold at this speed and it will still give four stops more background exposure than a 1/250 second sync speed would. While a tripod is undoubtedly useful in these circumstances, it is not essential. You will find that, as long as you steady yourself against a pillar or wall or rest on a table, you can take a reasonably sharp, if not crisp, slow-sync picture at quite slow speeds.

Timed exposures with flash

When your shutter speed drops into multiple seconds a tripod – or at least a solid wall, bench or other support – becomes a necessity. Flashlit pictures at these speeds are only really necessary for times when you want to record a person outside at night with, say, a building behind, or perhaps in a very dimly lit interior. As long as the subject is standing next to, rather than in front of the background subject (and has an area of deep black behind them) they could actually leave the scene once the flash has gone off and the viewer of the picture would be none the wiser.

Recording movement

Flash really comes into its own when you want to record movement. The briefness of flash allows for visual effects that would be impossible without it. Depending on the technique you use, flash can either freeze fast action or produce a blurred, impressionistic interpretation.

The freezing option really works, artistically, only with living or fluid subjects where their position in time would not be possible without movement. It might be an athlete with flailing arms or legs in mid-leap, or a splash of liquid with droplets poised in mid-air. A subject such as a moving car would simply look as though

Using Flash

it was stationary. With ultra-fast subjects, such as speeding bullets or the flapping of a hummingbird's wings, even a normal flash is too slow to stop the movement, and specialized highspeed flash must be used.

Although the phrase 'slow-sync flash' applies to any flashlit picture taken at a slow shutter speed, it has come to be particularly associated with moving subjects, and with good reason. More often than not, the best way to convey movement is to use a slower shutter speed so that, while the flash records a frozen moment of action, the longer shutter speed records the continuing motion as a blur around it. This technique is more accurately referred to in some quarters as 'flash-blur' and is often more effective than just a slow shutter speed

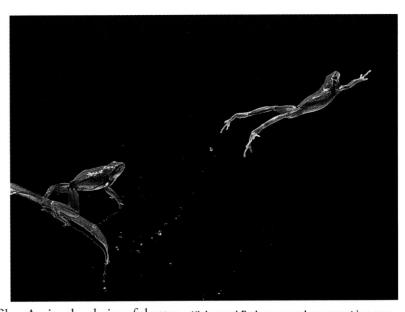

ce of shutter High-speed flash can record movement in a way which the human eye would be unable to arrest.

alone, where only the blur is registered on the film. Again, the choice of shutter speed for this technique depends on the speed of the movement and the degree of blur you want, but experiment by starting at 1/60 second and working your way down through the speeds to see exactly the sort of effect it has.

Second-curtain sync

Flashguns are synchronized to fire at the beginning of an exposure, rather than the end. At the sync speed the time difference is only a fraction of a second, but with slow-sync flash it can be a significant period of time. Some flashguns (and a few SLRs with built-in flash) allow you to choose to trigger the flash at the end, rather than the beginning, of the exposure. This feature is called secondcurtain or rear-curtain sync, and can have a marked effect on pictures of movement during long exposures, when you get a frozen flash image accompanied by a streak of motion blur.

Say you are photographing someone running, or perhaps swinging a tennis racket. Our minds expect the streaks of movement to follow behind the action, thus indicating its forward motion. This effect requires the flash exposure to be at the most forward point in the direction of travel – in other words, at the end of the exposure. In the standard flash mode, the flash image is recorded at the beginning of the travel, and the motion streaks follow afterwards. In the final photograph the blur will appear to precede the action – giving the impression that the subject is moving backwards.

making it appear more natural than if it was to precede the movement of a subject.

Bottom right: Using a longer shutter speed creates a 'ghosting' effect, which can be very atmospheric.

Top right: The blur created by second-curtain sync 'follows' the action,

BOUNCE FLASH

One of the drawbacks of using a flashgun is its harshness. As a small highcontrast light source it produces illumination which, while better than nothing, can be very unflattering. Faces often look stark and ghostly (often with red eyes) and ugly shadows are cast on nearby backgrounds. Even mildly shiny objects such as polished wood are frequently scarred by large glaring reflections, or 'hotspots'. There are several possible ways to combat this problem, but all have the same aim: to make the light from the flashgun appear softer and spread over a larger area.

How to use bounce flash

With a suitable flashgun, the easiest way to achieve this is to bounce the light off a wall or ceiling. In doing so, this surface effectively becomes the new light source. Bounce flash can have a marked and dramatic effect on the quality of the light from a flashgun. As well as producing softer, more flattering illumination on faces, it also solves the problem of red-eye, and greatly reduces the density of background shadows. There are a few conditions which must be met, however.

- You need a flashgun with a head which can tilt upwards and/or rotate to the sides. Ideally it should do both, so if you want to bounce light off the ceiling, for example, you can do so whether the camera is held vertically or horizontally.
- Your chosen surface should be white, or off-white. If it is coloured it will turn the bounced light, and therefore the subject, whatever colour the surface is. Ceilings tend to be favoured over walls for this technique – not only are they more likely to be white but, because they are above the subject, the resulting illumination more closely resembles the light from the sky so it looks more natural.

Left: Direct flash produces a slightly unflattering, washed-out result. Centre: Bounce flash with a diffuser attached is far more flattering and natural. Right: Bounce flash on its own is also more desirable for portraiture than direct flash.

The flashgun

The wall/ceiling

Using Flash

Bounced flash has to travel much further, so your surface must be quite close to the subject. Whatever the maximum range of your flashgun with your chosen film/aperture combination, it must be greater than the total distance from the flash to the surface, and from the surface to the subject. And, since no wall or ceiling reflects all the light that hits it, allowance must be made for the light which it absorbs. Also, some of the bounced flash is scattered elsewhere, and the type of room you are in will influence how much of that stray light gets back to the subject (not much if you are in a capacious ballroom, more if you are in your living room).

Like a snooker ball, flash will bounce off your surface at the same angle at which it struck the surface. If you are bouncing off the ceiling for example, and you point the flash straight upwards, the light will bounce right back over your own head, or just in front of you. And if the flash strikes directly above the subject's head, the bounced light will fall at too steep an angle, resulting in ugly shadows under the nose and chin and in the eye sockets. The same applies when using walls. If the flash is aimed too close to the subject, the side of the face away from the wall will remain unlit. For optimum results, aim the flash-head to hit the surface roughly midway between you and the subject, or at least a metre in front of them.

Calculating exposure with bounce flash

You can see how power hungry bounce flash can be, so it is no surprise that the biggest problem associated with it is underexposure. With a TTL flashgun you have little to fear, because it knows how much of the flash has reached the film, although you do need to keep an eye on the underexposure indicator to make sure the subject was within range. Automatic non-TTL flashguns should also be able to give a fair indication of whether or not your flash exposure was correct, as long as the sensor on the flash remains pointing at your subject when you turn the flash-head.

With a manual flashgun, your calculation should be based on the total distance the flash has travelled (including to and from the bounce surface). Whatever aperture you have arrived at (whether through your own maths or by reading off the table on the back of the flashgun) you should set the lens to at least a stop wider to allow for this absorption and scatter.

Reflector cards

The concept of bounce flash is so sound that photographers have found a way to use it even when there is no nearby surface to bounce it off. They do this by The distance

The angle

tilting the flash upwards and fitting a piece of white card to the back of it. You can make these cards yourself, or buy one of the numerous manufactured ones. The cards, which vary in size and shape (some are formed into a scoop), can be attached with Velcro, sticky tape or elastic bands, and are small enough to fit into a pocket or camera bag. One of their advantages is that the light does not have to travel so far before it is bounced, so flash power is not as dramatically curtailed as when using a wall or ceiling – although because they are smaller, their degree of diffusion is not as great. When using reflector cards, the precise position of the flash-head will depend on the shape and angle of the card. It should be pointing slightly downwards, but not too far – unless your intention is to light your subject's knees! This is something you should be able to judge by eye.

Diffusers

Diffusers are an alternative to reflector cards. Like reflectors, they fit on the flashgun and soften the light, but there are differences between the two. First, since you do not have to angle the flash there is no dispute about where to point the head – and of course diffusers will work on flashguns with non-moving heads. The resulting illumination is more direct and generally less soft, depending on the model used. The smallest diffusers are made of frosted plastic and fit directly over the flash-head. The largest are miniature versions of studio softboxes and have to be assembled before use. There are even inflatable models. You can, of course, make your own – for example, from an old margarine tub, slide-box lid or plastic bag – but remember that the larger the diffuser, and the less transparent the diffusing material, the less light it will transmit.

Exposure measurement is more tricky than with bounce flash. With manual guns you will have to perform some tests to determine how many stops you lose. With auto models, just make sure the diffuser does not obscure the sensor on the flashgun. If it does, you will have to resort to using it in the manual mode, if it has one. TTL flashguns should do the work for you, but bear in mind that if the diffuser covers the AF illuminator you may have difficulty focusing in very low light.

A mini softbox, which is fitted over a standard flashgun, is ideal for creating more diffused, flattering results.

USING YOUR CAMERA'S BUILT-IN FLASH

Most modern SLRs and virtually all compact cameras include a small built-in flashgun. On the face of it these diminutive devices may seem like an afterthought – fine for 'happy snaps' or emergencies but of no use in 'serious' photography. They do, after all, share several unpromising qualities: they have a very short range; you cannot move them, bounce them or diffuse them; and they offer little control to the photographer – often, the only variables possible are 'off' and 'on'. However, while a built-in flash is no substitute for a decent accessory flashgun, there are many circumstances when it is all you need.

Few casual photographers ever consider using their flash until the natural light fails, but arguably the most useful application of a built-in flashgun is when the ambient light is at its very brightest – to fill in the harsh shadows produced by bright sunshine. The fact that it is not very powerful is not really a problem. Fill-in flash is meant to be subtle and the aim is only to lighten, not eliminate, the shadows. As long as your subject is within the flash range it will have some effect. A modest *contre-jour* effect should even be possible.

Only the most sophisticated cameras will switch the flash on automatically in these conditions, so you must activate it manually. This is usually done by sliding a switch, pressing a button or, with some SLRs, physically raising the pop-up flash. Once activated, it may fire only at full power, but don't worry; in bright sun it's unlikely to overwhelm the ambient light (unless you are at very close range).

A positive side effect of fill-in flash, whether you are in bright sun or not, is the catchlight it puts into your subject's eyes. Without a catchlight, eyes can look dull and lifeless. Adding catchlights gives them a very flattering sparkle which somehow brightens the subject's expression and makes them look more attractive. For this reason, many photographers use a very small burst of fill-in flash for all outdoor shots of people – whether in bright sun or not. Fill-in flash

Adding catchlights

Left: Ambient light can be a little dull. Right: Using built-in flash to provide fill-in gives the eyes more sparkle and reveals extra detail in the child's jacket. The reds are more saturated.

Warming up a portrait

Brightening colours

Renowned Magnum photo agency photographer Martin Parr deliberately uses direct flash in close-up to reveal all the garishness of his subjects.

Freezing movement

Indoor and low-light portraits **Flash tends to be cooler in tone than sunshine,** but it can be warmer than the natural light on a dull, miserable day. In the latter conditions faces often take on an unflattering bluish tinge, which can make them appear slightly unhealthy. A small amount of flash can give faces a lift and help make people stand out from the background. This also applies to indoor shots under fluorescent lighting, where the greenish cast can give faces an even more sickly appearance. While this is also a fill-in flash technique, its purpose is different from that of the more traditional, shadow-filling application.

Brightly coloured objects can be made to appear even more saturated by exposing them to a burst of flash at close range. For proof of this effect look no further than the work of the acclaimed photojournalist Martin Parr, who has used this technique to emphasize the gaudiness and vulgarity of modern life. In his pictures, food, packaging and bric-a-brac are brought vividly to life using direct flash close-up.

As long as your subject is within range, even a small built-in flash can freeze the movement of a running dog or a child on a swing. Without flash, moving subjects can sometimes be rendered a messy blur. Flash will allow you to record the subject in sharp relief, even if it is against a motion-blurred background. This is especially useful with compact cameras, where you have no idea of, or control over, the shutter speed.

This is the obvious application for a built-in flashgun. Parties, family snaps, special occasions – these are all subjects of photographs which tend to be lit by flash. If you are an SLR user it is worth remembering that without a built-in flashgun pictures like these are a lot more trouble. Fiddling about trying to find, set up, charge, then use, your high-tech accessory flashgun (assuming you have one) may cause you to miss the crucial moment. And in these situations any picture is better than none.

The disadvantages of built-in flash

Short range

With average-speed film, built-in flashguns have a useful range of only 3 or 4 metres. For subjects further away than this they cannot be relied upon to make a significant contribution to the overall lighting.

Lack of control

As mentioned earlier, most built-in flashguns can only be switched on or off. There is no ratio control to fine-tune the output, and no means of bouncing or diffusing it to soften the light it produces.

Harsh lighting

A general principle of light is that the smaller the source the harsher the illumination will be. Built-in flash tends to produce very deep, unflattering shadows when it is the main light source. These are particularly prominent around the nose and neck of the subject, and on the background behind them. Also, because the light hits the subject almost head on, built-in flash produces no natural modelling (the soft shadows that reveal shape and form) and can give the subject a startled, 'rabbit-in-the-headlights' appearance.

Red-eye

Red-eye is arguably the most unpleasant side effect of built-in flash. It gives subjects a demonic appearance which can completely ruin a picture. The worst news is that, despite the manufacturers' best efforts (with various 'reduction' devices), there is no sure-fire way of avoiding it without recourse to a separate flashgun. Red-eye is caused by flash illuminating the blood-vessels in the back of the eye and bouncing back into the lens, and usually occurs in low light when the subject's pupils are open wide. The best cure is to move the flash further away from the lens so that

these reflections bounce away from the optical axis, but of course you cannot do this with a built-in flash. If you cannot switch to a separate flashgun – preferably on a bracket and diffused – the only option open to you is to try to increase the room lighting to shrink the subject's pupils.

Battery usage

A final, financial, consideration is that flash is a very power-hungry feature, and frequent use will quickly eat into the battery's life. If your camera takes the more expensive lithium-type batteries this is something to be aware of.

WHEN NOT TO USE FLASH

When the subject is out of

When it would distract the

range

subject

atmosphere

Flash is a very useful tool to have at your disposal, but it is by no means the best way to cope with every low-light situation. There are times when flash is inappropriate and other techniques would serve you better.

'No Flash Photography' - this sign is a common sight in museums, galleries, stately homes, theme parks, cinemas and other public places. Sometimes this When flash is forbidden rule is intended to protect and conserve, say, a valuable art work from light degradation, but often the reason is commercial - your hosts would much rather you spent your money buying their postcards instead. If you know about this rule in advance, the best plan is to load up with fast film beforehand, then shoot in available light if you can. If you are forced into long exposures, brace yourself against a wall or other rigid surface to minimize the risk of camera shake.

Taking a photograph through a window is obviously not appropriate when it With glass or reflective comes to flash, as the light will simply bounce off the glass, leaving you with a picture surfaces showing just a giant out-of-focus reflection. Likewise, if your subject is standing in front of a pane of glass, or a mirror, or even a shiny metal surface, the flash can reflect back into the camera to such an extent that the flare may overwhelm the subject itself. If you must use flash, and you cannot move the subject elsewhere, the best approach is to shoot at an angle to the offending surface to minimize the risk of flash bouncing back. Better still, resort to the flash-free, hand-held method.

> There is no point in wasting battery power trying to light a subject which is beyond the reach of your flashgun - especially since the maximum range quoted by the manufacturer is usually rather optimistic in the first place. Move closer to the subject if you can.

> When your subject is engaged in an activity that requires their full attention - knife juggling, for example - taking a flash photo of them is probably not the most considerate thing to do. Instead, load up with fast, grainy film to enhance the atmosphere.

Many people, on finding themselves somewhere with a pleasant ambience - say, a When it would ruin the candle-lit restaurant or a lit-up December street – decide to record the moment for posterity. On comes the flash - and out goes the atmosphere. In any situation where someone has taken the trouble to set the mood, the flashgun is best left in the off position. This is also true during laser shows, light shows and firework displays, where of course you won't see any of these lovely effects if you use flash. The best technique in these situations is to rest the camera on something solid (a table, say), select the flash-off mode, activate the self-timer and keep still during the long exposure (assuming you want to be in the shot). Alternatively, the fast-film, hand-holding option is always worth a try.

Both of these images, although very different, would have been spoiled if flash had been used. In their different ways, each is atmospheric thanks to the lighting conditions which already exist. In the top picture, flash would have frozen the subject's hands, reducing the feel of concentration and movement, while in the bottom picture the balance between natural and ambient light creates a lovely palette of colours, which would have been neutralized by flash.

STUDIO FLASH

Many photographers are drawn to working in a studio-based environment. The discipline is in a different realm from most outdoor photography. Studio photographs are, by and large, constructed rather than found images. They are the product of the photographer's (or someone else's) imagination, rather than observations or snatched moments in time. Studios provide photographers with a technically controlled environment in which to work, and in which they can influence virtually every aspect of the picture – the props, the styling, the composition, the pose (if a portrait) and the background.

In a studio you are not at the mercy of the weather: the lighting can be as bright and contrasty or as soft and subtle as you like, whatever is going on in the climate outside. You can work at your own pace, as slowly and methodically as you wish, and with still life you can even leave it unfinished and come back to it another day. You can leave it set up until you have processed the films, just in case. Then there are all the comforts of being indoors, in the warmth, with a kettle and a comfortable chair nearby.

What is a studio?

A studio does not have to be a purpose-built room, it can be almost anywhere: a spare bedroom, a loft or basement, the garage – even the corner of your living room. You do not have to use flash, you can use daylight or tungsten-balanced light if you prefer, but if you do decide to use flash you will find that your portable flashgun has several drawbacks. The most significant of these is that you cannot see what effect the light is having on your subject until you develop the film. You cannot see where the shadows are falling, or detect any unwanted reflections. You cannot easily mould the light into the shape and style you require. This is where studio flash comes into its own. If, having dabbled in studio-based photography, you find yourself developing a serious interest in it then it will almost certainly be worth making the investment in a basic set-up.

Basic equipment for studio flash

Studio flash-heads are very different from portable flashguns. For a start, they are much bigger. They run off the mains, so they are a lot more powerful and recharge more quickly between flashes. Most important, they incorporate a tungsten or halogen 'modelling' lamp so you can see approximately how the

flash will look – and they allow the attachment of a huge range of modifying accessories to radically alter the lighting effect.

Studio flash systems fall into two main categories: those with integral heads (called monoblocs) which are fully self-contained, requiring only a stand and a mains lead to be attached to them; and those based on power packs. With the latter, the heads contain only the modelling lamps and flash-tubes, and all the power-generating components (the capacitors, etc.) are contained in a separate floor-standing unit to which the heads are attached. These are generally more powerful and more expensive and are really only necessary for serious, heavy-duty professional work. For most enthusiasts, monoblocs are the answer.

Anatomy of a monobloc flash-head

Studio flash systems do not use guide numbers to indicate their power, since this figure would depend entirely on what accessory was attached. Instead, their power is judged by their electrical input, which is measured in joules, or watt-seconds. The entry-level, lowest-powered monoblocs are usually rated at about 200–250 joules, with mid-range models at around 400–500j. Power-pack models tend to start at about 1000j. The relationship is simple to calculate: a doubling of the joules figure is a doubling of power (or an increase of one whole stop).

Obviously, the higher-powered models are more versatile: you can shoot at smaller apertures, light subjects further away, attach larger softboxes and so forth, but they can be a disadvantage when you need only a small amount of power – perhaps because you want to shoot at a wide aperture. Although the output can almost always be adjusted, some units will only go as low as a quarter – or even half – power, which may not be low enough. Some can be adjusted only in increments of a whole or a half stop; others can be steplessly varied.

Power

A monobloc flash head is operated entirely from a panel on the back of the unit.

Modelling light

(_)

The modelling light is usually a photoflood or halogen bulb, which is situated next to the flash-tube. Its purpose is to provide continuous illumination to give you a rough idea of the effect you will get from the flash. It should be possible to adjust the power of the modelling light in proportion to the flash. This is especially important when you are using more than one light. That way, if you reduce one of the flash-heads to half power, the modelling light will reduce its output so you can see the relative difference in brightness between them. Most makes of flash include this feature, but there are exceptions. Other useful modelling light features include an ability to switch it off altogether and the option to link it with the recharge circuit, so that the modelling light goes off when the flash is fired and only comes back on when fully charged. This latter feature is particularly useful in portraiture, when you're more likely to want to shoot pictures in quick succession.

Your camera is connected to the flash unit via a cable, which triggers the flash as the shutter is opened. If you are using more than one flash-head, though, you will need some means of firing the second one at the same time. This device is a light-sensitive cell called a 'slave' and is built in to most modern units. Ideally, slaves should be positioned so that they will see the flash from the other unit wherever it is positioned. On some (usually older) models, the slave is a separate accessory which must be plugged into a socket on the flash-head and rotated to face the correct angle.

Common accessories

Most studio flash-heads need some sort of modifying accessory attached to them to channel the flash and prevent it from going where it is not wanted. The type of accessory you fit, however, depends entirely on what effect you want. With the right modifier you can create high-contrast or low-contrast light, a wide spread or a narrow beam. The following items are the most popular attachments.

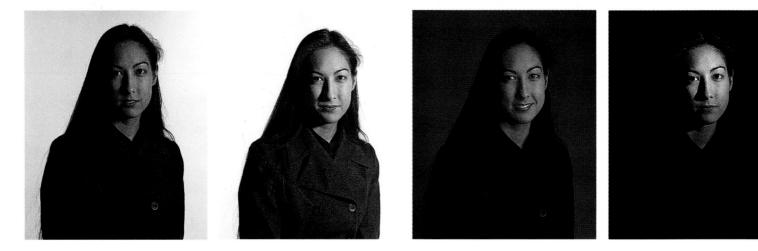

Slave

The sequence below reveals the wide range of effects which can be created by using just one flash head and varying its attachment. These portraits used (from left to right) an umbrella, a softbox, a dish reflector and a snoot. A softbox is exactly that: a box-like structure with a white translucent front \bigcirc which produces soft light. It is designed to replicate the effect of indirect sunlight coming through a window. Softboxes come in various sizes, from under a metre square to several metres across, and the larger the softbox, the more diffused the light will be at a given subject distance (all other things being equal). The drawback is that a larger softbox requires more power to produce the same light output as a smaller one would. The degree of softness they produce can also be controlled by their distance from the subject. The closer they are, the larger they appear and therefore the softer the light they produce. Some softboxes are of rigid construction, others are made of fabric – like tents – and can be dismantled for transportation. Softboxes are popular where reflections of the light source are likely, as a square of light is less obtrusive than most other forms of reflection. Some photographers stick strips of black card on the front of them so the reflection looks like a window.

Brollies come in various sizes and surfaces. With most types, the flash-head is turned to face away from the subject and the light is bounced back on to it from the brolly. Most umbrellas are comprised of white, silver or gold material, while some are reversible with white on one side and a metallic surface on the other. Some are made of translucent fabric and are designed to fire the flash through

Umbrella

A softbox is the most common flash accessory, providing a wide, even spread of light which is particularly suited to portraiture.

Softbox

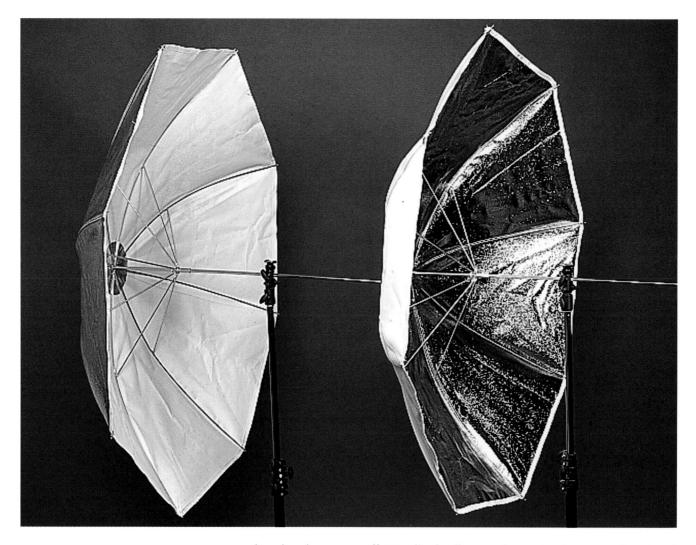

Umbrellas, also used mainly for portraiture, come in a variety of surfaces, each giving a slightly different quality of light.

Dish reflector

rather than bounce it off. Metallic brollies produce a harder, more directional light than white ones, with the gold obviously fulfilling a secondary warmingup role. Brollies are among the most popular of modifiers because they are relatively inexpensive, fold up quickly to a small size and are quite versatile – especially the reversible versions.

These are bottomless metal bowls which attach to the front of the flash-head to produce a fairly hard, directional light. Again, they come in a wide range of shapes and sizes: the tiny 'spill-kill' is designed to stop light from escaping around the sides when an umbrella is fitted; deeper, narrower dishes produce a relatively small circle of hard light; wide, shallow ones result in a larger circle of softer light. Some of these wider types incorporate a cap in the centre which covers the flash tube and prevents any direct light from reaching the subject. Dish reflectors are not as easily portable as brollies or collapsible softboxes, and their high-contrast light requires more skill to control properly.

Snoots produce a very narrow beam of light, and are commonly used in a secondary role – to light hair or throw a spotlight on the background, for example. Used as a main or 'key' light, the result would be very hard illumination with dense black shadows. There are two main types: conical snoots through which an ever-decreasing diameter narrows the flash spread; and honeycomb snoots which use a honeycomb grid to prevent the light from spreading outwards.

Snoot

A conical snoot focuses the beam of light on to a very small area.

of a spotlight which can be focused, via a fresnel lens, down to a small, sharpedged circle. They are commonly used with gobos – patterns such as venetian blinds, key-holes and so on, cut out of sheets of metal or etched on glass. These are then focused on to the subject or background to create special lighting effects. This is a fairly expensive and

Some flash-heads allow the attachment

the subject or background to create special lighting effects. This is a fairly expensive and specialized accessory, though still cheaper than the few stand-alone focusing spotlights.

Since you cannot attach a studio flash-head to the top of your camera (not that you would want to), you need to attach it to a stand. These are usually three-legged devices, with height-adjustable stems. Some are on wheels to facilitate easy movement, others feature hydraulic damping so that when you undo one of the height locks the head glides gently downwards rather than dropping abruptly – thus reducing the risk of damaging the fragile flash-tube. When choosing stands, it is best to avoid the thin, flimsy ones as they tend to sway when a heavy flash-head is attached to them.

Focusing spot

A focusing spot is useful for creating special effects, when used in conjunction with patterned gobos.

Stand

Using Flash

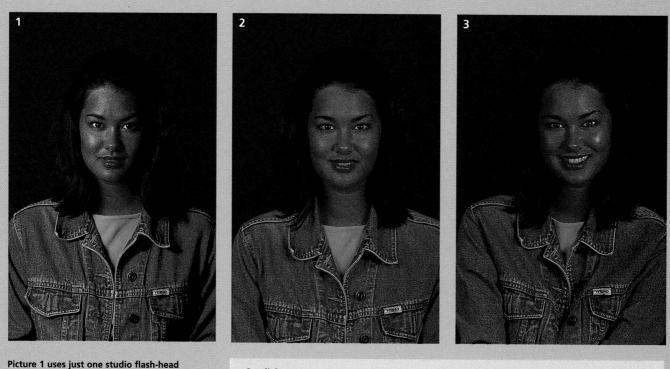

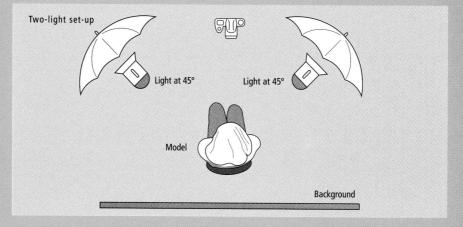

Pictures 2, 3 and 4 use two studio flash-heads, each placed at a 45° angle to the model.

with an umbrella, which throws one side of the model's face into shadow. While the result is satisfactory, the shadow created by her nose is not ideal.

Picture 2 has both lights set at full power, which illuminates the model's face completely evenly.

In picture 3, the output of the right-hand unit has been reduced to half power. The resulting subtle shadow on the left-hand side of the model's face creates a little more depth.

In picture 4, the output of the flash has been reduced to quarter power, making the shadow more pronounced. In each case, the left-hand flash unit has stayed at full power.

Using Flash

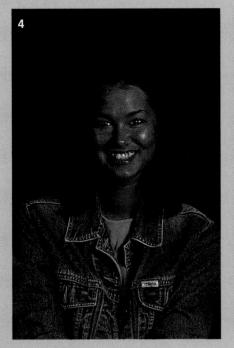

One background light

One mainlight

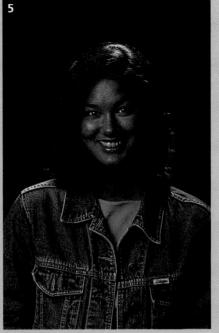

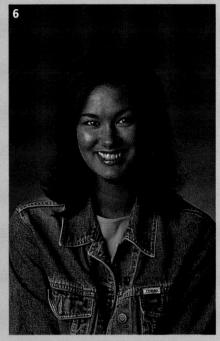

In picture 5, the photographer has kept the main flash unit at full power, but this time has added a light with dish reflector pointing down towards the back of the model's head. This adds a highlight to the model's hair – as suggested by the term 'hairlight' – making the photograph appear more three-dimensional.

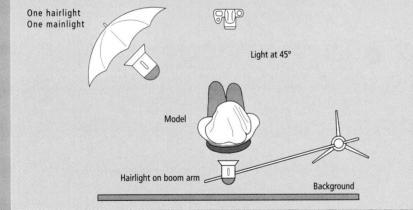

FUP

Model

Background light

Light at 45°

Background

Picture 6 uses the main flash at full power once more. However, for this image, a flash unit with dish reflector was placed behind the model, pointing towards the background. This makes a pleasing 'glow' behind the model, and creates the effect of a graduated backdrop, even though it is actually one uniform colour. The output of the background light can be altered from full, to half, quarter, eighth or even sixteenth power, which effectively gives you five backdrops for the price of one!

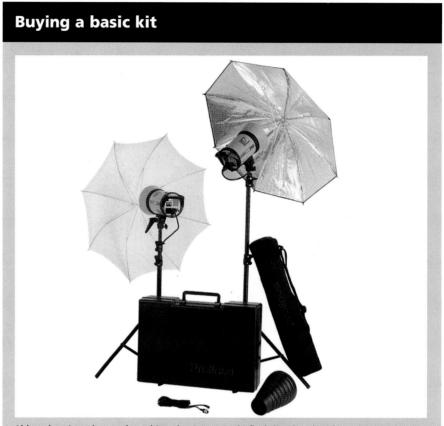

Although quite a lot can be achieved using a single flash-head with a few accessories, most studio photographers use two or more lights, as this provides significantly more versatility. In use, one of these will be the main or 'key' light. This will provide the shape and modelling on the subject. A second, less powerful light may be used as a fill-in, to reduce the density of the shadows cast by the key light. The second light (or a third one) could also be used to light the background, perhaps to cast a circle of illumination behind the subject to help make it stand out more. If the subject is a portrait, a light may be used to light the hair and give it a sheen. Of course reflector boards could be substituted for lights in some of these situations, but it is useful to have at least a couple of lights at your disposal.

If you are starting out it is usually cheaper to buy one of the ready-made two-light kits than to buy lights separately. These kits may comprise two identical lights or one which is more powerful than the other. Generally, the kit will include a couple of stands, and either two brollies or a brolly and softbox. A sync lead will also be provided.

The only additional purchase necessary is a flash meter, and some kits even include these. Because studio flash units are not automatic and have no guide numbers, you need a flash meter to measure the aperture reading with your particular unit/distance/modifier combination. An ordinary ambient-light meter is not suitable for this purpose. Flash meters vary in specification, but a basic model is adequate for most needs. More complex models offer features such as multiple flash measurement, remote (cable-free) flash measurement, and selective reflective flash measurement, which you may or may not use.

A huge variety of studio lighting effects can be achieved with two flash units and a few accessories. Many manufacturers sell studio starter kits that provide everything you need.

CLOSE-UP AND MACRO PHOTOGRAPHY

One of photography's greatest qualities is its ability to show us things which are either outside our normal field of vision, or which we could see if we looked but usually fail to register in the general hubbub of daily life. In few fields of photography are these qualities more powerfully expressed than in close-up and macro photography, whether it is the intricate vein structure of a fallen leaf which we would otherwise have trodden underfoot on our way to work, or the fine hairs on the knees of an insect whose entire body would go unnoticed unless it happened to land on us. Close-range photography can show us a world unknown to us, and reveal the beauty, shape, structure, texture and colours of things which we see but take for granted. In this respect, it is one of the most rewarding areas of photography but, for numerous reasons, it can also be among the most challenging.

AN INTRODUCTION TO CLOSE-UP WORK

Close-up and macro photography reveals a world not normally visible to the naked eye.

Texture, shape and form, while fundamental to all photography, take on a whole new meaning when studied through a macro lens, as demonstrated by the smoothness of these tulip petals.

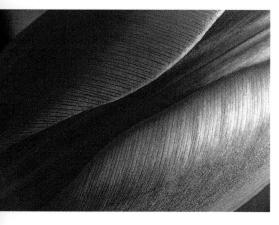

Close-up photography

What makes a good macro subject?

Almost anything can be a suitable subject for a close-up or macro image. Collectors of stamps, coins and other small objects can record and catalogue their examples; electronics students can photograph circuit boards and so forth for later study; but overwhelmingly the most popular subject for close-up treatment is nature, in its myriad forms. Perhaps it is because the flora and fauna of our world are so endlessly fascinating, or because there is such a tremendous variety of accessible subjects to choose from.

Going in close, however, presents numerous technical and aesthetic challenges, and the closer you get, the greater they become. These potential pitfalls must be understood and mastered if the photographer is consistently to produce good close-range images. Perhaps the first step in the process is to decide how close you want to get to your subject. The answer to this question will determine the equipment you need in order to do so.

Definitions

There is no technical definition of what constitutes a close-up. It is basically just a more intimate than average view of a subject. You do not need any special equipment to shoot close-ups; your existing lens at or near its minimum focus point will do fine. All you need is an eye for detail.

The term 'macro' is possibly the most misused word in photography. For years, lens manufacturers have been using it to describe any lens that focuses slightly closer than average. In fact, what they refer to as macro should, more accurately, be called close-up. Technically speaking, a photograph cannot be considered a true macro shot until the subject is reproduced on the film at life size (1:1) or greater, although the definition has stretched with misuse to include ratios of 1:2 and even 1:4. Macro photography extends beyond life size to ratios of about 4:1. At these magnifications you will need a small

amount of specialized equipment, but the good news is that it is not expensive. The full technical term for macro photography is, in fact, photomacrography. Macro suits us fine!

This is not about photographing very small objects close up, but is in fact the process of making tiny photographic images, such as on the microfilm so beloved of James Bond and other spies.

If you want to, you can photograph subjects too small to be seen with the naked eye; this is done by attaching your camera to the top of a microscope and shooting through it.

Macro photography

Macro photography is not limited to reproducing a subject at life size – it can go even closer to make it appear larger than life!

Microphotography

Photomicrography

Photomicrography goes in even closer, magnifying cells and suchlike to a degree which shows us their make-up.

Essential equipment for macro work

Although you can shoot close-ups with any camera, at high magnifications an SLR is virtually essential. This is for several reasons. First, at close distances, compacts and other non-SLR cameras suffer most markedly from parallax error – the difference between what the lens sees and what you are looking at through the viewfinder. The few centimetres in distance between the lens and the viewfinder may cause you inadvertently to crop part of the subject out of the picture, or even to miss it altogether. Secondly, non-SLRs will not be able to focus close enough for high-magnification work, and in most cases their fixed lenses rule out the use of supplementary macro accessories. There are other reasons, too, but these are enough to underline the importance of using a reflex camera.

The SLR you use should also have certain features. First, a depth-of-field preview facility is needed, both to check which parts of the subject are in sharp focus and to see what effect changing the aperture has. A mirror lock-up, while not essential, is a highly desirable addition as it reduces camera vibration when the shutter is released. If your camera is an autofocus model, you will need some means of switching off the AF and, for larger than life work, you will need either a stopped-down metering mode or manual exposure. This is because you may need to fit an accessory between the camera and the lens. This would sever the electronic link which automatically closes down the lens to the chosen aperture when you depress the shutter button.

Macro photography is a great test of optical quality. Because there is usually so much detail, any lens which is less than crisp from edge to edge will quickly be found out. If you are serious about macro photography, get the very best lens you can afford. Prime lenses are generally more suitable than zooms. Not only are they likely to be sharper but their wider maximum apertures make critical focusing easier, especially if you have to fit additional light-reducing accessories.

Consider also the focal length of the lens. With a short lens, such as a standard 50mm, you may find you are so close to your subject that you are casting a shadow over it and blocking out the light. If it is a living subject, you also run the risk of frightening it away. A short telephoto can be a boon with certain subjects and when using ambient light. A lens with internal focusing is an advantage. These maintain a constant length irrespective of the focus point. Ordinary lenses increase in length as the focal point gets closer, and you run the (albeit small) risk of poking your subject with the front element if you are not careful.

This is an essential accessory, especially when you are working near or at true macro. This is partly because high magnifications also magnify camera movement and therefore increase the risk of camera shake, but also because depth of field is so shallow that your plane of sharpness is likely to drift off the subject if you try to hand-hold the camera.

The lens

The camera

A tripod

Close-up and Macro Photography

Reproduction ratios

The relative magnification of a close-up subject is usually indicated by its reproduction ratio (sometimes called a magnification ratio). When a subject is recorded on film at half its real size (e.g. when a 20mm long object measures 10mm long on the film) it is said to have a ratio of 1:2. When it is a fifth of its actual size it has a ratio of 1:5. At life size it is 1:1 and if it was three times larger on the film than in reality it would be 3:1.

Note that these ratios apply only to film and not prints. It is easy to make a subject appear life size or bigger on a print simply by making an enlargement. You can only make a subject appear larger on the film by getting closer to it or by using a lens of greater magnification. This is when it falls into the realm of closeup photography.

ACCESSORIES FOR MACRO

When you have racked your lens to its minimum focus point and you still cannot get close enough, you need to adopt another strategy. This will probably involve interfering with the lens in some way – usually by attaching something to the front or back of it. Depending on how close you want to get, here are the options:

Close-up dioptre lenses

These are often incorrectly referred to as filters, because they screw on to the front of your lens just as a filter would. Close-up lenses represent the simplest, cheapest way to get closer to your subject. They are generally available in three strengths: +1, +2 and +3 dioptres, with the higher number indicating greater magnification (though stronger ones are available, and they can also be used either singly or in any combination). Close-up lenses work by bending the light rays passing through them so that they focus at a nearer point than they would otherwise.

Pros and cons

The main benefits of this type of lens are cost (under £20 in most cases) and the fact that, since they do not reduce the amount of light entering the lens, no exposure compensation is required. Their main drawbacks are that, because you are placing another optical element in the light path, they do impair image quality to some extent. Also, magnification potential is limited unless you combine them, but then the quality deteriorates markedly.

Increasing the distance between the lens and the film plane allows you to focus in on subjects more closely, and the greater the distance, the greater the image magnification possible. Extension tubes are a set of hollow rings which fit between the lens and camera body to act as spacers. They are usually sold in sets of three rings of different depths and, like close-up lenses, can be used either singly or together in any combination.

Pros and cons

0

Because they contain no glass, only air, extension tubes do not degrade image sharpness at all. They do, however, reduce the amount of light reaching the film, so longer exposures, wider apertures or faster film will have to be used. With most (though not all) tubes you retain the aperture coupling so you do not have to stop down manually, and TTL metering is still possible. You may, however, lose the autofocus function, though AF is of limited use in macro work anyway.

One of the big disadvantages of tubes is that you have to keep dismantling your set-up to add or subtract tubes and, because they are of set sizes, fine adjustments to magnification are not possible, as the required extension may be between ring sizes. Extension tubes are, however, relatively inexpensive for the degree of magnification you can achieve.

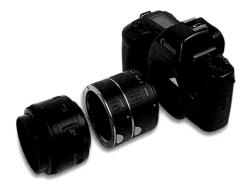

Extension tubes are fitted between the lens and the camera body. This increase in distance between lens and film plane allows you to get in closer than if you were using the lens on its own. Bellows also fit between body and lens and work in the same way as extension tubes. They are comprised of a length of light-proof, flexible bellows mounted on a metal rail. One end of the bellows attaches to the camera's lens mount, and the other houses another mount for the attachment of a lens (which may be a standard or wideangle optic or, if preferred, an enlarger lens). The bellows extension is usually adjusted by means of a lockable rack-and-pinion device on the base, so magnification can be increased or reduced at the turn of a knob.

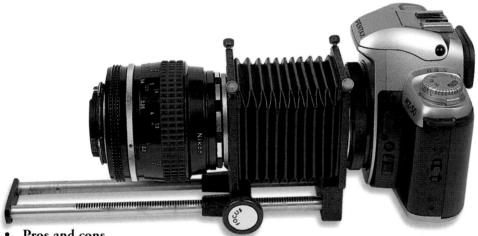

Bellows

Pros and cons

Bellows are much more versatile than tubes. Unlike tubes, which can only extend in stages, and must be dismantled to do so, bellows can go from minimum to maximum extension steplessly and without necessitating the removal of the lens or body. Their ultimate length is longer, too, so much greater magnifications are possible - up to four times life size with a suitable lens attached. On the minus side, they are bulkier to store and use and, in most cases, you will lose the automatic diaphragm function. This means you will have to stop the lens down manually before exposing and, depending on your camera, metering may be problematic. Also, at longer extensions, a greater amount of light is lost in reaching the film than with tubes, so even longer exposure times will be needed. Finally, they can be quite expensive (two or three times more so than tubes) so they are only really suitable for serious macro users.

Macro lenses look pretty much like normal lenses, except they can focus much more closely. True macro lenses can focus straight from infinity down to 1:1 life size in one rotation of the focusing ring, while others go down to 1:2 and must be used with a matched extension tube for the final adjustment to life size. Macro lenses are commonly available in two focal-length ranges: the standard lens (50mm – 60mm) and the short telephoto (90mm – 105mm), though there are one or two 200mm macro lenses. Basically, the longer the focal length of the lens, the less close you have to get to your subject to obtain a given magnification. This is handy if your subject is dangerous or likely to scare easily, but also means you are not in your own light, casting a shadow on your subject.

Bellows provide more flexibility than extension tubes, as magnification can be increased or decreased by extending or retracting them.

Macro lenses

Pros and cons

With macro lenses it is mostly pros. Optically they are far superior to ordinary lenses, particularly at high magnifications where normal lenses may not always be up to scratch. Since they focus to infinity you can also use them as regular lenses. For macro work they are simplicity itself to use: nothing needs to be added or removed and full metering, focusing and stopped-down features are retained. There is only one real drawback – the cost. But if you buy a used lens or one of the handful of excellent independent brands they can be surprisingly affordable.

Teleconverters are generally used to extend the effective focal length of your lens to make it more telephoto, but they also enable greater magnifications to be achieved at close range. They are usually available in two strengths, 1.4x or 2x, and effectively magnify the subject size by these amounts even at the minimum focus distance, which usually remains unchanged. They can also be used in conjunction with extension tubes or bellows.

Pros and cons

Teleconverters are similar in price to extension tubes, but their magnification potential is not as great. They are useful, therefore, if you already own one for telephoto work, but not worth buying specifically for macro work. Also, since they contain lens elements, there is some effect on image quality.

These are thin metal rings incorporating a filter thread on one side and a lens mount on the other, and are designed to allow you to fit your

lens on backwards. This may seem like a strange thing to want to do, but in fact there is sound logic behind it. At high magnifications, most lenses provide

better optical quality when they are reversed. This is because of the way they are constructed. A lens can be reversed when it is used in conjunction with extension tubes or bellows for beyond life-size magnifications, but the simplest and cheapest method is to attach it directly to the camera body.

Reversing rings

Teleconverters

The reversing ring is shown here between the camera body and the reversed lens.

Pros and cons

Reversing rings are a fairly inexpensive way to obtain macro images, and with a typical standard lens you can obtain near 1:1 magnification. The quality is high, too. The drawbacks are that you lose all coupling with the lens – including aperture stop-down and metering. The magnification you get is non-adjustable and the focus range limited. Also, they do not work so well with lenses whose aperture diaphragms are at the back of the lens, because when they are reversed the diaphragm will be at the front, causing diffraction and, therefore, some loss of image quality.

These are similar in appearance to reversing rings, except that, rather than a lens mount on one side, they have a filter thread on both sides. This allows one lens to be fitted, in reverse, on to the front of another. The reversed lens becomes, in effect, an elaborate close-up dioptre lens, but offering better optical quality and much greater magnifications. Ideally, the reversed lens should be between 24mm and 50mm, and the camera-mounted lens should be a telephoto of at least 100mm. The magnification achieved by the combination is calculated by dividing the attached lens by the reversed one (so with a 50mm lens reversed on to a 100mm lens the magnification is 2x life size). For best results the tele lens should be used at minimum aperture to reduce the risk of vignetting caused by the reversed one.

Stacking rings

Stacking rings are screwed on to a conventionally fitted lens, while a reversed lens is fitted on to the other side.

• Pros and cons

Very high magnifications are possible at very low cost, assuming you have the lenses already. Even if you do not, second-hand ones of any make (you do not use the lens mount) can be bought quite cheaply and used to stick on the front of your existing lens. All the functions of your taking lens (stopped-down aperture, TTL metering, etc.) are retained. The only drawback is that the magnification cannot be varied without using a different combination of lenses.

GETTING STARTED

Depth of field

Many of the so-called rules that we have come to take for granted in our 'normal' photography no longer apply when we move into the world of macro. Going in close to your subject presents several technical challenges, and these tend to magnify in size along with your subject. Here are the main ones:

The more you magnify your subject, whether by moving in close or using a telephoto lens, the less depth of field you have. Even at small apertures, where the depth of field is greatest, it may still be only a few millimetres deep once you approach, or exceed, life size. This is not a big problem with a flat, two-dimensional subject such as a stamp (as long as you are perfectly square on to it), but with a three-dimensional subject you are likely to find that you are unable to get the entire subject in focus at once. If you are able, one solution is to rotate the subject until it is presenting its shallowest profile to the lens – or move the camera position to achieve the same effect. If you cannot do either of these things, or if you have already done so but you still do not have enough depth of field, then you have to decide which part of the subject to render in sharp focus and which parts to blur.

The extremely shallow depth of field afforded by macro photography is not always a hindrance – sometimes it adds to the apparent mystique of the subject being photographed.

This lack of depth of field, although highly photogenic, requires extremely precise focusing skills. Even the tiniest imprecision could spoil an otherwise stunning shot. In this case, perfect focusing on the centre of the flower blurs everything beyond the plane of focus.

Close-up and Macro Photography

This limited depth of field makes it almost impossible to photograph moving subjects, as even a fractional shift in subject position may take them out of the zone of sharp focus. This applies whether the subject is a living creature attempting to escape your scrutiny or an inanimate twig blowing in the wind. And it is not just subject movement you need to be concerned with. Your own movement, no matter how steady you think you are, can cause your plane of focus to drift off the subject. Even a fractional shift in position is enough to render your subject completely out of focus. At small apertures you will probably find yourself using slow shutter speeds, too, so the potential for problems caused by movement are magnified. You can also see why hand-holding the camera is out of the question.

This is linked to the last two problems in that the necessity to use a small aperture will, unless the ambient light level is high, also force you to select a very slow shutter speed. If the subject is, say, a flower in the garden, even a gentle breeze may cause enough movement to produce blur. This problem is exacerbated if, in your quest for maximum image quality, you have chosen a slow speed film. Boosting the light level with the aid of flash brings problems of its own, not only in controlling the visual effect but also in calculating flash exposure when you are faced with the fourth problem ...

As we have already seen, once you start fitting supplementary accessories between the camera and the lens, you can no longer rely on your camera to do all the work for you. Not only will you lose the autofocus option (which is of little use in macro anyway), but the resulting loss of coupling between the lens and the body may, depending on the particular camera, cause the loss of your TTL metering, dedicated flash exposure and auto diaphragm linkage. This slows down the whole procedure of taking a photograph, which in many ways is no bad thing. It also means you may have to resort to a pencil and scrap of paper to work out what exposure you need to give.

Taking the first steps

So you have your camera loaded and ready to go, and you have your tripod and close-up accessory. You are keen to photograph something, but what? A good place to start is your own garden. Not only is this a handy location if you have to go back indoors for extra bits and pieces, but it is a safe environment where you can leave your camera and work in a methodical, unhurried manner, experimenting with different techniques. The natural light of the outdoors will also eliminate the added complication of having to introduce your own lighting – which you would probably have to do if you stayed in the house. Best of all, the average garden offers a potential feast of subject matter, from flowers, plants, bugs and insects, to wood, stone, metal and plastic.

Movement

Light level

Loss of camera functions

Insects become like characters from 1950s B-movies when placed under the scrutiny of a macro lens!

Choosing a subject

Macro photography allows us to isolate a single aspect of a subject and emphasize it. This could be its colour or texture, its shape or form. It could also be its beauty or sheer ugliness! Strong colours can be found not only in flowers but in the deep green of a leaf or the vivid red of a ladybird. They could be the artificial colours of man-made objects such as children's toys, ceramic pots, or your collection of garden gnomes. Textures can be found in the hairs on the wings of a butterfly, the aged wood of a fence post, the gnarled bark of a tree, the rusting metal of an old shovel, the peeling paint of the potting shed. Shapes? How about the concentric lines of a snail shell, or the graceful pose of a fuchsia? Perhaps it could be a shape made by the play of light and shadow cast by an ornament.

A dew-laden spider's web is photographed at an oblique angle to highlight its abstract quality.

Thinking about the composition

There are two basic choices in the composition of macro photographs. Do you crop in tightly, isolating the subject from the environment and emphasizing the quality which attracted you to it (its texture, for example)? Or do you step back slightly and show the subject in the context of its surroundings? There is no right or wrong choice – it is a purely subjective decision, but the course you choose will determine the techniques you need to apply.

Going in close magnifies the problems in depth of field and other areas, but the results can have more instant impact. On the other hand, the wider view presents a more natural result which is less alien to our normal field of vision. If

How many people would normally take the time to study the feathery and maze-like underside of a mushroom?

Butterflies and moths are classic macro subjects.

you decide upon this latter option you should also consider your choice of lens. Wideangle lenses, for example, can be extremely effective in showing off the subject in its surroundings. At close range, very wideangle lenses produce a strong, 'in-your-face' result in which the subject is disproportionally large and appears to be bursting out of the frame, while the entire garden and beyond stretches out to infinity in the background.

Another compositional choice facing you is whether to use the camera vertically ('portrait' format) or horizontally ('landscape' format). A tall flower may seem like an obvious case for a portrait picture but you may find that a landscape shot is more interesting, especially if you place the subject off-centre on one of the thirds and there are some good tones and colours in the background. Symmetrical subjects, such as butterflies and some plants and flowers, often look good when you abandon the rule of thirds altogether and place them in the dead centre of the frame. This emphasizes their symmetrical shape: if the picture was cut down the middle, one half would be a mirror image of the other.

As with any photographic subject, consider the contrast between colours within a composition, and frame it with as few distractions as possible in the background.

> When deciding on a viewpoint, study the subject first to decide on the most interesting angle. Move around the subject but also remember to look from above and below. If the subject is a flower, say, try to find a perfect example. Examine the aspect presented to you and if there are flaws, such as localized damage, blight or decay, choose an angle which hides it or find another example – unless of course the imperfection is visually interesting and enhances the subject's appearance.

The background

With macro, as in all photography, it is easy to get so absorbed in the subject that you do not notice the intrusive telegraph pole in the background. Do check carefully to ensure there is nothing in the background which would distract from the subject. This is especially important if you are showing the subject in the context of its environment. Look through the viewfinder with the depth-of-field preview activated to see what the picture would look like at the aperture you plan to use, since things which are blurred beyond recognition when viewing (which is usually performed with the lens wide open) may become sharp enough to annoy once the aperture is closed. With very wideangle lenses you will have a much larger area of background to police in this way.

If you are going in close, you still need to examine any areas of background that are visible in the picture. How do they look with the lens stopped down? If they are far enough away they will be just a blur, but consider the colour and tone of that blur. Would the subject look better against a light or dark

Close-up and Macro Photography

background? Look at the relative lighting on the subject and background. If the subject is in sunlight and the background in shadow, the latter will come out dark whatever its intrinsic tonal value. Very dark backgrounds rarely flatter, even with light subjects – they tend to look like cut-outs, pasted on.

While a completely dark background is usually inadvisable for macro subjects, in this case the strong sidelighting makes it a suitable option.

Bottom left: Sometimes even the shallow depth of field associated with close-up photography is not shallow enough, and the background becomes distracting

Bottom centre: There is a simple solution. Take an out-of-focus photograph of some green foliage, make a matt-surface enlargement and place it at a distance behind the subject (this will throw it out of focus even further). No one will ever be any the wiser.

Bottom right: Detail in the background should be carefully considered. In this example, the blurred flowers are successfully incorporated into the composition, as they suggest a profusion of flowers which continue beyond the confines of the frame.

Dark subjects on dark backgrounds? Well it doesn't sound promising, does it? (Though there are bound to be exceptions.) If the natural background is not suitable, it is easy to create your own with a sheet of coloured cardboard placed behind the subject (on a clamp or stand) just beyond the range of focus. You can use any colour you like, but if you want a natural-looking picture it is best to use a green or a light brown (the colours of flora) or blue (to simulate a blue sky). Beware, though, that unless they are used correctly, card backgrounds will look like exactly that. Keep them well out of focus, and if you can get some dappled light on them to break up their uniformity, all the better.

Supports and other aids

The use of a clamp, tripod, lighting stand or some other means of support has already been mentioned with regard to holding a card background but, like an ailing football team, the subject itself can often benefit from some additional support. With subjects like flowers and plants, which tend to wave gently in the wind, getting them to hold still for the duration of the exposure can be a frustrating experience. You can reduce the problem by using a stick, cane or rod as a splint, and bag ties or string to gently fix the stem of the subject to the support. Care should be taken to ensure that the subject is not damaged while doing this, and that the support does not appear in the shot. An alternative is to use a sheet or stiff board as a windshield, deflecting the breeze around the subject; you need to be careful that this does not cast a shadow (unless you want one – but that is another story). With either technique, you still need the wind to die down as much as possible before taking the picture, because these tricks are only an aid, not a cure.

The indoor option

If you would rather stay indoors – perhaps because it is raining outside – you can still take macro pictures. Indeed, many photographers prefer to do this for the control it gives them. There is no wind to worry about and, since it does not take up much space, you can leave a macro set-up in the corner of a room indefinitely and come back to it whenever you like. Subjects can be brought in from your own garden or elsewhere (though do think twice before picking wildflowers or removing wildlife from its home), or you can find plenty of objects in your home to photograph: houseplants, ornaments, fabrics, coins, food from the fridge, etc. Lighting can be a problem, since the illumination in your home is likely to be lower than that outside, but you can either shoot near a window or use artificial light.

LIGHTING AND EXPOSURE

As with all types of photography, the success or failure of a macro image can hinge on the lighting. Macro photographers have more options open to them in this regard than those in other specialisms. As always, there is natural daylight in all its forms. This can be modified as required by the use of reflectors or flash. If you decide on the latter, there is a further decision to make: on or off camera flash, ringflash or macroflash? And would you like diffusion with that, sir? Moving indoors, your horizons broaden further. You can still use natural light, either from a window or in a conservatory, and this can be supplemented with the same flash options. Alternatively, you can block out the daylight and just use flash. No flash gear? Tungsten lighting will do fine. If your subject is static, even an anglepoise lamp will do the job.

Outside

In the great outdoors daylight is the natural choice, but not just any old daylight. Direct sunlight is in most cases a poor choice because the hard shadows it casts make it generally unsuited to revealing the fine detail in tiny, delicate subjects. There are exceptions, though. Some subjects – translucent ones, for example – may be enhanced by being photographed *contre-jour*. This would make colours sing out and reveal delicate internal structures. Opaque subjects can be revealed in silhouette or with rim-lit edges.

On the whole, though, hazy, diffused light is best. This type of illumination is of lower contrast, so highlights will be less burnt out and darker areas will still carry detail. In diffused sunshine, when the sun is behind clouds, the light still

You need to decide whether to shoot in natural light, or with flash. In this comparison, the naturally lit flowers (below left) are revealed in more detail than the flash-lit version (below right). Although the colours in the flash-lit image are more saturated, the flash has cast harsh shadows – similar to those that would be cast by harsh sunlight.

Even flash lighting in this example has created the surreal impression that the flower is suspended in mid-air.

The even, diffused light of an overcast day is perfect for photographing macro subjects, both indoors and out. has some directional quality, so you get attractive soft shadows. On sunless, grey days the light tends to be rather flat and virtually shadowless, but colour saturation can be quite intense, especially after rain.

If the natural light is not quite right for your needs – perhaps it is too directional or too flat – it can easily be modified to your requirements by the use of a few simple accessories. One of the most useful of these is a pocket reflector. This may be one of the elaborate folding fabric types or a simple sheet of card. A reflector can perform several useful functions. On a bright, sunny day it can fill in areas of shadow, reducing image contrast, or it can be used to light the front of backlit subjects. It can also be used as a shield to screen the subject from direct sunlight. On a dull day it can be placed near the subject and used to provide some direction to the lighting. Reflectors come in different surfaces – usually white, silver or gold – to produce different effects. A piece of translucent fabric such as muslin can perform a similar light-softening function in bright light, by allowing sunlight to filter through it. Another, more radical option is to carry a small mirror or piece of silver foil to introduce a hard, targeted highlight to a specific area. You can, of course, also use fill-in flash instead of a reflector.

Indoors

Creating an indoor macro studio is relatively simple, and provides more lighting versatility than outdoor photographers are accustomed to. If you set up in a conservatory you may find the ambient light almost as bright as it is outside, and

by selectively closing certain blinds or curtains or pinning up a white sheet the light can be modified to your needs. If you do not have a conservatory, a large window can be useful, though this will be less bright and, since the light is coming from only one direction, you will have to turn the subject to control the way the light falls on it. Again, this light can be diffused with a bed sheet.

An alternative to daylight is tungsten light. Your ceiling light is not a good option here because you cannot move or control it easily, but an anglepoise type of lamp is fine. The main drawbacks are that this light is not very bright, and the colour is very orange, but these problems can both be cured quite easily. If you are using print film the cast can be corrected at the printing stage. With slide film you can either use a blue 80A filter over the lens or switch to a tungstenbalanced film. If you use tungsten lighting, you should make sure you block out all daylight otherwise your subject will be lit by both types of light. This will make it impossible to achieve neutral colour, since correcting for one cast will make the other worse. Getting the right amount of brightness is less of a problem indoors since you can use very long exposures (minutes, if necessary) without worrying about the wind blowing your subject and causing it to move.

Domestic tungsten lighting is usually quite harsh, because most types consist of a bare bulb in a metal reflector. This will be less noticeable with tiny subjects, but if you wish, the harshness can be diluted either by using several lights (to build up the brightness level in the shadow areas) or by shining the light through a sheet of white cloth, tracing paper, bubble wrap or any other diffusing material.

Another drawback of tungsten light is the heat it generates. If the light is too close to the subject, or left on for too long, the heat may wither or even burn it. It is also crucial to avoid placing any diffusers too close to the light source, because if they get hot they will become a fire hazard.

If you become serious about indoor macro photography, and wish to use artificial light, you can buy tungsten-balanced studio lights, which are brighter than ordinary domestic lights and can be modified with a range of accessories. Alternatively, you could use flash ...

Using flash in macro photography

As artificial light goes, flash is by far and away the most versatile. You can use it indoors or out, move it to any position you like, modify it by a surprising degree, and since it runs on batteries, you do not need to be near a power source. At close range, even relatively small flashguns are large in comparison with the subject, so cumbersome diffusion devices are less essential. The main drawback is that you cannot see the effect flash produces until you get the film processed, so you will have to rely on experience to visualize it. In fact, it is best to find a set-up which works for you, perform a few tests, then stay with it.

Flash on camera

Off-camera flash

A macroflash set-up

A macroflash unit – although appearing slightly cumbersome – is a versatile and portable way to light your macro subjects. A standard hot-shoe-mounted flashgun is not ideal for macro work. At close range, the angle between the flash tube (several inches above the top of the camera) and the subject is quite steep. Unless you can angle the flash downwards, most of the light will miss the subject anyway, and that which does reach the subject may produce long shadows underneath. A built-in flash is even less useful. A long lens (or extended lens) is liable to cast a shadow over the subject so none of the flash will reach it. There are several alternative options.

By using a suitable cord you can take the flash off the hot-shoe and attach it to a bracket or stand. This will allow you to position it wherever you like – perhaps closer to the lens axis or looking down on the subject from above, to simulate light from the sky. Diffusers and reflectors can, if desired, be used to modify the flash. The main drawback of off-camera flash is the cost of the cords, especially for dedicated units. The alternative is to use a PC cord instead, but you will lose your TTL flash metering. If your flash and camera do not have the necessary connections you can buy inexpensive adapters.

A macroflash is a purpose-designed unit composed of two flash tubes, one on either side of the lens. Some are physically attached to the lens, others are supported on adjustable stalks or brackets like antennae. With some models you can control each flash independently, adjusting the output of each or even switching one of them off if required. With fixed-output, manual models you

can control the ratio between the tubes by fitting a neutral density filter over one of the heads. There are several models of macroflash on the market but you may find it worthwhile, financially, to make your own. This can be done quite easily. The advantage of macroflash is that it produces relatively even lighting which still has some direction and modelling. It can also be adjusted to suit your tastes and the subject. Because it is attached to the camera, a macroflash rig is easily portable.

These are discussed in greater detail in the section on flash (page 110). They are basically doughnut-shaped flashtubes which fit around the lens. They are similar in appearance to some macroflash units but, because the tube wraps all the way around the lens, the light they produce is virtually shadowless. Many macro photographers find ringflash too flat for their taste and prefer the greater control and more natural modelling of a macroflash.

For indoor macro photographers who already own studio flash equipment this is an option, but it is not worth buying specially. Because studio flash units tend to be quite large, their illumination is always likely to be fairly uniform when used on tiny subjects, and even with a dish reflector fitted. Ringflash

Studio flash

A ringflash is a circular flash tube which wraps around the camera's lens, producing a completely even light.

Calculating exposure

Ambient light

Thankfully, most modern cameras offer TTL metering and this is retained with many supplementary accessories. The only thing to be aware of is particularly light or dark subjects and backgrounds fooling the meter reading, and for this some adjustment should be made. If you do not have the benefit of TTL metering, you will need to take a separate hand-held reading from the subject and then adjust this exposure to allow for the greater magnification. Luckily there is a simple formula to calculate the required compensation:

At half life size add one extra stop over the meter, at life size add two stops, and so forth.

You can make this adjustment by opening the aperture, but it is usually better to reduce the shutter speed so you retain your depth of field.

Flash exposure

This is more tricky. With TTL flash you should have few problems, but you may find your TTL system less accurate at close range. Perform some tests to find out. In any event, you will still need to compensate for unduly bright or dark areas in the picture. When dedication is lost, you will need to shoot a test roll of film to determine the required aperture. There are a few points to bear in mind when performing these tests.

First, remember that the decrease in light is quite rapid at close range. Every doubling of flash distance causes a light loss of two stops, and at macro distances this may be just a few inches. Because of this fall-off, you may find that the flash produces an unnaturally dark background. This can be cured to a great extent by positioning the

flash much further from the subject so that fall-off is less pronounced. The resulting increase in contrast by moving the light further away (it now appears smaller from the subject's position) can be offset by diffusion. You will, however, need a more powerful flash if you want to use it further away. An alternative solution to the fall-off problem is to try to balance the flash with the ambient exposure so that the fall-off is less visible (see 'Non-dedicated fill-in flash', page 118).

Remember also that whatever exposure setting you arrive at will apply only at a specific magnification range. Adding extra extension tubes or other lens extensions will cut out more light and necessitate further testing.

Chapter Seven

GOING DIGITAL

Unless you've been living somewhere very remote for the last decade you can't fail to have heard about digital imaging. In the last few years it has become the fastest growing area of photography, with new products being launched almost weekly. It has introduced the joy of creative picture-making to a new generation of people and rekindled the flame in many lapsed photographers. Within conventional photography circles, however, opinions have polarised, with traditionalists fearing the end of film and chemicals and the sense of craftsmanship that they currently enjoy from photography.

In reality, traditional film-based photography is likely to be around for generations to come. There are millions of cameras in use and film is still the cheapest means of recording an image. In fact, the two technologies work very well in tandem with one another, and you can happily practise digital imaging using your existing 35mm camera.

WHAT IS DIGITAL IMAGING?

Previous page: Pictures stored in a digital camera can be downloaded straight into a computer and viewed on screen.

Pixels are the 'building blocks' of a digital image, in the same way that silver halide crystals form the basis of a conventional photograph. When you make a big enlargement of a digital image, as here on screen, you can see the pixels. Traditional photography and digital imaging share more similarities than you may imagine. With the former, images are formed by millions of tiny, lightsensitive, silver halide crystals which darken in proportion to the intensity of light falling on them. In digital imaging these crystals are replaced by microscopically small light-sensitive dots or 'pixels' (an acronym made from the words PICture and ELement), each of which produces an electric current in proportion to the light falling on it. In photography, an exposed film must be processed in chemicals in order for you to see the images on it. In digital imaging it must be 'processed' by appropriate software which translates these electrical signals into a recognizable image.

Like traditional photography, the final stage in the cycle is the output stage, where the image is printed on to paper – though in digital imaging there are other alternatives.

At the heart of the digital-imaging universe lies the computer. It is the control centre into which most or all of your other digital appliances are connected, and almost all digital data passes through it at some stage of its life. Although some printers allow for the direct connection of a digital camera, thus bypassing the computer stage, in practice you'll almost always need to 'tidy up' your digital pictures (adjust brightness, contrast, colour, cropping and so on) before printing them.

So to get the best out of digital imaging, it is important to understand a little bit about computers, how they work and how they process images.

Going Digital

Software programs used for image processing and manipulation offer a wide range of functions. These are made available via menus which are displayed on screen. While very complex tasks can be performed, you can also do something as simple as brightening a picture, or increasing or decreasing its contrast, as shown here.

The computer

Computers can perform incredibly sophisticated tasks but, perhaps surprisingly, they can only count in base two – the binary series of ones and zeros you may remember from school maths lessons. They cannot think or understand in any real way, their task is to store, manage and produce information, or 'data'. This data is read by the computer as binary code. The smallest possible unit of data is called a 'bit'. By switching a bit on or off (1 or 0 in binary), it can be made to communicate two possible instructions – perhaps 'yes' or 'no'. Two bits together can signal four different instructions (11, 00, 10, 01). Eight bits, known as one 'byte', can produce 256 permutations. A computer which designates eight bits to process each instruction given to it can therefore do any of 256 different things at once. That's enough for all the characters on a keyboard, for example, but there are more than 256 possible colours and shades in a photograph – there are millions. That's why most modern computers, which are designed to handle data-hungry items such as sound and pictures, use at least 24 bits for each instruction. This provides 16.7 million possible permutations.

If eight bits equals one byte, one million bytes makes one megabyte. This sounds like a lot, but when you consider that the computer will use three bytes (24 bits) to describe a single pixel in a photograph, you can see that a one-megabyte image isn't very big.

Bits, bytes and megabytes

Hard disks, RAM and the desktop If your computer is a 'virtual office', then the hard disk is the filing cabinet. It's where your computer stores all the data entrusted to it. This includes its own built-in software, other software applications which you have installed on it, and any files, letters, pictures or other documents that you have created.

In the real office, you can't read or work on documents when they're still in the filing cabinet, you take them out and put them on your desk. On computers the screen layout is also called a desktop, because it displays your open documents and anything else you need quick access to. While documents are open on the desktop, any changes that you make to them (adding text or cropping a picture, for example) are stored in RAM (Random Access Memory). RAM remembers what you're doing while you're doing it, but, like our own memory, its only temporary. When the computer is switched off the RAM is wiped clean, so you must save your changes to the hard disk beforehand or lose what you have done.

The microprocessor or 'chip' is the part which processes and carries out the instructions you give it. It's the computer's engine. Like a car engine, the more powerful the computer's processor, the faster it will run. High-resolution photographs make many demands on your PC. Imagine the simple task of rotating a one-million pixel photo 5° clockwise. The processor has to map the position of every pixel, then calculate the new co-ordinates for each one so that everything ends up in the right place. That's a lot of calculating. Processor speed

Your workplace when you use a computer is called the desktop. The computer also contains a filing system which stores your work files and software programs. When you open folders, programs or files to view or use them, their contents are displayed on the desktop in windows. You can have a number of windows open at once, which is helpful when sorting or selecting images, for instance.

The microprocessor (CPU)

Going Digital

Choosing a computer

If you don't yet have a computer, you're at some advantage over those who do, because you'll be able to buy the latest-specification model. Buying a computer is in many ways one of the most depressing purchases you can make because you know your new toy will be out of date within weeks. Fortunately, most computers are upgradeable so you can slow down their obsolescence by buying extra memory and other bits as you can afford them. As each successive generation of PC comes with a faster processor and more memory it's difficult to say specifically what standard of specification you need for digital imaging – the goalposts are continually shifting. Nevertheless, here's a broad guide to what to look for:

The processor (CPU)

Buying the fastest chip you can afford will speed up the whole imaging process and cut down on the time you'll spend staring at the egg-timer or watch-face icon on your screen while the CPU tries to keep up.

RAM

The obvious comment here is to get as much RAM as you can afford, but more important, choose a machine where the RAM can be expanded at a later date. A machine with 64 Mb of RAM which can be expanded to 500 Mb would be a better buy than one with 128 Mb of RAM which can't be expanded.

Hard disk

It makes sense to get as large a hard disk as you can from the outset, but don't worry if you do find yourself running out of disk space – you can add an external hard disk or a removable storage drive (e.g. Zip) to ease the problem.

CD-ROM

Photo CD is a cheap and easy way to get your photos on to the computer. Make sure that a reasonably fast CD-ROM drive is included.

CD writer

In the same way that a tape recorder is needed to record on to magnetic tape, a CD writer archives data and pictures on to a CD-ROM.

The monitor

When you're working with pictures, the bigger the screen the better. The tools and palettes of an imaging application like Photoshop take up a lot of space before you even open the image. The smaller your working area the smaller you'll have to keep the image in order to see it all. When you enlarge it to work on a section you'll find yourself continually scrolling around the image. Aim for at least a 17 inch model. Trinitron-type monitors are brighter, crisper and higher in contrast than other types and curve only in one direction.

Mac or PC

Windows-based PCs dominate the computer market as a whole, but Macs are still the computer of choice in the graphics, publishing and design industries and many photographers also prefer them. If your computer will be used for other things, such as games, education and business, or will be used by other members of the family, a PC may be the best option. If, on the other hand, your computer will be used almost entirely for serious imaging work you may find the Mac more suitable, especially if you'll be dealing with the creative industry.

PCs have adapted to audio-visual uses. They are often sold bundled with a scanner, printer and even a digital camera, as well as software.

This Apple Macintosh is connected to a 17 inch screen. For picture manipulation, a screen of this size (or larger) gives you a bigger image area to view, which is handy when you're working on detail. is measured in megahertz (MHz), with one megahertz being equal to one million instructions per second. The latest computers boast processors with speeds well in excess of 750 MHz.

This software controls the appearance and functionality of your computer interface and allows you to communicate with it. It translates your commands into language which can be understood by the processor. When you buy software it must be compatible with the operating system you are using. Almost all domestic multimedia computers use a graphical-type interface based on the use of windows, icons and drop-down menus – all controlled by a 'mouse'. There are two main operating systems: by Apple, who first introduced the interface on their Macintosh computers; and by Microsoft, whose Windows software dominates the market.

The digital image

In the same way that fine grain produces better quality photographs, so fine pixels and bit depth create sharper, more detailed digital images. By measuring the dimensions of a picture by its pixel count we can gauge not only its shape but its size and, therefore, quality. A picture which measures 300 pixels by 200 pixels, for example, contains 60,000 pixels altogether. One measuring 600 x 400 would contain 240,000 – four times larger. If both images were shown at the same physical size, the 600 x 400 pixel image would appear significantly sharper because its pixels would be more densely packed within the space. It could therefore be said to have a higher resolution.

The physical dimensions of a digital image depend on the size at which these pixels are displayed. A computer monitor shows images at a resolution of 72 dots per inch. The 300 x 200 dpi image would therefore be just over three inches wide and a touch under two inches high when shown at full size. When reduced to the 300 dpi minimum needed to produce photo quality prints, this file would shrink even further to one inch by two-thirds of an inch – ideal for postage stamps, but little else.

The size of a digital file is more usually measured in terms of the number of megabytes it contains. This can be easily calculated by multiplying the total number of pixels by the number of bytes the computer chip allocates to describe each of them. (With a 24-bit image, as most are, this will be three bytes, since eight bits make a byte.) A 1000 x 800 pixel image, therefore, would be 2.4 million bytes, i.e. 2.4 megabytes. To make photo-quality A4 prints, however, your digital image files need to be in excess of 20 Mb.

When an image is captured or recorded digitally the data must be stored in a particular way so that it can be read easily. Its method of storage is known as its file format. There are numerous file formats, each recording essentially the same

Operating system

Pixels, resolution and image size

File formats

data but using a different set of codes to do so – in much the same way that people from different countries may record the same story using different languages. Not all software programs can read or understand every file format, and this can be a source of problems when an image saved in one format is passed on to someone using software which doesn't recognize that format. Serious image-editing programs such as Adobe Photoshop can work with most of the major formats, but even so it is best to stick to the more common formats, especially if you want to share files with others. If your circle of friends and family includes both Mac and PC owners, use one of the handful of 'cross-platform' file formats such as TIFF. Other popular file formats include PICT, BMP, EPS, PCD, JPEG, GIF and PNG, outgrowing GIF.

Digital image files take up a lot of space on your hard disk – much more so than most other types of file. And the higher the resolution, the more space they need. This fact has many implications, not only for storage but also when it comes to copying them from one place to another, or transmitting them down a telephone line. And if you're not the patient type you'll be frustrated by the length of time the computer takes to perform every task. The only real cure for this last problem is to get a computer with as fast a processor as you can afford, but there is a simpler answer to the problem of the storage and transmission of files – compression.

Some file formats will shrink the size of an image file to speed up the transfer of its data, say, along a phone line, and allow more files to be stored in a smaller space. The most commonly used of these is the cross-platform JPEG file format. It works in a relatively simple way. Instead of recording the value of every individual pixel, it compares each pixel to the one next to it and says, for example: 'the next 500 pixels are more or less the same colour and tone as this one.' Where you have uniform blocks of colour, a JPEG file just needs to remember which pixels share that colour and where the borders of that colour lie, so that it can give each pixel the correct value when you reopen the picture file.

The big drawback is that the format throws away all the individual data to make this space saving, so some of the subtle changes in hue and tone (produced by the lighting, for example) are lost. This type of compression, where information is permanently lost, is known as 'lossy' compression. Some formats use 'lossless' compression, in which no data is lost, though these are generally less effective at saving space and memory. TIFF has inbuilt lossless compression.

When saving an image as a JPEG file you are given a choice of how much compression you want and, therefore, how much information you want to throw away. Moderate compression is barely noticeable to the eye but the more you compress, the more the quality will deteriorate. You should also avoid repeatedly resaving in this format, since every time you do so more data is lost. And when you open a JPEG file on the computer to work on it, it is best to convert it to another format such as TIFF first.

File size and compression

SHOOTING WITH DIGITAL CAMERAS

Ð

Most consumer digital cameras work in very similar ways to 35mm compacts – you just point and shoot. However, many have the added advantage of allowing you to view an image on a small LCD screen on the rear of the camera, so you can decide whether to keep or delete an image immediately.

makes sense, all other things being equal, to shoot them digitally in the first place? Perhaps, but all things are not equal, and there are many reasons why a digital camera may not be the preferred choice. By no means the least of these is the fact that, pound for pound, they're much more expensive than the film-based alternative. The main reason for this is the level of sophistication of the technology involved in producing digital cameras, and nowhere is this more amply demonstrated than at the heart of the digital camera – the CCD.

The very term 'digital image'

implies the use of a digital

camera. Although you can easily

conventional cameras, surely it

on

digitize images taken

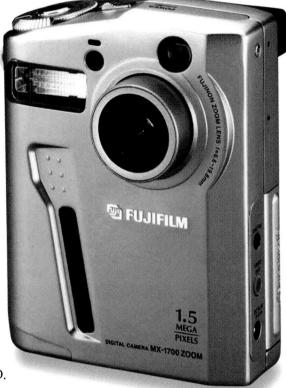

The CCD is what digital cameras use instead of film. It is basically a grid composed of microscopically small light-sensitive cells – similar to the one in your exposure meter but with perhaps over a million of them in an area little bigger than the average thumbnail. When light reaches the CCD, each sensor or 'pixel' produces an electrical signal proportional to the intensity of light it receives. From this grid of pixels an image is built up. It follows that the more pixels that can be crammed on to a CCD chip, the finer the detail will be, but the challenge faced by digital camera manufacturers is in trying to produce CCDs with enough pixels to match the quality of film. A typical 35mm negative contains tens of millions of grains of silver, while the latest digital cameras have just reached the three million pixel mark – and these models currently cost several thousand pounds. There are a few reasons for these high prices, including the cost of the technology involved in making something so precise and yet so small, and the rejection rate resulting from such high manufacturing tolerances (if, for example, any of the pixels in a CCD fail to work).

While the quality of digital images is not yet equal to film, there are limits to how much detail the eye can see, especially at the relatively small sizes at which pictures are viewed. So the quality difference between the two systems is less marked than it may at first appear.

The CCD

Most digital cameras employ styling borrowed from 35mm compact cameras. The size of the CCD chips used in these cameras varies dramatically and this is reflected in the price. At the bottom end of the spectrum are cameras with

Chip sizes

CCDs containing around 240,000 pixels, the socalled VGA models. Cameras with CCDs containing more than a million pixels are called 'megapixel' cameras. Some of the top-of-the range models are essentially 35mm SLRs with CCDs built into them. However, since even a three megapixel chip is quite a bit smaller than a 35mm negative, the effective focal lengths of the lenses change and become more telephoto. Extreme wideangle lenses must therefore be used to get even a moderate wideangle perspective with these digital SLRs.

With larger format digital cameras the cost of producing a CCD large enough to cover the

image area would be prohibitively expensive, so these cameras employ a single row (or several rows) of pixels and move them across the film plane, line by line. Obviously these cameras are only suitable for static subjects. These scanning CCDs are often housed in special backs which are attached to the camera.

Once you've taken a digital photo, your camera has to put it somewhere. The trouble with digital image files is that they take up a lot of storage space. Most cameras allow pictures to be taken at a choice of resolutions (high, medium and low quality) and at the high setting there may be room on the camera's builtin storage disk to hold only half a dozen images – hardly ideal for a day's shooting. An alternative is to shoot at a lower resolution but there are obvious quality disadvantages. That's why most of the better cameras on the market save the pictures on to a card which can be removed and replaced with a fresh one when it is full up – just like film. The big difference compared with film, though, is the cost of the cards! However, since you can preview pictures immediately and delete the ones you don't want, you only need to save the good ones, unlike film. There are two main types of storage card: CompactFlash and SmartMedia. They're not compatible so once you choose one of these systems you are tied to it.

One of the major advantages that digital cameras have over film cameras is their ability to give an instant preview of the picture you have just taken. If it is good you can keep it. If not you can delete it and perhaps reshoot it. In order to be able to do this in-camera, without recourse to a PC, the camera must have an LCD display on the back. Most manufacturers now recognize the importance of this feature and screens are usually provided. In most cases you can also use this screen to compose and shoot with (it is a good way to shoot candid photos, for example) though your battery consumption will suffer if you do. Some cameras provide an optical viewfinder as a more battery-friendly means of taking pictures, along with the LCD.

Professional digital cameras resemble conventional 35mm SLRs, and are fast becoming as versatile – though they are more expensive.

Storage

Viewing

Uses of digital cameras

As well as being novelty toys for technology lovers, digital cameras have many serious applications. In commerce, the civil service, the media and various other sectors they have elbowed film-based cameras on to the sidelines.

Newspapers were among the first to adopt them, especially for sports coverage. When there's an evening football match and the pictures need to be back at the picture desk before 10 p.m., a digital camera has obvious appeal. Pictures can quickly be scanned on to a laptop computer and transmitted via modem back to the office just minutes after they're taken. Important press conferences and events are now widely covered by press photographers with digital SLR cameras and many in the industry predict the demise of film cameras for press photography in the long term. Some new models of digital press cameras even have a mobile phone card built in for connecting directly to the office.

Photographers in other fields are using them, too. Mail-order catalogues are increasingly being shot digitally because of the high volume of relatively small pictures needed. The saving on film costs can be in five figures.

The civil service, hospitals, social services, police forces and the military now use digital cameras. Even the low-resolution models have many uses. Quality is a relative term, and the cheapest digital cameras can produce reasonable prints at two or three inches across. For many business users that's as large a picture as they need for record shots for files or as a sales tool. Estate agencies and secondhand car magazines are two other users of low-resolution cameras. Some companies use small digital images in their stock catalogues.

Pictures that are only intended for use on the computer screen, rather than as prints, do not need to be of high quality, because PC monitors contain only 72 dots per inch. Even modest digital cameras exceed that. So digital images are fine for illustrating web pages, for example.

News photography is rapidly being taken over by digital imaging. Pictures from anywhere in the world can be sent to a newspaper's picture desk within minutes of having been shot.

INPUT

The first step in the digital-imaging cycle is to get your chosen image on to the computer so you can start working on it. Good old-fashioned film is overwhelmingly the most popular source of images for manipulation among photographers and enthusiasts and is likely to remain so for some time. This is not only for reasons of quality, though that is an important consideration. It's also because there are several billion prints and negatives already in existence, so there will always be a need for a device which enables them to be transferred on to the computer. The device in question is called a scanner. Scanners convert prints, slides or negatives into digital data. They vary dramatically in price depending, to a large extent, on the resolution (number of pixels per square inch) they are capable of resolving. The functions of the scanner are controlled by the computer, using software supplied with the scanner. Typically this allows you to preview the image being scanned, crop out unwanted areas, set the scan size and resolution you require and perform basic enhancements before clicking on the 'scan' button. There are two main types of scanner.

A flatbed scanner scans prints and other hard copy from light reflected off their surfaces, which is recorded as digital data. Some scanners can also scan transparencies, but you may need to buy an adapter for this job. To scan a transparency, a scanner needs to read light passing through the transparency, not reflecting off its surface.

(C)

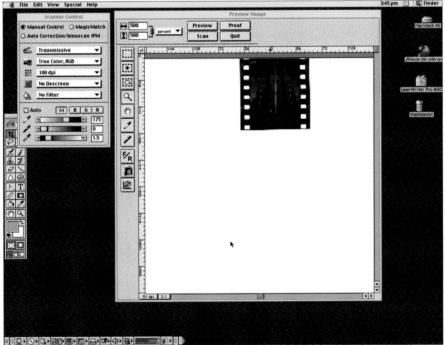

This type of scanner works in a similar way to a photocopier, but instead of outputting on to plain paper it converts the image to pixels and writes the data on your computer's hard disk. To use it you simply lay your photograph or artwork face down on the glass plate, and close the lid.

The flatbed scanner contains an optical lens which focuses light bounced from the image on to a strip of CCDs. This strip moves along the length of the Film scanners

If you intend to scan only 35mm negatives and slides, it would be best to invest in a special film scanner.

Film or flatbed

Resolution

image, converting the image to pixels. The resolution is quoted in two dimensions: the number of elements per inch, and the number of steps per inch made by the CCD strip as it moves across the print (e.g. 600 x 1200 dpi).

Flatbed scanners are the most versatile of the two main types – as well as photographs up to A4 size, you can also scan artwork and text documents and, with some models, transparencies as well (via an accessory hood attachment). With smaller film formats, such as 35mm, flatbed scanners do not offer good enough quality for serious work, and you'd be better off buying a film scanner.

For scanning 35mm slides and negatives a dedicated film scanner is the best option. These are smaller than flatbeds and generally more expensive. Because

scans of negatives will be enlarged significantly, they need to be of much higher resolution than print scans – hence the extra cost. Some 35mm film scanners can also scan APS film with the relevant adapters. They're bad news if you're a medium format user, though. Scanners for 120 roll film are currently much more expensive than 35mm models, often costing thousands of pounds.

Choosing a scanner

Ideally you would have both types of scanner, but realistically you'll have to choose between them. If you shoot mostly 35mm slides, a film scanner is the obvious choice. Print film users and medium and large format camera owners may be better off with the more versatile flatbed, space permitting.

Measured in dots per inch, the higher this figure is the better. Basic flatbed models start at around 300 dpi, but you should try to aim for at least a 1200 dpi model. Because negatives must be enlarged significantly, film scanners should be at least 2000 dpi. These figures relate to the *actual* resolutions. Some scanners bump up this figure by 'interpolation', where they guess at the information contained between each pixel and add a few of their own to bump up the figure. The quality of interpolated resolutions is never as good as genuine ones. Note that, although the pixel count is an important gauge of the sharpness of your scans, other factors are almost equally important. The scanner's lens and optical system will have a tremendous effect on the detail it can resolve, and the influence of the software can be almost as great as the straight pixel resolution.

Going Digital

This refers to the number of binary digits or 'bits' used to represent the CH colour and tone of each pixel. The higher the bit depth the greater the range of colours and tones the scanner will be able to resolve.

Few basic scanners are able to record the full density range of high-contrast slide films such as Fuji Velvia. The result is usually a loss of highlight and/or shadow detail. Study the specs to compare different models if this is important for you.

The time taken to scan an image varies with different models. If you're not the patient type choose a faster one to avoid having to wait for your scans.

There are several types of connection for computer peripherals, including SCSI ('scuzzy'), parallel and USB. Make sure that the scanner you're considering can be connected to your computer.

Other sources of pictures

The web

There are millions of pictures on the internet which you can download at the click of a mouse. Many are low-resolution images which could not be printed much beyond postage-stamp size without a severe drop in quality. Some of the millions of high-resolution images can only be downloaded by paying a fee or entering a password. There are, however, plenty of free, accessible pictures on the web to play with. Do note, however, that it is illegal to print or distribute them without the permission of the copyright holder (usually the photographer). If you wish to download and use pictures for anything other than your own amusement stick to what are generally called royalty/copyright-free, freeware or shareware (where you pay a nominal fee to the owner) photos. If you're looking for specific photos you can perform a search. Some search engines, such as Lycos, allow you to search just for photographs.

CD

The CD-ROM has become ubiquitous in recent years. They're stuck to the covers of magazines on newsagents' shelves, given away as promotions, sold in computer, music and games retailers, and so on. Most of the cover-mounted 'freebies' and plenty of bargain-basement CDs are samplers which contain a selection of treats for your PC or Mac, including pictures. You can also obtain special royalty-free photo CDs to use as you wish. These range in price from nothing to hundreds of pounds, depending on the pictures included. Don't forget that you can have your own photos saved on to a CD either at the time you get them processed or retrospectively. This costs from just a few pence per image.

Digital cameras

If you have a digital camera – or access to one – you can easily transfer pictures taken on it to your computer. There are two ways to achieve this. Most modern digital cameras come with removable memory cards, such as SmartMedia or CompactFlash, on to which pictures are recorded. With the relevant card reader attached to your computer, transferring images is simply a matter of removing a card from the camera, inserting it into the reader then copying the image(s) to your hard disk. If you don't have this option, the camera can be connected directly to your computer using a cable and the computer can then 'acquire' the images from the camera direct.

Bit depth

Density range

Scanning speed

Connections

SOFTWARE FOR IMAGE EDITING

You've scanned a photo on to your computer, so what now? Well, nothing if you don't have any image-editing software. If you bought your computer relatively recently it may well have been 'bundled' with a selection of software packages including a simple imaging one. Basic or out-of-date image-editing software is also often given away on cover-mounted CDs. Don't dismiss these out of hand – even the most rudimentary application can perform most of the basic adjustments and corrections you are likely to want to make to your pictures.

Types of software

If you're planning to buy some image-editing software, the first thing you should know is that they fall into two main categories, which you could call friendly and advanced. The friendly applications are aimed at those people who don't know a huge amount about digital manipulation. They want to have fun with their photos but don't want to face a steep learning curve first. These applications feature a user-friendly interface which typically offers you a selection of available tasks in the form of icons. When you select one of these the software then guides you, step by step, through the various stages and options until you have completed your task. These programs often come with lots of templates to make greetings cards and so forth, and emphasize the fun side of playing with your

Adobe Photodeluxe – an image manipulation program – is a junior version of Adobe Photoshop, with a simpler interface which instructs you as you work. pictures. Examples include Adobe PhotoDeluxe, MGI PhotoSuite, Microsoft PictureIt and Kai's Photo Soap.

If you intend to take up digital imaging in a serious way, you may not want a software program which holds your hand and explains things simply. You may prefer a more business-like interface with lots of tools and palettes and no clue at all about how to use them. You want to remove a dust spot from your image? There's no button marked 'Remove blemishes' - you have to work it out for yourself or read the instructions. You'll have to learn the technical jargon, too. What these programs lack in friendliness, though, they make up for in sophistication. Your tools can be adjusted for size, shape, edge sharpness and opacity; colour corrections can be made just in the highlights or shadows, or anywhere in between; you can measure the colour and density of a single pixel. These programs offer a fine degree of control over what you're doing, rather than delegating responsibility to the computer. In this respect they can be compared to using the manual exposure mode on your camera. The leading software, used by the majority of professional photographers and designers, is Adobe Photoshop, but others include Live Picture and Xres. These professional programs cost several hundred pounds but there are cheaper alternatives with a similar ethos: PaintShop Pro, Corel PhotoPaint, Picture Publisher and PhotoImpact spring to mind.

In addition to these mainstream programs there are also a selection of more esoteric programs which are designed for specific 'fun' effects.

Some of the things you can do with software

Not all software applications can do all of the things listed here, but all can do some of them. Some of these tasks are fairly specialized and the software to do it doesn't strictly count as image editing, but it all comes under the photographic software umbrella.

One of the main features common to almost all software is the ability to make basic adjustments to the colour, brightness and contrast of your picture. This is most often achieved using sliding controls. With some software you can enter an actual value, e.g. (+10 Yellow). As well as correcting or improving the colour of your original you can, if you wish, remove all the colour from your picture to make a black and white one, or turn it sepia.

You can take the proverbial scissors to your picture by chopping off unwanted areas around the edges. Most people naturally shoot from too far away, and this is the cure. If your horizons are sloping, or if you'd like to add a more dynamic twist to that portrait, you can do this by rotating your image within its borders.

Adjust brightness, contrast and colour

Crop and rotate

Resize

Remove blemishes

Numerous filters are at your fingertips when enhancing or manipulating an image. If you choose the 'dust and scratches' option, any marks which resemble the program's interpretation of dust are 'filled in' by pixels copied from those around the dusty area. You want an 8 x 10 inch of that enprint to put on the wall? No problem. As long as you scan at a high enough resolution you can blow up even small sections of your images. If you want prints bigger than your printer can make (usually A4 is the maximum) you can save the picture files to a disk and take them to a commercial bureau.

Hair and dust on your pictures can be removed quite easily on the computer, as can spots and pimples on your subjects' faces. With the guided software there's often a button specially for this, otherwise the task is usually achieved using the clone tool, which copies pixels from areas adjacent to the area you wish to cover.

Add or remove unwanted people and objects

Create border effects

Is there a telegraph pole growing out of your subject's head? Or an embarrassing ex-partner in your photos? These and more can be removed in the same way that you'd remove dust and hairs, except on a larger scale. If the unwanted area is large it may be difficult to cover using the clone tool alone. If you prefer, you could cover it by pasting something from another image over the top of it. Alternatively, you could cut out your main subject and paste it on to an entirely different background. It takes skill and practice to make this sort of thing look natural, though.

Presentation is important and digital imaging software can help, especially when it comes to borders. Whether you want a narrow or wide border, white, black, coloured or patterned, it can be easily achieved. How about creating a key line around the image, or perhaps vignette the edges? You can create the impression of liquid emulsion by adding brush-stroke style edges, or scan and add the film perforations for a contemporary look.

Dozens of 'filters' are provided with most software and you can add others later in some programs. The most useful of these is the sharpening filter for making your image that bit crisper. Alternatively, you can go the other way and create a soft-focus effect. How about adding a grain effect, or mosaic tiling, posterisation or paint-brush strokes?

(an

P. N

1. 1

Use filter effects

You can alter perspective by stretching, squashing or twisting your image. Other possible distortions include a concentric ripple, a bulbous look and a pinching effect. You can also remove some distortion such as that caused by converging verticals. Some software allows you to create caricatures from people's faces and one program, Kai's Goo, is designed specifically for this purpose.

Distort

By choosing the 'perspective' option, you can create an impression of exaggerated converging verticals.

Going Digital

Create montages from several originals

One of the benefits of digital imaging is its ability to combine elements from as many different images as you like into one single montage. This is achieved simply by cutting out each required element and 'pasting' it into your main shot where it can be resized and positioned as required. Many digital artists do this routinely.

A montage can be as simple or as complex as you want it to be. It might involve placing a cut-out of one image over another (and they don't even both have to be photographs), or it could entail the amalgamation of several pictures. The joins between the pictures can be as crude or as seamless as you like, too!

Add text, graphics and clip art

Restore old photographs

- T)

1

Publish web pages

Create panoramas

Filing and captioning

Amuse the kids

A practical application for digital imaging is combining pictures with text and graphics to make greetings cards, postcards, calendars and so forth. If an image-editing package is combined with a desktop publishing one, newsletters and even magazines can be produced.

By combining blemish removal with brightness/contrast and colour adjustments, and perhaps the sharpening filter, old and damaged photographs can be restored to something approaching their original splendour.

Want to produce your own web page? Some image-editing software allows you to prepare images for this, and a few even help you to create 3D buttons and other graphics for use on the site.

By stitching together a sequence of pictures, some software enables you to produce 360° panoramas. Some of them even let you scroll around and zoom in on particular areas of interest. This is great for showing all four walls of a room, for example, or the view from a high vantage point.

This is less exciting than distorting your photos perhaps, but more useful. There is software available which will help you keep track of where your pictures are, print captions for the slide mounts or the backs of the prints and search for particular types of picture using keywords (e.g. dogs or boats).

There is software available which can turn your pictures into jigsaw puzzles, paint-by-number line-drawings, embroidery templates, impressionist paintings and so forth.

OUTPUT AND STORAGE

You've imported a photo into your computer and given it the Photoshop treatment. What next? The chances are that you'll want to share the finished picture with family and friends, some of whom may live many miles away. Putting your computer in the back of the car and driving to see them is not a practical solution, but there are several other ways to share your pictures.

The traditional means of showing and distributing photographs is to print them. Prints are in many ways the perfect carrier for an image. They can be easily transported, require no special equipment to view, and additional copies can be made at very little cost. It's hardly surprising then that the first thing that most people want to do once they've finished manipulating their pictures is to make a print. However, the procedure is not as straightforward as it may seem and to get the best results you'll need to know about some of the factors which affect print quality.

Inkjet printers measure their performance in terms of the number of ink dots per inch (dpi) they produce. It is generally considered that a minimum of 300 dpi is needed for true photo quality: if it is any less the eye will be able to see the dots. Some printers now boast 720 dpi or even 1440 dpi, though in practice there's a limit to how many ink dots you can squeeze into a linear inch before they all start overlapping. It isn't just the number of dots that count, but also the precision and method of applying them, and the application of the ink or dye.

One of the biggest sources of confusion about printing concerns resolution, and how big a file needs to be to make a print. The size of the image file determines the maximum size at which it can comfortably be printed before the image starts to break down into its pixel components. You can calculate this size by taking the pixel dimensions of the image you wish to print (your software can tell you this if you don't know) and dividing it by the resolution of the printer. For example, a 2400 x 1800 pixel image on a 300 dpi printer could happily be printed to 8 x 6 in. It is possible to make a larger print but your software would have to interpolate the image (see 'Choosing a scanner', page 172), which would reduce the quality.

You can't automatically assume that the output from your printer will match the colour of what you saw on screen, and some adjustment may be necessary. This is hardly surprising, since an inkjet printer uses cyan, magenta, yellow and black inks to reproduce an image which is displayed on your screen using red, green and blue glowing phosphors. Colours can be adjusted, however, to obtain a fairly close match. This can be achieved first by checking that the calibration of the monitor is correct, and then by fine-tuning via the printer control panel.

Photographic quality prints are now achievable with inkjet printers.

Printer	reso	lution

File size

Colour matching

Print media

Although you can use plain paper in most inkjet printers, for photo-realistic results it's best to use the specially coated papers which are available. They come in a range of surfaces: gloss and matt, of course, but also such oddities as linen and canvas – though heavily textured media like these will have a detrimental effect on the apparent sharpness of the image. You might think that all glossy inkjet papers were the same but you'd be wrong: they vary tremendously in quality, and some testing is advised. Best results are often obtained by using the printer manufacturer's own brand of paper.

Types of printer for use at home

Photographers seeking traditional colour prints from negatives are faced with a limited range of choices: print size, surface (glossy/matt) and, sometimes, whether or not you want borders. This is not the case with digital images, where there is a greater variety of printer types, each with its own advantages and disadvantages. If you are to reap the benefits in terms of speed and convenience of digital imaging you really need to be able to make prints from your files yourself. For this you need your own printer at home.

A typical ink-jet printer.

Inkjet printers

The vast majority of consumer digital printers are inkjet models. These work by squirting microscopically small ink droplets on to specially coated paper. In recent years the quality of inkjet printers has improved dramatically, while prices have tumbled. Inkjets represent the cheapest practical way to print your files. The almost instant result means that if you're not happy with the first print you can make adjustments and do another. You can print on a range of paper sizes from postcard to A4 (or A3 if you have one of the larger and more expensive printers) and with some models you can print on different types of paper, such as textured watercolour paper for a fine-art look. On the minus side, inkjet printers are slow, taking several minutes to print a high-resolution image. Most are quite noisy, and replacement ink cartridges are expensive. Image quality, while good, is still no match for a conventional photograph – unless you own one of the modern 1440 dpi printers, which produce results that are virtually indistinguishable from photographs – and careful examination of the prints will reveal the dot pattern produced by the individual ink droplets. There are also question marks about the permanence of inkjet prints, since they tend to fade more quickly than silver ones, though more archival inks are now coming on to the market.

A handful of consumer printers use alternative technologies. Micro-dry printers resemble inkjets but use solid sticks of ink which are heated until they liquefy, and are then fired on to the paper where they resolidify on the surface. Since little ink is absorbed by the paper, micro-dry printers can print on to a wide range of paper types.

A laser printer.

This system uses lasers to expose a donor paper, which is then sandwiched with the printing paper and heated until the image is transferred. This system produces prints that are more archivally permanent than inkjets but the printers themselves tend to be more expensive.

Thermal Autochrome

Printing at a lab or bureau

If you want to make portfolio-quality prints which are beyond the capabilities of your inkjet printer, you will need to save your digital files to a disk and take them to a bureau or lab. There a digital print can be made which is in every sense better than those you could do at home. They ought to be – the machines that produce them cost thousands of pounds.

There are drawbacks, of course: loss of speed and convenience, and higher cost - expect to pay between £10 and £20 for an A4 print. There are lots of different types of digital printer in commercial use, and the type of print you get depends on where you go. These are the main options for printing photos:

The dye-sublimation printers favoured by Kodak-appointed outlets work by heating the dyes from coloured ribbons and vaporizing them, one by one, on to the surface of the paper. Fuji's rival pictrography system is a fancy professional version of its thermal-autochrome process. Both types of print are virtually indistinguishable from conventional photos.

There are also several other digital printing systems in existence (e.g. colour laser prints, Cromalins and matchprints), some of which are used in the printing and pre-press trade and are not widely available to the public.

The latest high-tech printing machines write digital files directly on to the standard RA4 colour paper that your enprints are made from. This marriage of analogue and digital technologies is one made in heaven – the prints are indistinguishable from photos because they *are* photos, and their longevity is therefore exactly the same. Again these prints are more expensive than making your own inkjets and of course there is the inconvenience of having to take or send your files to the lab.

Inkjet printers will still be considered an essential peripheral for instant proofing even if the finished prints for the album, frame or portfolio are made elsewhere.

Other output media

CD-ROM

If you own a CD writer you can burn your digitally manipulated images on to a disk and not bother printing them at all. This is a good option for image storage. You can get numerous images on to a disk (depending on file size and file format) and they can be accessed later on almost any semi-modern PC. If you don't own a CD writer you can get a lab to do it for you for a small fee.

Dye-sublimation and pictrography

Conventional silver prints

Going Digital

Writable CDs are extremely cheap and are now the mainstay of the photographic community. You can also save your images on to Zip, optical or any other type of storage disk. Their advantage over CD is that you can erase them at a later date if you change your mind about them (although rewritable CDs are now gaining a foothold), but that's also one of the disadvantages – the risk of accidental erasure (set the erasure prevention tab to prevent this). Another drawback is the possibility that your local bureau may not have a drive for your particular type of storage disk.

Most digital images are originally shot on conventional film. If you like, you can go full circle and have your digitized image written back on to film, in whatever format you like. You can then slip it into your slide show and, if it is a high quality image, your viewers will be none the wiser.

Sharing pictures electronically

Although prints are the obvious means of sharing your pictures, digital imaging opens up avenues of print distribution not available to non-computer users. One of the most exciting of these is the use of the telephone line.

Growing numbers of people are now connected to the internet and are finding e-mail the quickest, most convenient and reliable way to communicate – not just with distant friends but even with people working in the same office! One of the

🕯 File Edit View M	essage Format Tools Window 🔗 Help 5:13 pm 🖭 🐔 Outlook Express
	Photography
New Reply Reply All hox Outbox Outbox Sent Mail Deleted Messages Drafts (2) untitled folder Contacts Microsoft News Serv Four 11	Send Save Add Attachments Signature Contacts Check Names
	Account: E-mail account 2 Priority: (Normal 2) To: Mike Smith
	Ce: Bee: Subject: Photo
	Size Medium 🔹 B/U 📰 📰 🗐 🗐 🗐 🗐
	Attached is the <u>pic</u> you requested. Hope it's O.K.
	Regards
	Gri∦∐

Other storage disks

Film

E-mail

most useful features of e-mail is the ability to include attachments with the email message. The symbol representing this feature is, appropriately, a paper clip, and you can attach anything from text documents to software and, of course, photos. The speed of this means of distribution is truly impressive. Within a few minutes of your scanning a photo into your computer the recipient can be viewing it on the other side of the world. Photograph files are larger and slower to transmit than text files, so to save on your phone bill (and the other party's) pictures should be saved as files which compress the data to a smaller size, such as JPEG.

The world-wide web

If you have your own web page you can post your pictures on to it, so your furthest and dearest can log on from anywhere in the world and view them. If you don't have your own web page Kodak offers this service (called PhotoNet) for a reasonable price on its own website.

THE INTERNET

The internet has a lot to offer photographers. Listed below are a few of the features and benefits.

Keep in touch with friends and family around the country, or perhaps the world, and send them pictures of important people and/or events in your life. They'll get them within hours or even minutes and can either view the pictures on screen or make prints of them.

You can see some of the world's greatest pictures on the web, from Ansel Adams' 'Moonrise' to NASA's 'Earthrise'. Many of the pictures from top international museums and galleries are on-line. There's a brisk business in signed limited editions too.

There are tens of millions of pictures on the web, of every conceivable subject. Many of these are in on-line picture libraries which show only very lowresolution images, but there are plenty which you can legally download and do what you like with.

There are numerous places on the web where you can get free (or virtually free) software, much of it 'home-made' by amateur programmers. You can also get free demonstrations of brand-name software so you can try before you buy.

If you're thinking of buying a piece of kit (or just window shopping), visit the manufacturers' website first. You'll find information on whatever you're looking for, with pictures, detailed descriptions and technical specifications. Major companies have several sites serving different countries. Often you can order literature or access a list of local dealers.

'E-commerce' is still in its infancy but already has a turnover in billions. Most high street retailers are on-line, but there are also thousands of smaller operations, based all over the world. You can shop at international sites and find products not available in the UK. Familiar items may also be cheaper. Recent advances in credit card security are making it safer to shop, too.

On the web you can find in-depth information on almost any subject. Whether it is the history of photography, a biography of an individual or details about a vintage camera, you'll probably find what you need somewhere on the web.

Set up your own website and put your best pictures on there. If you're a pro or semi-pro you may get some work, if not you may still get some complimentary comments about your pictures.

Communication

Inspiration

A source of free pictures

Freeware and software

Corporate sites

Shopping

Research

Showcasing your own work

Finding out what's on	
Meeting new friends	Chat or argue about photography with other enthusiasts from around the world in one of the hundreds of chat rooms on the web. These allow you to converse, in real time, with other people by typing on your keyboard.
	Buying a printer
	Print quality is the main deciding feature when it comes to choosing a printer, but there are also other factors to consider.
	Print size Most desktop printers for home use print up to A4 size. You can use smaller sizes, such as A5 and A6, or you can print several images on a single sheet of A4. You can even print panoramic pictures, as long as they are no wider than A4. A3 models are available at a premium; if you want to print for portfolio or exhibition use you may consider the investment worthwhile.
	Speed The speed of printing with most inkjets is linked to the main computer's processor speed and memory size. A photo-quality A4 image can take over five minutes to produce.
	Noise Inkjet printers can be noisy, but some are quieter than others. If your home office is next to the baby's nursery, for example, you'll be glad you chose one of the quieter models.
	Direct printing A handful of printers include built-in PCMCIA memory card readers so they can print images directly from digital cameras without needing the intervention of a computer. Others allow for serial cable connection between printer and camera. Print options include single prints of individual images or digital contact sheets of every image on the card.

CHAPTER EIGHT

THE BLACK AND WHITE DARKROOM

The unique ritual of making a black and white print still has a huge following in the world of photography. Indeed, many photographers, once they have run a few rolls of black and white film through their camera, become completely hooked and choose from that moment to see the world only in monochrome. Part of the passion often comes from learning that black and white photography is not merely about shooting a few rolls and handing them over to someone else for processing. With practice and a certain amount of expense, the photographer can easily discover the joys of dabbling in the darkroom and producing their own beautifully crafted black and white prints.

EQUIPMENT

Developing films: what you need

Although it is not necessary to develop your own films – you can simply take them to a lab and ask for developing only – it is a good idea to learn how to do this if you would like to have maximum control over your final image.

This is a small, lightproof plastic barrel in which the developing process takes place. It is usually designed to develop two 35mm rolls of film, or one 120 roll – although you can buy tanks with a capacity of four 35mm rolls.

The unprocessed film is threaded on to a reel to form a spiral so that none of the film emulsion touches itself. If the emulsion touches, the developer cannot get in between to form an image on the film.

There are several types of black and white film developer on the market, each with its own qualities. Some are designed to give optimum results with a particular film, some are formulated especially to produce fine grain, while others will give a grainier result. So much of black and white developing and printing is down to personal preference, it is best to try a few different developers and then stick to the one which gives the most pleasing results for you.

This is a chemical that clears the developed film, leaving you with a black and white negative. After the film is fixed, it is safe to look at it in daylight without risk of fogging.

Developing a film is a precise art, so an accurate measuring cylinder is essential. Invest in two, and label one for developer and one for fix. That way, you lessen the risk of contamination between the two chemicals.

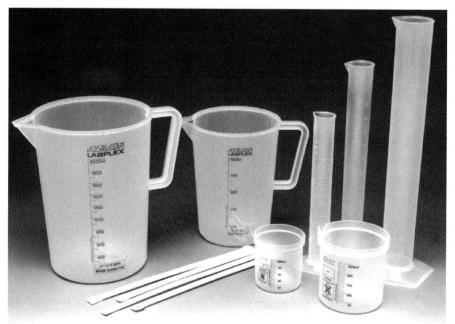

Developing tank

Reels

Developer

Fix

Measuring cylinders

Precise measuring of chemicals is fundamental to accurate black and white processing and printing results.

The Black and White Darkroom

Developer has to be mixed at a particular temperature for the best results (usually around 20°C). The water to rinse the film after developing and fixing also has to be around the same temperature, otherwise you risk reticulation. This is when the film emulsion breaks down because of extremes of temperature, which will produce a speckled effect on your prints.

will suffice for most users.

Printing: what you need

This is the biggest outlay you will need to make but, once purchased, the equipment should last many years. Make sure you know exactly what you want from your darkroom before parting with your hard-earned cash, as you could end up making false economies.

While a drying cabinet provides the best conditions in which to dry your developed print, a line rigged up in a dry, dust-free (or as near as possible) room

If you are serious about black and white printing, you should give as much thought to the enlarger you buy as you would to a new camera. There are two main types of enlarger - diffuser and condenser. For general use, the diffuser type is recommended, as condenser enlargers produce a harder, more contrasty light, and will show up every last speck of dust on your negative.

If you plan to print exclusively in black and white using variable-contrast papers, you can choose between an enlarger which allows you to dial in the grade of print you require, or one used in conjunction with variable-contrast filters. The filters slot in either above or below the enlarger lens, depending on the model of enlarger.

Another alternative is an enlarger with a colour head. Although these can be used for variable-contrast black and white printing, you can run into problems

Drying line

Enlarger

Thermometer

Buying an enlarger is the single most important investment you will make for your darkroom. Make sure you consider exactly what you require from the enlarger before writing the cheque. with exposure times once you start dialling in different filtrations. Invest in one of these only if you plan to experiment with colour printing, or if you do not mind abandoning the colour filtration head and using it in conjunction with a range of variablecontrast filters instead.

Also bear in mind the size of negative you will be printing with. If you shoot a lot of photographs on medium format, there is obviously little point in buying an enlarger suitable only for printing 35mm negatives. Size also matters when it comes to prints. If you know you are unlikely to want to print bigger than

10 x 8 in., then this is as big as you need your enlarger to go. However, you may find this limiting in the long term, so it could be better to choose a model which allows you to go up to 12×16 in. or even 20×24 in. if you plan to print up your own exhibition one day!

- In the same way as a camera lens dictates the quality of your photograph, an enlarging lens influences the quality of your black and white print, particularly when you start to make prints larger than 10 x 8 in. If you will be printing solely from 35mm negatives, you need only buy a 55mm lens. However, if you will also be printing from medium format negatives, you will need to invest in an 80mm enlarging lens as well.
- These are essential if you do not have a head on your enlarger which allows you to dial in the contrast. Variable-contrast filters are plastic squares which slot into a tray either below or above the enlarger lens, and which allow you to control the contrast of your print in graded increments between one and five (one giving the least contrast, and five producing the greatest contrast between highlight and shadow areas).

As well as securing your printing paper and holding it flat, an easel provides the easiest way to make borders on your black and white prints. Again, buy one which can accommodate up to the largest size of paper you are likely to want to

Enlarging lens

Filters

Easel

The Black and White Darkroom

use. Unfortunately, these are expensive accessories, and you would be better off buying a more substantial second-hand piece, than skimping and going for a cheaper new version.

For consistent, repeatable results, the only solution is an enlarger timer. Keeping an eye on the second hand on your watch is a very poor substitute! You need not invest in a sophisticated model, just a sturdy, reliable and accurate one.

In the low light of the darkroom, you cannot always rely on the naked eye to tell you whether or not your print is in focus. A focus finder does the job for you. It can take a little getting used to, but will prove invaluable once you do.

Luckily the developing process does not have to take place in pitch black. You are permitted the glow of the red safelight, which you can use without fogging your paper. Different paper manufacturers recommend different types of safelight for use with their products, but do not be fooled into thinking they are simply trying to sell you their own model. The quality of your print can be marred if the wrong safelight is used, so adhere to the recommendations on the printing paper box.

A standard two-blade easel.

A digital timer is more accurate than counting 'elephants'. Make sure you keep a note of exposure times for your prints, so they are straightforward to repeat.

Timer

Focus finder

A focus finder ensures a sharp print. Other versions of this accessory resemble miniature microscopes.

Safelight

A safelight will allow you to see what you are doing, without risk of fogging your paper.

Developing trays

Upright print developers and washers are ideal for darkrooms with limited space.

As with the easel, even if you plan to print only on 10×8 in. paper, it's worth investing in a set of three trays of 12×16 in., because it would be frustrating to limit yourself in the event of wanting to produce larger prints. Obviously, though, the larger the trays, the greater amount of chemicals you will require. Some printers invest in a separate set of trays for toning their prints, to avoid cross-contamination.

As with film developer, print developer has to be measured accurately, to ensure repeatable results.

There are many different types of developer on the market, each with its own characteristics. Some enhance grain, while others make it appear finer. Some are designed to boost contrast, others to lessen it, while yet more produce prints which display cold, neutral or warm tones. To further complicate matters, the length of time a print is allowed to develop and the concentration and temperature of the developer can also affect the outcome of a black and white print. Your printing will show more consistency if you stick to one developer to start with and learn about its characteristics, keeping to the dilutions and developing times recommended by the manufacturer. If your printing is likely to be mainly on variable-contrast paper, there are developers specifically for these. Since it goes off quickly, it is false economy to buy and mix up large quantities of developer. After making several prints, the developer starts to become exhausted, taking longer to bring about the image on the paper. Once this happens it should be poured away and replaced.

Measuring cylinders

Developer

193

The Black and White Darkroom

Some printers simply use a bath of water to arrest the printing process before iplacing the print in the fix. However, for optimum control, a stop bath is vital because it halts the developing process immediately.

This makes your image permanent and allows you to look at it in daylight \bigcirc without risk of fogging.

Print tongs are essential for moving prints from one tray to the other, but they must be used carefully to avoid creasing or tearing the paper. For those who are only happy if their hands are in the developer, plastic or latex gloves are essential. Some people go for years happily immersing their hands in various chemicals, only to develop allergies very suddenly, after which it can be very hard to print without irritation, even when wearing gloves.

Use tongs so that your hands do not come into contact with the chemicals.

1

Wearing soft gloves while handling your processed negatives reduces the risk of scratching them or covering them with fingerprints.

Choosing your paper

Selecting a black and white paper on which to print is not a straightforward task. Do you want to use graded or variable-contrast paper? And should that be fibrebased or resin-coated? Then there's the finish to consider. Will your print look best on matt, glossy or something in between, like pearl? Only you can decide.

There is still a certain snobbery attached to resin-coated paper, many believing it delivers an inferior result to that of its fibre-based counterpart. It certainly feels very different, with almost a plastic quality. However, as your printing skills develop, there is no reason at all why you should not produce equally as good a print on resin-coated paper as you would on fibre-based. Its advantages are that it is much quicker to wash, therefore less wasteful of water, and also that it doesn't buckle, so can be mounted extremely easily when dry.

Those who still adhere to the snobbery mentioned above would argue that fibre-based paper has a certain depth and a wider range of tones than resincoated. In the end, printers should use whatever they feel produces the best results for them. Because the chemicals soak through the emulsion layer of fibre**Resin-coated paper**

Fibre-based paper

Fix

Other accessories

Stop bath

based paper into its base paper, fibre-based paper needs to be washed for a very long time - around 45 minutes to one hour in slow-running water. It also buckles while drying, making dry mounting necessary before it can be framed properly.

These are papers which are available in packs of one grade only, from 0 to 5. Economically, they make less sense, as you have to buy six boxes of paper in Fixed-graded paper order to give yourself the full choice, while one box of variable-contrast paper can provide the same range - in fact, even wider, because variable-contrast paper gives you the grades in between, too. The uses of these papers are more limited nowadays, as the quality of variable-contrast papers has improved considerably.

The huge advantage of variable-contrast paper is that you can utilize the entire range of grades within one print. As already mentioned, their quality nowadays is easily comparable with their fixed-grade counterparts, making them the most versatile and economical option for any printer.

> Once you have decided upon resin-coated or fibre-based, variable-contrast or fixed-grade, you then have to choose the tone of your paper. Warm-toned papers are now commonplace, giving a result which appears to have been very slightly sepia-toned. Neutral papers, on the other hand, produce much colder greys. In the end, your choice should come down to the sort of mood you would like your print to evoke.

> > Gloss is far and away the most popular finish for a paper, appearing to give a crispness and density which seem to be lacking from matt, semi-matt or pearl finishes. It is also possible to buy papers which have textured surfaces - anything from a stippled effect to those which appear to be more like watercolour paper than something intended for photographic use.

Lightproofing a room

Whether your darkroom is in the attic, the basement, the bathroom or the cupboard under the stairs, it must be completely lightproof to prevent fogging either of the film as you load it on to the spiral before placing it in the developing tank, or of paper when you remove it from its light-tight box and place it under the enlarger.

The main area where light can encroach into a darkroom is around the door frame. This can be rectified guite easily by using black tape or paper around the edges, or rigging up a blind or curtain made from heavy black fabric. Although most darkrooms are painted black, don't assume you have to paint your bathroom this colour if that's what you use as your darkroom! White is just as suitable. It is also extremely important that your darkroom has adequate ventilation.

Variable-contrast paper

Paper tones

Paper finishes

CONTACT PRINTS AND TEST STRIPS

The process of making a contact print and test strip, although laborious, is the only way of telling which negatives are most suitable for printing, and what the best exposure is going to be for that particular negative. Making a contact print also allows you to consider potential crops as you can draw on it with permanent felt-tipped pens, and these prints are also invaluable for filing purposes.

The contact print

The variations in exposure you may have used while shooting a roll of black and white film mean that sometimes not every negative will appear identically exposed on the contact print. This means that either you will need to make a couple of contact prints, giving each a different exposure time under the enlarger, or else you will need to burn in those negatives which need extra exposure.

Although you can buy specially made contact frames in photographic retailers, these are not vital to making a good contact print. The only essential piece of equipment you need is a sheet of glass large enough to cover the rows of negatives as they are placed on the piece of printing paper. Since most contact prints are made on 10×8 in. paper, a sheet of glass measuring 12×10 in. should suffice. It is essential that this is kept as clean as possible, as you do not want any grit to scratch your negatives before you have even had the chance to see which ones you want to print!

The height of your enlarger should be adjusted so that the coverage of light is slightly bigger than the paper. You might like to make a note of this height, as it will help keep future contact prints consistent. Since grade 2 paper is considered to be the ideal average, it is a good idea to make all your contact prints on this grade of paper.

A contact print is essential to any filing system, and allows you to select which negative you want to make an enlargement from. First, you will need to make a test contact sheet by moving a piece of black card across the sheet of negatives at equal intervals. For a contact sheet, you can get away with five-second intervals, as exposure is less critical than when you are making a test strip from one negative. Select which of the exposures gives the best average results (for example, 10 seconds) and make a full contact sheet by exposing the whole set of negatives at that time. If some of your negatives are too dense to have exposed enough on the paper, but you can see they have enough detail still to have potential as a print, make another test to determine an adequate exposure. Then you can make a second contact print, burning in the appropriate negatives (see page 199) and retaining the original exposure for the remainder of the negatives, so they are all correctly exposed on one sheet. You should write the exposure times on the back of the contact sheet, in the event that you need to make another copy in the future.

The test strip

Once you have made your contact print and decided which of the negatives you want to enlarge, the next step is to make a test strip. This is a procedure that is often taught incorrectly, and in a way which can result in far more work and wastage of printing paper than is necessary.

As with the contact print, test strips should be made on grade 2 paper (either fixed-grade, or variable-contrast paper with a grade 2 filtration).

The first step is to adjust the enlarger to the correct height for the size of paper you will be using. As exposure times vary depending on the distance between the enlarger head and the paper, there is little point in carefully determining your exposure, only to alter the height of the enlarger when you decide you want a 12×16 in. print instead of a 10×8 in.

The next step is where people often go wrong, placing a sheet of paper on the

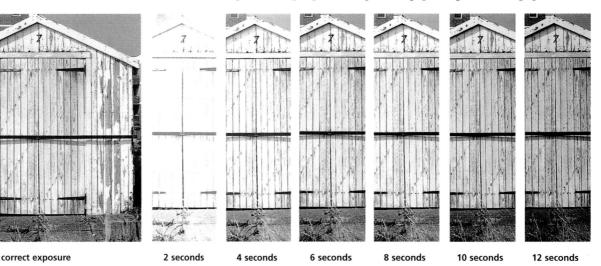

By making a test strip from an identical area of the negative, you are better able to select the correct exposure for your enlargement than if you were to expose the whole negative at equal intervals across the paper. In this case, eight seconds was selected as the correct exposure. baseboard and exposing the entire sheet in intervals. This makes no allowance for which part of your negative you consider to be the most important, and where it falls in your composition. Therefore you need to decide which part of the negative forms your main subject, tear your paper into five or six strips of about 1–2 in. wide, and expose each strip in the same place on the baseboard. These strips do not have to be laid vertically. If the most important part of your negative sits horizontally or diagonally in the frame, you should place each strip accordingly.

There is little point in varying your exposure in large intervals, as the test strips with very long exposures are almost guaranteed to be far too dark. Instead, try exposing at five-second intervals so that you end up with five test strips, say, exposed at 5, 10, 15, 20 and 25 seconds. Put all the test strips into the developer at the same time, and do not be tempted to remove any until the full developing time recommended by the manufacturer is complete. They should be transferred to the stop bath, then washed in fix and dried in the same way as you would a print. Finally, they will be ready to examine under normal lighting conditions – either a well-lit room or, preferably and if printing during daylight hours, in natural light.

If none of the test strips appears to give quite the right exposure, decide which two are the closest, and make another test strip with an exposure halfway between them. For example, if 5 seconds is slightly too light, and 10 seconds is slightly too dark, make a test strip exposed at 7.5 seconds.

Testing for the correct grade

Now that you have your correct exposure, it is time to decide which grade of paper is best for the enlargement you want to make. You might decide that the grade 2 paper on which you have made your test strips is correct for the negative you are enlarging. However, as you become more accustomed to printing and assessing your negatives, you will begin to see how a different atmosphere or feeling can be injected into your prints when you increase or decrease the contrast between highlight and shadow areas.

The method of determining the correct grade is identical to that of making a test strip, except that this time you alter the grade you are using. If you are using graded paper, the exposure time will be the same across all the grades, assuming you are using paper by the same manufacturer. If you are using filters or dialling filtration into the enlarger head, however, you should double the exposure for grades 4 and 5. Therefore, taking our above example, you would expose grades 0 to 3 at 7.5 seconds, but grades 4 and 5 at 15 seconds.

Again, these strips should all be developed at the same time, then fixed, dried and examined under good lighting. Only then will you be able to decide properly which is the correct grade of paper or filtration for that particular negative.

Selecting a grade is often down to the printer's personal taste and desire to bring out extremes of contrast, or every possible tone of grey. Neither is right or wrong. The printer here decided that a filtration of grade two provided the desired result.

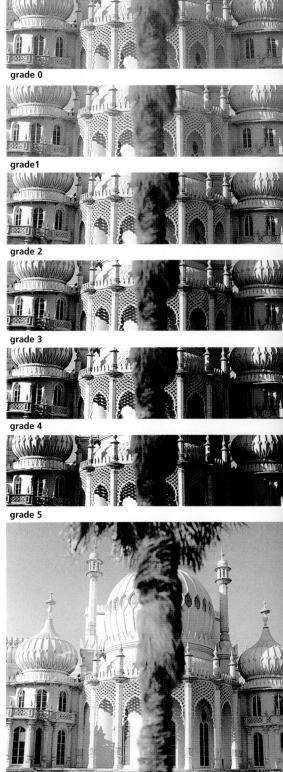

MAKING A PRINT

A filtration of grade four ensures that the mountains appear in silhouette, while the clouds in the mackerel sky are bright white.

The wide range of tones and textures in this detail in a ground-level shot is revealed by printing at grade two.

Now that you have gone through the process of making your contact print and testing both for correct exposure and the correct grade, you are finally in a position to make an enlargement from your negative.

The initial enlargement

The first step is to make a print exposing the whole sheet of paper at the time and grade indicated by your tests. Before you expose the paper, you will need to check your focus, using the focus finder (mentioned above). It would be frustrating and wasteful of paper if you were to make an enlargement, only to find the focus had slipped since you made your test strips. After exposing the paper, quickly slide it face up into the developer, and ensure an even dispersal of developer across the paper by rocking the developing tray gently. Do not be tempted to prod the paper into the developer using your tongs, as this will more often than not result in the print scratching or the paper creasing.

Develop the print for exactly the same length of time as you did with your test strips, then remove it carefully, using the tongs to hold the edge of the print. Slide it into the stop bath and then the fix. Make sure it is fixed properly, and do not be tempted to remove the print early in your haste and excitement to see the final result. Once it is washed and dried, as before, take it into a decent light source to study it.

The next step

In an ideal world, your first print would be perfect, displaying exactly the ideal range of tones and contrast to convey the feeling you had intended. However, as we all know, the world is not perfect! You might find that one part of your print is too dark at the given exposure, becoming muddy and reducing detail you wanted to include. Another area might be too bleached out, creating a highlight which detracts the viewer's attention from your main subject area. Or you might feel that a completely straight print, with equal exposure throughout, is simply too bland, and an altogether more dramatic print could be created with just a few alterations.

Now is the time to make a second print, this time altering the exposure according to the changes you want to make. This is usually done by a process known as dodging and burning.

Dodging and burning

First study your print and decide which areas need to be altered. You might decide that a person's eyes are too dark, and need to be lighter in order to draw attention to them. This would require dodging to hold back the eyes, thus giving them less exposure. You might then decide that a highlight in the background is too distracting, drawing attention away from the main subject. This part of the print would therefore have to be burned in to reduce the highlight, or even get rid of it altogether.

The tools to perform the tasks of dodging and burning cannot be bought, one of the reasons being that your hands are often the most versatile tool you can use. However, where your hands cannot perform the task, a piece of card cut to shape, or a length of thin but sturdy wire with a roughly cut piece of card or a blob of Plasticine on the end will do the job to perfection. The shape and size of the dodging or burning tool will vary according to the alterations you need to make to your print.

Making the changes

There are many different ways of solving printing problems through dodging and burning, so it is up to you to find those which suit you best. However, those described here are some of the common printing issues which can arise, along with some suggestions of how to deal with them.

appropriate to how long you want to hold back the eyes. For example, if your basic exposure is 12 seconds and you have decided the eyes need 30% less exposure, set your timer to 4 seconds. Holding the dodging tools close to the enlarger lens to avoid obvious signs of dodging, make the exposure while moving the wires very

lighter than the rest of the print the eyes need to be (e.g. 30% lighter or 50% lighter). Use two small pieces of Plasticine, each on the end of a piece of wire (one for each eye) as a dodging tool, and set your enlarger timer to a time

Assess how much

The area in shadow in the straight-printed negative (top) still showed detail in the negative, so a mask was cut and the area held back for part of the exposure.

Eyes too dark

Left: Although the grade of paper was correct for what the printer wanted, a straight print meant that the right-hand side of the subject's face was too dark. Right: To bring out the detail in his eye, cheek and ear, this area was dodged (or held back) during exposure. slightly to blur the lines between dodged and undodged areas. After this, set the timer to the remainder of the exposure time – in this case, 8 seconds – and expose the whole sheet of printing paper as normal.

No detail in the sky

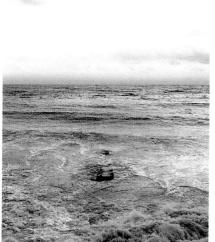

It is common for the sky in a black and white print to burn out when the foreground is correctly exposed. When the horizon is straight it is very simple to burn in the sky to the desired level.

An object encroaching into the horizon

foreground, then to make another set of tests for the sky. If your picture has a relatively straight horizon, the procedure is quite straightforward. Say your tests have shown the sky needs 20 seconds exposure, while the land needs only 10. Set the enlarger timer to 10 seconds, and hold your hand close to the enlarger lens, placing it across the picture so it covers the land. Make sure there are no chinks between your fingers which could allow light from the enlarger through. Expose the paper for 10 seconds, moving your hand very slightly up and down. After this, expose the whole sheet for the remaining 10 seconds. Alternatively, you could cut a mask from a piece of card, and burn in

the sky this way. With both methods, the most important thing to avoid is a 'halo' around the area which has been held back. While this can occasionally be used to artistic effect, more often than not it forms a distraction and simply looks like a bad printing technique.

You may have a lack of detail in the sky but with the complication of something – whether a person's head, a building or a flower – which crosses the boundary between the horizon and the sky, and in which you want to retain detail. If the

shape is very uniform – a straight-sided, rectangular building, for example – the solution is easy. Simply cut a card mask to the shape of the horizon and the building, and burn in the sky while holding the mask over the area to be held back. If the shape is less regular,

A card mask can be cut to hold back an area of the print, but be wary of overlapping into the burnt-in area, which creates a 'halo' (centre).

things become a little more tricky. However, your hands and fingers are probably the best option again. For example, you could use your left hand to cover the main area of the print, then hold your other hand over the top so that a finger (or fingers) or thumb covers the detail which encroaches into the horizon.

This is more straightforward than it sounds. If, for example, one side of the face is bathed in bright light while the other is in dark shadow, you could simply change to a lower grade to reduce the contrast between the two. However, if you prefer the

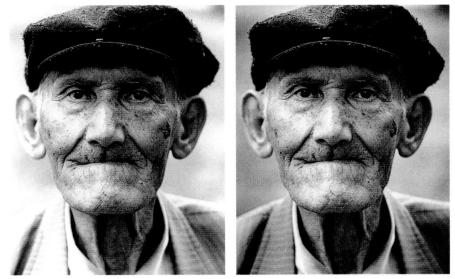

higher contrast but simply want a little more detail in the bright area, you cup your hands beneath the enlarger lens, leaving a hole of the appropriate size between the edges of your palms. During the extra exposure required you gently move your hands to burn in the area. Alternatively, you could make a small hole in a piece of card using a ballpoint pen, and hold the card over the paper, only allowing light through the hole to burn in the required area.

Keeping it consistent

Once you have made a perfect print, you will not want to go through the process of testing every area all over again if you return to make further prints at a later date. Therefore, it is essential to keep a record of the procedure. The method most favoured by printers is to lay a sheet of tracing paper over the print, and draw around the areas which have been changed – using a felt-tipped pen – then writing within that space the alterations you made. For example, if your basic overall exposure was 15 seconds at grade 3, you would mark all the areas on the print which adhered to this exposure. If another part of the print required an extra five seconds, you would mark this as such, while yet another area might have been held back for seven seconds and, again, you would indicate this on the tracing paper. Burning a small area

While the old man's face was correctly exposed, the background needed to be darker, so the print was burnt in around the edges to create a more even spread of tone.

CREATIVE PRINTING TECHNIQUES

Once you have mastered the making of a good print, the world of black and white printing is your oyster, and you can let rip on the numerous creative printing techniques possible even with the most basic of darkrooms. However, as we saw earlier in the book, simplicity is, nine times out of ten, the key to a successful photograph. Going over the top on technique could detract from what would be a very successful image if it was left to speak for itself. And, as we have also said, you cannot mask a bad photograph with the use of techniques. Learn how to be more creative, but also learn the best time to use these techniques. If you are unsure, it's advisable to leave well alone.

Borders

The borders of a black and white photograph are not strictly a technique, as their inclusion or exclusion, and the type of border you decide to use, should be considered an intrinsic part of the final print. However, since they can be so varied, it is worth looking at them here. These are some of the effects which can be achieved.

You may feel that your black and white image requires no border at all, simply the even white surround created by using an easel, which can vary in width and can be deeper at the bottom to provide an improved sense of balance.

This is the most common border seen on black and white prints, and is usually the most effective as it is subtle, neat and suits a wide variety of subjects and styles. It is created by using a negative carrier which is slightly larger than the negative itself, thus revealing part of the film's rebate. The easel is then adjusted according to how thick you would like your black border to be. This border particularly suits pictures which have a great deal of white surrounding the main subject – a high-key portrait, for example.

This is achieved by making a normal print, then placing a piece of black card – which has been cut to a size slightly larger than that of the image, and according to the size of the white keyline you prefer – over the print and exposing the edges for long enough to give a full black. Obviously you will need to do some tests first to determine how long you need to expose the paper in order to achieve this black. This border tends to suit more formal, darker prints.

Showing sprocket holes This has to be used quite carefully, because the sight of the sprocket holes of the negative can draw attention to the technique you have used, instead of the image itself. It simply requires a negative carrier too big for your negative (e.g. using a 6 x 7 cm negative carrier to print a 35mm negative).

No border

Black keyline on white border

White keyline on black border

The Black and White Darkroom

Left: Sometimes a frame can appear confining, so some photographs are better with none at all.

Right: A black border can be created by filing down the edges of a neg carrier in order to create a bigger aperture.

Below: A white key line surrounded by a wide black border is extremely eye-catching when used in conjunction with a dark image.

Below left: Showing the rebate of the film can also be effective.

Below centre: The sprocket holes of a negative are a good complement to some subjects, but should be used carefully as they are sometimes a distraction.

Below right: These ragged edges are particularly suited to the diffused print.

Used in conjunction with the right style of image, this can look very effective. Simply cut a 35mm-sized aperture out of a piece of card, making a point of distressing the edges with a scalpel. Slot the card into the negative carrier along with your negative and print as normal.

Ragged edges

Toning

Like so much of black and white printing – indeed of photography as a whole – the decision as to whether to tone a black and white print is a purely subjective one. And, once again, it can either enhance a print beautifully or it simply may not work for that particular style of image. Most toners can be bought 'ready-made' from photographic retailers, although some printers still prefer to buy the chemicals themselves and mix their own combinations. Books that give the chemical formulae are quite readily available, and the chemicals can be purchased from specialist suppliers.

Toners which are designed to add colour to a black and white print are usually a two-bath process, requiring a bleach bath, then a toning bath. It is essential that the print is washed thoroughly after being fixed, after it has been bleached and again after it has been toned.

Toning can be done in normal light, but must always be carried out in a well-ventilated area. If you are intending to tone a print, you should print it slightly darker than normal, as the bleaching process can make the highlights too bright, and therefore a distraction. Also, toners can react slightly differently to different types of paper, so it is worth conducting some tests of your own to have the utmost control over your final result. The three main types of toner are explained here, but there is no reason why you should not experiment with gold toner, copper toner, or even tea or coffee!

While it can add a purplish tinge to a print and increase slightly the density of the blacks – depending on the dilution used and the length of time the print is allowed to remain in the toner – the principal purpose of selenium toning

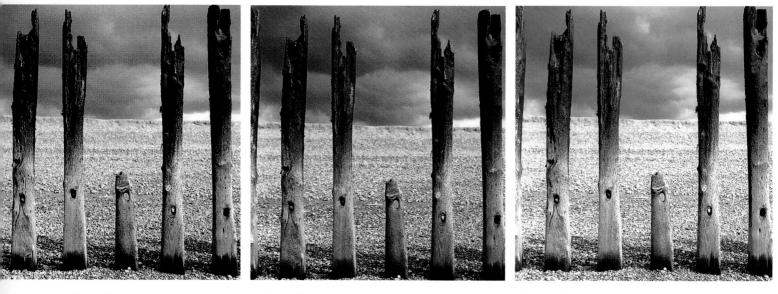

Untoned

Selenium toning

Sepia toned

Blue toned

is to prolong the life of the print. For this reason, it is used by many professional and 'fine-art' printers who wish to produce archival quality prints. Selenium can be highly dangerous, and must, without fail, only be used in a well-ventilated area and while wearing gloves and using tongs. It is a one-bath process.

This is a two-bath toner, the first stage being to place the print in a solution of potassium ferricyanide – or bleach. The bleach works on the highlight areas of the print first, and the darker areas last. The satisfying aspect of sepia toning is that it is very controllable, and can be used to either very subtle or very obvious effect. It is common to allow the bleach to work on the print only for a brief period, to keep depth in the darker areas of the print and show only a hint of the warm, brown tone. It can even be painted on to very specific areas of the print, using a paintbrush or cotton bud. Alternatively, the print can be kept in the bleach until the entire image has disappeared, before being removed and washed thoroughly until the yellow staining has disappeared. When placed in the sepia toner, it will then completely take on the brown tone, resulting in a print that suggests it was shot decades earlier than it actually was. Sepia toning, like selenium, is an archival process which prolongs the life of a print.

This is another two-bath process and, like sepia, its intensity of colour can be controlled carefully. Only rarely will a vivid blue suit an image, so it is better to remove the print from the bleach bath fairly quickly, wash it, then place it in the blue toner until a cool, steely colour is achieved. Where blue toner really comes into its own is when a print is first sepia toned, then blue toned afterwards. Sepia toning

Blue toning

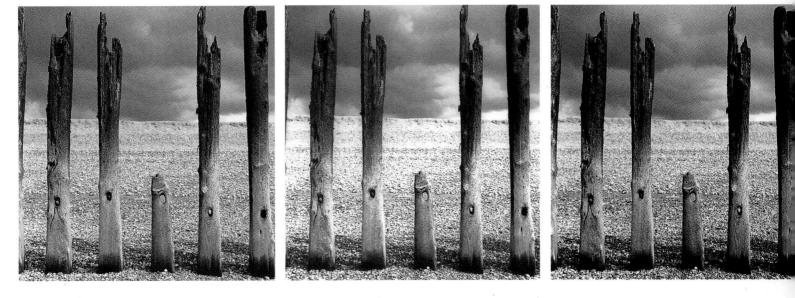

Copper toned

Intensified blue

Split toning: blue and sepia

Hand colouring

Hand colouring a black and white image requires a steady hand, a fair bit of practice, and a touch of restraint. The final point is important, as it defines the amount of colouring or tinting a print may require. Sometimes only partial colouring of a print can be very effective – for example, painting in a single flower on a model's dress, leaving the remainder of the picture in monochrome.

Hand colouring conjures up an atmosphere of times gone by, and suits a rustic subject such as this still-life composition. Or you could paint completely a still life of a basket of flowers, say, giving it an olde worlde feel. Hand tinting also works well when applied on top of a print which has been toned, and some practitioners believe it works best on fibre-based papers.

Various hand-colouring kits are available, in the form of oils or dyes. They should be applied using the best paintbrushes you can afford.

Diffusing

A diffused print has an ethereal quality which can enhance and romanticize a black and white picture very effectively. It is also an extremely simple technique to master. The difference between diffusing at the shooting stage as opposed to the printing stage is that soft-focus filters on a lens bleed the highlights into the shadow areas, while in the printing process the darker areas blend into the highlights. The technique suits all manner of portraits, as well as landscapes and still-life images.

The old cliché of Vaseline on a skylight filter – held under the enlarger lens during exposure – creates the perfect romantic atmosphere for a print such as this.

```
Undiffused print.
```

In the same way that soft-focus effects can be achieved in camera, the stocking-over-the-lens or the Vaseline-smeared skylight filter approaches work just as well in the darkroom. However, for the most consistent, repeatable results, it is worth investing in a diffusing filter. Although they come in varying strengths, there is little point in purchasing every strength available, as the level of diffusion can be controlled very easily. All you have to do is make a series of test strips, each one slightly more diffused than the next. For example, if your print requires an exposure of 20 seconds, make one test strip which diffuses the light for the entire time, then reduce the diffusion by 5 seconds for each subsequent test strip (in this example, 15 seconds with diffusion, 5 without; 10 seconds with diffusion, 10 without, and so on). Then simply make the print in the normal way, using the quantity of diffusion you feel will suit the image best.

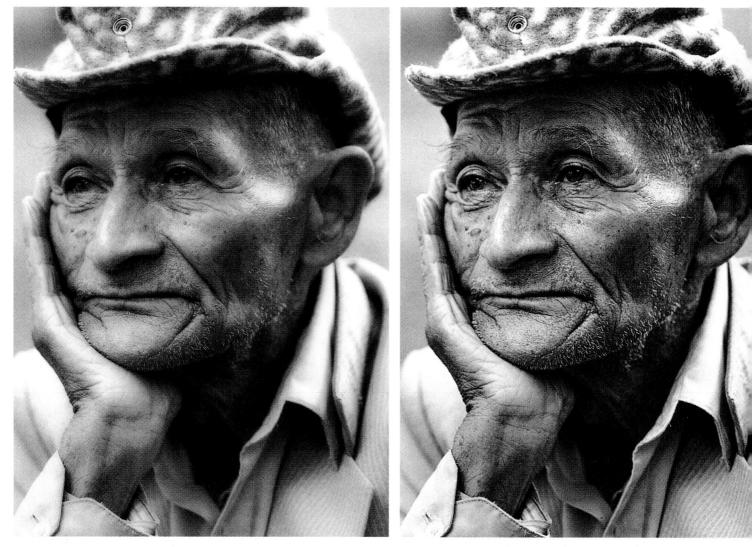

Print diffused for the whole exposure time.

Print diffused for half the exposure time.

CHAPTER NINE

1

CREATIVE TECHNIQUES

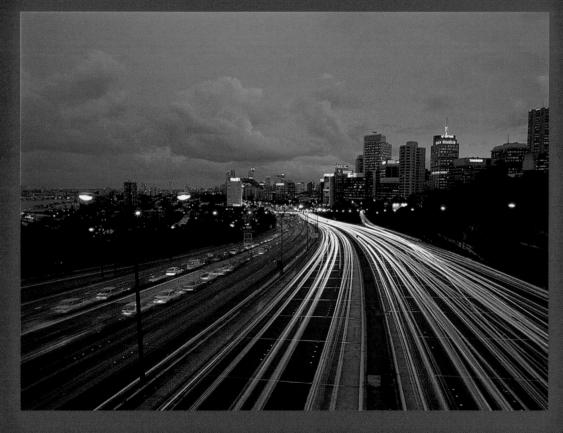

Once you've become more confident with your basic camera and exposure technique, it's a good time to start experimenting to gain more exciting results. How many times have you been sent to sleep by other people's unadventurous holiday snapshots? As a more creative photographer, you owe it to your friends and family to arm yourself with a few clever tricks and techniques – and don't worry about making mistakes: it's only by risking the odd frame of film and trying out new ideas that you can really reap the artistic rewards.

Long exposures and the 'B' setting

When taking pictures at night or in dark conditions where flash would spoil the mood and overpower more subtle ambient lighting effects, it's useful to set the camera on a tripod or other steady surface and turn the shutter-speed dial to 'B'. This allows you to extend exposure times beyond the camera's own automatic shutter-speed settings (usually ranging from around 1/2000 second to 2 seconds) and time them manually instead, measuring the length of the exposure by counting out the seconds in 'elephants' or using the second hand of your wrist watch. (At night it helps to have a wrist watch with an illuminated dial, or to use a small pocket torch to help see the time.)

One of the easiest ways to practise making long exposures is to fix your camera to a tripod and find yourself a safe, pedestrianized bridge overlooking a busy motorway. At dusk, when there's still some purple-blue ambient light in the sky, you can capture the streaking trails of white and red head and tail lights as the cars speed along – though the car silhouettes themselves will magically disappear because they're moving too fast to record on film.

A busy street with floodlit buildings provides the perfect opportunity to perfect your 'traffic trail' technique. Note the photographer stood at a junction to obtain curved trails as well as straight ones. The trail going through the middle of the frame was created by a double-decker bus.

To capture this effect, just load up with a slow-speed film of ISO 100, set the shutter-speed dial to its 'B' setting and use a remote release to start the exposure to avoid jogging the camera. Set the aperture to f/2.8 and take a meter reading. For greater depth of field, you'll need to work backwards from the reading for f/2.8 to calculate the correct length of the exposure for a smaller aperture setting such as f/16 or f/22. (For instance, if the reading you get for f/2.8 is 1/2 second at ISO 100, you'll be able to calculate that for f/16 your 'B' setting exposure must last approximately 16 seconds, timed manually on your wristwatch.)

With long exposures, it's always wise to bracket, making the exposure longer in

regular increments. So if you take your first exposure at f/16 and 16 seconds, next try f/16 and 20 seconds, then 30 seconds, then one minute, adding the recommended extra exposure to counter reciprocity law failure (see page 97).

When studying your initial results you'll notice how the longer your exposure, the brighter your pictures become, and that as the night darkens, the composition loses sky-colour interest. Next time, try creating variations in different traffic conditions such as nose-to-tail rush-hour traffic jams and at traffic lights.

Traffic trails

Fairgrounds

Swirling colour, movement and light are favourites for creative night-time photography, and there are rich pickings of all three at the fairground. With such a wide variety of illuminated rides to choose from you're spoilt for choice, but photographers' favourites include big-dipper-style rollercoasters and giant rotating ferris wheels – basically, any ride which can be shot with a long exposure to blur the moving coloured lights against a dusky-coloured sky.

Again, long exposures are required if you

want to include dramatic movement in your pictures, and the best approach is to slip the camera on a tripod to avoid camera shake spoiling your results, and then set the shutter-speed dial to 'B'. To work out your exposure, take a meter reading at maximum aperture (usually f/2.8) to gauge the available light, then work back from this reading to a smaller aperture setting such as f/16 or f/22, to gain greater depth of field. Bracket the exposure, making it longer in set increments, to guard against reciprocity law failure.

So that you don't have to worry about leaving your camera bag unattended while

you line up your compositions, one option is to travel light, with just a camera and standard zoom and monopod, or else team up with a friend who can keep an eye on your gear.

Try to photograph the fun of the fair against a twilit sky to balance the artificial and natural light sources.

Choreographed firework displays always provide opportunities for great pictures – the difficulty comes in making sure the camera is pointed at the right stretch of night sky at the right time! Using a wide-angle lens gives you less scope for error, but a telephoto or zoom lens will help you fill the frame with the action. Use the first firework as a guide for cropping.

Making the exposure is the easy bit: just let the fireworks do it for you, by building up a composite image filled with colourful explosions as they happen. This technique involves finding an unobstructed vantage point over the crowds and setting the camera on a steady surface such as a tripod. Select f/16 as your working aperture and switch the shutter-speed dial to 'B'. Now line up the

Fireworks

Arrive at the site of a firework display in plenty of time to get a prime position. Either close in on the action to fill the frame with colour, or use a wideangle lens and include some silhouetted figures in the foreground to give a sense of scale. camera lens with the first firework as the display starts and release the shutter to start the exposure, holding a sheet of black card over the lens in between firework explosions and keeping the shutter open, manually, until you've caught about four or five explosions on film.

As the night sky is pitch black, there's little risk of overexposure unless you have a street lamp or some other unwanted light source sneaking into frame. Check all four corners of your viewfinder carefully.

Cross-processing

Usually when you send a colour film off for development, the processing lab will follow strict manufacturers' guidelines as to the correct chemical baths to use and for how long, their correct temperature and sequence – the aim being to achieve consistency and critical accuracy in reproducing image colours, density and contrast, time after time.

However, in recent years the rise of DIY home-processing kits and adventurous professional labs have made it possible to explore what happens when you fail to follow these stringent guidelines. For instance, in the early 1980s it was discovered that a whole range of weird and wonderful colour results are possible when you deliberately (or even accidentally!) flout film-processing rules in the name of art. It was found that surreal colour shifts and increased image contrast could be achieved by processing colour negative film in the chemicals designed for colour transparency film, and vice versa.

The normal processing sequence for most colour slide films involves using E6 chemistry to create a positive transparency image with a clear film base. Developing baths must be used in a strict sequence to gain acceptable results: the

Choose brightly coloured subjects if you plan to cross-process a film, as the shifts in cast will become more apparent. Do not forget that different types of film produce different results, so experiment with a variety of speeds and brands.

Colour shifts

first bath develops the film to form a black and white negative, the second is a reversal bath which chemically fogs the remaining silver halide, and the third bath acts as a colour developer, producing colour dyes to form a colour image.

However, when you subject an exposed colour negative film to this processing sequence, the E6 chemistry cannot take account of the film's built-in orange mask (which is designed to help keep the negative's colours pure during enlargement). As a result, a colour negative cross-processed in E6 yields all manner of wayward colour shifts in a palette that ranges from warm bluey-purples to deeply saturated cyan and rich navy black, depending on the film brand and any filtration used during picture taking.

Another important factor when cross-processing a negative film in E6 chemistry is the ISO speed at which you choose to rate the film. For example, if you deliberately overexpose the film a couple of stops when taking your pictures, or push–process it in the E6 chemistry, results tend to look brighter and cleaner, with more boisterous contrast and dramatic, burnt–out highlights. From these positive images created on negative film, you can make prints and manipulate the colour even more, via an internegative or by making an R–type print.

Conversely, by processing a colour slide film in the C41 chemistry normally reserved for developing colour negative films, you can make colour negatives with a clear film base. This time, because slide film lacks the orange negative mask mentioned before, the processed film comprises extremely high-contrast, high-key negatives with rich colour saturation. Again, the unnatural colour palette can be enhanced by selective filtration at the printing stage: it's best to start off at your normal enlarger settings, then play around for special effects.

If you don't have processing or printing facilities at home, contact your local professional lab – they are used to cross-processing films on customers' behalf.

Polaroid transfers and emulsion lifts

Polaroid instant films offer a range of creative opportunities for special-effects photography, and are well-suited to experimentation. For one thing, the image can be seen quickly enough to assess and amend any mistakes before the end of a shoot. For another, the prints are robust enough to withstand manipulation, and on certain types of Polacolor film the emulsion layer is sticky and mobile before it dries, which means, for example, that you can manipulate its gooey surface with a cocktail stick to distort picture shapes and create patterns.

Though the film packs aren't cheap, playing around with Polaroid images nearly always pays off, especially when tackling emulsion transfers and emulsion lifts. For both techniques, look out for 'ER' designated Polacolor films, which have the special gluey emulsion; in $6 \ge 6$ cm format look for Type 669; in $5 \ge 5$ in. sheet films, Type 59; in $5 \ge 4$ in. pack films, Type 559; and in $10 \ge 8$ in. sheets, Type 809.

Making negatives with slide film Fortunately for 35mm SLR users, you don't need to splash out on a Polaroid camera or special medium-format instant-film back to secure an image on Polaroid film. The company produces a special instant-image transfer unit called the Daylab Jr. Slide Printer, which allows you to project mounted 35mm slides direct on to Polaroid pack film, simply and quickly at the press of a button.

Once your image is captured on the correct type of Polacolor film, you can transfer it on to any other dampened, absorbent surface, such as textured watercolour paper or even damp cotton fabric or canvas, to give your images greater texture for a more painterly look.

To transfer the image, you need to separate the negative from its Polacolor paper prematurely – that is, before the print has finished self-development. Just peel away the protective paper and discard the underdeveloped print, flipping the negative face down

squarely on to your clean, damp sheet of watercolour paper. Apply pressure to the back of the negative with a rubber ink roller to ensure complete contact between the still-developing negative and the receptor paper. It's best to use a protective layer of fabric or paper in between image and roller to avoid damaging the end-result. The finished image transfer can now be dried and sprayed with a clear UV protective coat to seal the image. As variations, Polaroid suggest you might like to try cloth, wood and even unglazed clay surfaces.

Although transferring the emulsion

like this is huge fun, actually lifting the emulsion off the Polacolor print is far more challenging and the results every bit as rewarding.

This time, the exposed Polaroid image is allowed full development, and instead of being prematurely rollered on to a sheet of paper, the print is peeled away from its black paper sheath and plunged into a tray filled with hot water (80°C/180°F). After about five minutes, the gluey Polacolor emulsion begins to loosen and lift away from its backing paper, allowing you to – very, very gently – remove the translucent

Polaroid image transfers

The painterly, watercolour effect of the image transfer means it works particularly well on watercolour paper, which can be bought cheaply at art shops.

Polaroid emulsion lifts

Do not attempt to lay an emulsion lift completely flat – the creases, and even the slight tears which can occur, are all part of the charm of this technique. image with a blunt implement such as a pair of rubber tongs (or a soft bristle brush, or your finger inside rubber gloves, to avoid scalding yourself). This procedure can be extremely tricky and delicate, and opinion varies as to whether it's any easier to work with a larger format $10 \ge 8$ in. Polaroid than with fiddly $6 \ge 6$ cm. In either case, it takes a lot of time and practice to keep the image intact without any tears or rips.

Once the emulsion is free, the aim is to slide this flimsy, floating image off its original backing paper and on to a sheet of more attractive watercolour paper or other textured surface – in one piece. It's easiest to lie the watercolour paper flat inside the tray, alongside the Polaroid image, so the paper gets wet and the emulsion doesn't have so far to travel. After drying, fix the image in place using a clear UV lacquer spray.

If you find the hot water causes the emulsion to bubble and split, an alternative is to lift the emulsion by soaking the Polacolor print for 15 minutes in cold water. In this case the emulsion will not lift and float free, but will need persuasion with a rigid smooth scraper such as a credit card.

Multiple exposures

The ME function on most modern SLR cameras has made the art of multiple exposure photography a relatively quick, simple and painless affair. Just take a picture, press the ME button and take a second one – both exposures will appear on the same frame as a composite image when you get the film back from the processing lab.

Most cameras will even halve each exposure automatically for you too – the reason being that if you were to make a double exposure on the same frame without compensating for

the fact that the film is receiving twice the amount of light, you'd overexpose the composite image. In the same way, with more ambitious multiple exposures combining three or four separate images, you'd need to cut the exposure accordingly: just reduce the length of the exposure by the number of images you intend to combine on the same frame of film. For instance, with a threepart multiple exposure metered

A multiple exposure does not always have to combine two separate images. An effective, soft-focus result can be achieved by shooting a composition in sharp focus, then de-focusing the camera and making a multiple exposure to achieve this dreamlike image. You could even try three multiple exposures – one sharp, one slightly out of focus, and one completely out of focus. at f/8 and 1/60 second on ISO 100 film, you need to knock the exposure length down two stops to 1/15 second.

The object of most multiple-exposure photography is to show things in the same image area that would not be possible in real life. For instance, with ME photography you can take a picture showing you with your 'twin', or make a time-lapse type image, showing the growth pattern of a plant or a flower coming into bud. You can even move mountains or, if you really want to, put your house on the moon!

However, setting up a surreal image requires careful thought and planning. Bear in mind that dark parts of a scene shot on slide film will allow pale parts of the next exposure to show through. So, if you want to mask out particular areas, just cover them with a sheet of black light-absorbing velvet.

It is important to keep an eye on the composition: draw it on paper before you start and work out exactly where each part of the multiple exposure will appear in the composite. The value of keeping things simple will quickly become apparent!

Shoot the moon

cheating!

Below: It would be impossible to achieve such a perfectly exposed image by conventional

means - there's nothing wrong with a bit of

Multiple-exposure technique really comes into its own when you want to photograph a moody, moonlit landscape, using either slide or negative film. Ordinarily, with a landscape scene at night, the moon appears so small in frame as to be insignificant, and thanks to the long nocturnal exposures required, you risk including unwanted subject blur from the moon's movement across the sky.

The best bet is to shoot the moon and the landscape separately as a multiple exposure, with the camera on a tripod. First shoot the moon so it appears in the top right-hand corner of the film frame, using a telephoto lens to make it appear a little larger. Because it's bright against the dark sky, you won't need a very long exposure and won't risk subject movement. Next press the ME button (or disengage the film wind-on lever if using an older SLR camera) and change lenses to a shorter focal length. Re-compose the scene so the landscape occupies the bottom and left-hand side of the picture area, carefully cropping the moon out of frame this time, so it doesn't appear twice. This exposure will be longer, to record detail in the moonlight, but without subject movement from the moon. To make sure you've got a good exposure on film, try shooting several bracketed variations of the same scene, remembering to change lenses each time.

Alternatively, carefully load and shoot a whole roll of film showing just the moon in the top left-hand corner of the image area. As you load the film, take care to mark the leader with a chinagraph pencil to show exactly where it was positioned – this will help you reload and align the film later. After your moon exposures, finish the film and rewind it manually, leaving some of the film tongue hanging out of the cassette. When you're ready to shoot the landscapes, reload the film, making sure to align the film leader in the correct position.

216

Slide sandwiching

One of the quickest routes to an eye-catching image is to take two separate photographs on slide film and combine them in the same slide mount. This socalled sandwiching technique is useful when you want to create a surreal or abstract image, introduce mood through colour, or give an image a more painterly finish by adding pattern or texture to a scene. The best results are planned carefully in advance, shooting both images specifically with the intention of making a sandwich, although the technique can be used to enhance existing 'dud' images which lacked colour or interest at the taking stage and would otherwise be consigned to the wastebin.

Some of the most successful slide sandwiches are those where a texture has been introduced to an atmospheric landscape, giving it a painted look and

It might only be when you see two separate slides that you realize their potential to be combined in a single image.

These two photographs on their own are nothing special. However, once brought together to form a single picture, they produce a very pleasing result.

softening the sharp edges. This can be done by shooting and slightly overexposing either a sheet of stippled glass or a length of backlit muslin with a macro lens to gain a light pattern of highlight and shadow that evokes paint texture or canvas. Next shoot your landscape – again slightly overexposing the scene to lose highlight detail and make the image more ethereal. After processing, pair both transparencies together in the same slide mount and see how the overlaid texture image introduces a subtle hint of surface detail to the landscape.

If you're shooting for a sandwich, try to slightly overexpose both images so they come out paler on slide film than usual. This means that highlights in one image (such as a sunlit sky area) may be so bleached out that important shadow detail in the other shot shows through. Just hold the images up to a window to check whether the sandwich idea will work.

With more complex slide-sandwich projects – for instance, where largeand small-scale images are combined in the same surreal scene – one of the most difficult aspects to get right is making sure the image details fit alongside each other in frame without one obscuring the other. For this reason it helps if you can draft out a quick diagram as an aide memoire, illustrating where each part of the scene will fall in frame, then bring it along with you when shooting both scenes.

Though the joy of this technique lies in its simplicity, for more professional, permanent results, you can copy the slide sandwich pair together on to another film. You do this by inserting both slides into a zoom slide copier (approximately £50 second-hand) fitted on to your camera and use a flashgun to light the proceedings. It is best to stick to the manufacturer's recommended flash-to-copier distance, copy-film speed and aperture settings.

GLOSSARY

Agitation The act of gently shaking a developing tank during film processing to ensure an even spread of developer over the emulsion.

Angle of view The maximum angle which a particular lens allows you to see through the viewfinder. A 24mm lens has a wider angle of view than a 400mm lens.

Ambient light Any light – natural or artificial – available for the photographer to shoot by.

Aperture The adjustable opening in a lens which controls the amount of light allowed to fall on the film emulsion.

Autoexposure A setting on the camera which automatically selects the shutter speed and aperture combination to use.

Autofocus An electronic system whereby the lens focuses automatically.

Ball and socket A type of head for a tripod which allows seamless movement in all directions.

Barrel distortion A fault where straight lines in a picture seem to bulge outwards, seen more commonly with wideangle lenses.

Bit Short for 'binary digit', this is the smallest unit of digital data. Each bit can be one of two values: 1 or 0.

Bracketing Taking a series of shots of a difficult scene, under, at and over the suggested exposure, in order to ensure a correct result.

'B' setting A setting which keeps the shutter open for the whole time the shutter release button is depressed.

Burning in Allowing extra light from the enlarger to reach a selected part of the paper during printing.

Byte A unit of digital data storage containing eight bits. A byte can have any value between 0 and 255.

C-41 The process used to develop colour negative films.

Catchlight A small highlight in a portrait subject's eyes.

CCD Charged coupled device – a light-sensitive chip comprised of a grid of pixels, each of which produces an electrical output proportional to the amount of light striking it.

CD-ROM A compact disk used for storing digital data for use on computers. A CD-ROM can hold up to 650 megabytes of data.

Clip test When a small section of film is processed before the remainder of the roll, to see whether any adjustments to the processing are required.

CMYK Cyan, Magenta, Yellow and blacK – the colours used in inkjet printers, and in commercial print reproduction.

Colour cast When a slide or print displays a bias towards one particular colour.

Colour temperature A scale expressed in degrees Kelvin (K°), which defines the colour of natural and artificial light.

Compression A process which reduces the number of bits in an image so that it takes up less storage space or can be transmitted more quickly. The JPEG file format is the most popular one which uses compression.

Contact print A print on to which all negatives from a roll of film are exposed at their actual size. This is then used for reference when deciding which negatives to enlarge.

Contrast The difference between the bright and dark areas of a print or negative. *Contre-jour* Another term for shooting into the light.

Converging verticals The distortion created when tilting the camera upwards to photograph an object (usually a building) which has straight sides. It can be corrected with perspective- or shift-control lenses.

CPU (Central Processing Unit) Also known as the microprocessor, it controls all the data received by the computer, and carries out all instructions given.

Cropping Cutting out unwanted parts of the image around the edges in order to improve the composition.

Data Binary information.

Diaphragm The eight blades which make up the lens aperture.

Differential focus Choosing a wide aperture setting in order to render a certain part of the picture blurred.

Digitize The act of converting analogue information into digital data.

Dodging Placing an object between the enlarger lens and the printing paper in order to lessen the exposure in a particular area.

Download The transfer of data from one source to another.

Dpi Dots per inch, a measurement of print or scanner resolution: the more dots per inch the higher the quality.

E-6 The process used to develop colour slide films.

Emulsion The light-sensitive chemical coating on photographic films and papers.

Enprint The standard machine print used by photographic processing laboratories.

Exposure The quantity of light allowed to fall on to the film or paper emulsion, decided by a combination of shutter speed and aperture setting.

Exposure value (EV) The suggested combination of shutter speed and aperture setting at a given light level.

Extension tube A hollow tube placed between lens and camera which allows close-up or macro photography.

Fast film Film of ISO 400 or higher, which allows the use of faster shutter speeds and/or smaller apertures than would be possible with slower films.

File format The method by which a data file is stored. There are numerous different file formats, including TIFF, PICT and JPEG.

Fill-in flash A burst of lowintensity flash, normally used to add catchlights to the eyes or to brighten slightly a dull scene.

Film scanner A device which converts slides and negatives into digital data.

Film speed The ISO rating of a photographic film.

Flare Stray light that falls on to the film, reducing contrast and causing washed out-colours.

Flatbed scanner A device which converts prints, text documents, etc. into digital data. They resemble photocopiers in operation.

Floppy disk A low-cost storage disk which can hold up to 1.4 megabytes of data.

Focal length The distance between the optical centre of the lens and the film, when the lens is focused on infinity.

Focal-plane shutter The type of shutter used in all SLR cameras.

Fogging The effect of light leaking on to a film or paper emulsion before it has been processed.

F/stop The number (e.g 1.8, 5.6, 8, 11) used to indicate the size of the aperture.

Gb A unit of computer memory equal to 1024 megabytes.

GIF A popular file format used to store images on the internet.

Greyscale A monochromatic scale consisting of up to 256 tones of black and grey.

Guide number An indication of the flash output required for correct exposure.

Hard disk The area inside the computer which stores the software and files.

High key A scene made up predominantly of bright tones.

Icon Graphic symbol used to represent a file or folder. It is opened by the user clicking on it.

Image editing software A program designed to display, process and manipulate images.

Incident-light reading A reading where the light falling on to the subject is measured.

Inkjet printer A type of printer which uses nozzles to spray ultrafine dots of ink on to paper. Inkjet printers are the most popular for domestic use.

Internet A network of computers around the world, connected by telephone line.

Interpolation A method of increasing apparent resolution by inserting additional pixels based on the values of those around them.

ISO An abbreviation of International Standards Organization, which sets the internationally accepted standard for determining film speed.

JPEG A popular file format which compresses digitized photographic data.

Latitude The ability of a film to give an acceptable result, even if underexposed or overexposed. Print film has a wide latitude.

Low key A scene made up predominantly of dark tones.

Megabyte A standard unit used to measure computer files and memory. A Megabyte is equal to 1024 bytes.

Megapixel A CCD chip containing over one million pixels.

Mirror lock-up A function available on some cameras which locks open the mirror before the exposure is made. This reduces the risk of camera shake, which can happen when the mirror flips up and then back down again.

Modelling light A continuous light source on studio flash units which demonstrates the effect that the flash will have on the subject.

Modem Connects a computer to a telephone line in order to share data with others.

Monitor The computer screen.

Monochrome Either a black and white picture, or a colour picture made up of a variety of tones of just one colour.

Motor drive A device which winds on the film automatically, sometimes at very high speed.

Multimedia The combination of sound, text, graphics, video and still images.

One-touch zoom A zoom lens which allows the user to adjust the focal length and focus using the same barrel.

Overexposure When too much light is allowed to reach the film, resulting in bleached-out highlight areas.

Pan and tilt A tripod head which allows movement from side to side and up and down.

Panning The act of making an exposure while following a moving subject with the camera.

Parallax The difference between what is seen through the viewfinder and what is taken by the lens when using a rangefinder-type camera. It is noticeable particularly when shooting close subjects.

PC socket A socket on the camera into which a flash sync cable can be plugged.

Peripheral A printer, scanner or other device that can be connected to a computer.

Photo CD A digital image storage system which uses compact disks.

Photoshop A popular professional image-processing and manipulation program by Adobe.

Pixel (Picture Element) The smallest building block from which digital images are made up.

Pushing When a film is uprated to a speed higher than its ISO rating.

RAM (Random Access Memory)

The temporary memory created when the computer is on. Software/files are stored here while they are being used.

Rear-curtain flash When the flash is triggered at the end of the exposure of a moving subject.

Rebate The edge of the film, which shows details about type of film, frame number, etc.

Reciprocity failure Exposures which are too short or too long for the film emulsion to cope with, resulting in underexposure and colour casts.

Reflected-light reading A reading where the light reflected from the subject is measured.

Resolution A measurement of the amount of information contained in a digital file or achievable by a capture or output device. Usually described in terms of pixels per inch (ppi) or dots per inch (dpi).

RGB Red, Green and Blue – the additive system of colour filtration used by computer monitors.

SCSI A type of connection for plugging peripherals into computers.

Slave flash An off-camera flash containing a cell which triggers the unit at exactly the same time as the on-camera flash is fired.

Spot meter A lightmeter or TTL metering mode which takes a reading from a very small area of the frame.

Stopping down Reducing the aperture in order to allow less light on to the film emulsion and to increase depth of field.

Sync speed The fastest shutter speed at which a correct exposure is ensured when using flash.

Teleconverter An accessory which increases the focal length of a lens. The most common types are 2x and 1.4x.

Test strip A strip of paper used during a test to determine the correct exposure for a print.

TTL meter Abbreviation for Through The Lens – the camera's inbuilt metering system.

TWAIN A software protocol for exchanging information with image-capture devices such as digital cameras and scanners.

Underexposure When too little light is allowed to reach the film, resulting in loss of shadow detail.

USB (Universal Serial Bus) A cross-platform interface for the connection of peripherals.

Vignetting A darkening at the corners of the frame, caused when using a lens hood too small for the angle of the lens.

VRAM (Video Random Access Memory) A graphics card in the computer that controls how many colours you can see on the screen.

Waist-level finder Most commonly found on medium format cameras, this allows the photographer to compose by looking down into the viewfinder, while holding the camera at waist level.

USEFUL ADDRESSES

CAMERAS

Bronica Introphoto Ltd Priors Way Maidenhead Berkshire SL6 2HR Tel: 01628 674411 Fax: 01628 771055 Website: www.introphoto.co.uk

Canon UK Ltd Woodhatch, Reigate Surrey RH2 8BF Tel: 01737 220000 Fax: 01737 220022 Website: www.canon.co.uk

Contax Kyocera Yashica UK Ltd Unit 7, Suttons Business Park Sutton Park Avenue Earley, Reading RG6 1AZ Tel: 0118 935 6300 Fax: 0118 935 6309 E-mail: kyu@kyu.co.uk Website: www.kyu.co.uk

Fuji Photo Film UK Ltd 125 Finchley Road London NW3 6JH Tel: 020 7586 5900 Fax: 020 7722 5630 Website: www.fujifilm.co.uk

Hasselblad UK Ltd York House, Empire Way Wembley, Middlesex HA9 0QQ Tel: 020 8903 3435 Fax: 020 8902 2565 E-mail: hasselblad.uk@hasselblad.com Website: www.hasselblad.co.uk

Konica UK Ltd Plane Tree Crescent Feltham, Middlesex TW13 7HD Tel: 020 8751 6121 Fax: 020 8755 0681 Website: www.konica.co.uk

Leica Camera Ltd Davy Avenue, Knowlhill Milton Keynes MK5 8LB Tel: 01908 666663 Fax: 01908 671316 E-mail: leica-camerauk@compuserve.com Website: www.leica-camera.com

Mamiya Johnsons Photopia Ltd Hempstalls Lane Newcastle-under-Lyme Staffordshire ST5 0SW Tel: 01782 753344 Fax: 01782 753340 E-mail: info@johnsons-photopia.co.uk Website: www.johnsons-photopia.co.uk

Minolta UK Ltd Precedent Drive, Rooksley Milton Keynes MK13 8HF Tel: 01908 200400 Fax: 01908 200334 Website: www.minoltaeurope.com

Nikon UK Ltd Nikon House 380 Richmond Road Kingston-upon-Thames Surrey KT2 5PR Tel: 020 8541 4440 Fax: 020 8541 4584 Brochure line: 0800 230220 Website: www.nikon.co.uk

Olympus 2-8 Honduras Street London EC1Y 0TX Tel: 020 7253 2772 Fax: 020 7251 6330 E-mail: info@olympus.uk.com Website: www.olympus.co.uk

Pentax UK Ltd Pentax House Heron Drive Langley, Slough SL3 8PN Tel: 01753 792792 Fax: 01753 792794 E-mail: info@photo.pentax.co.uk Website: www.pentax.co.uk

Rollei Prisma Europe Ltd

Unit 16 Aston Fields Industrial Estate Off Aston Road, Bromsgrove Worcestershire B60 3EX Tel: 01527 556300 Fax: 01527 556301

INDEPENDENT LENSES

Sigma Jenoptik UK Ltd PO Box 43 1 Elstree Way, Borehamwood Hertfordshire WD6 1NH Tel: 020 8953 1688 Fax: 020 8953 9456

Tokina Introphoto Ltd Priors Way, Maidenhead Berkshire SL6 2HR Tel: 01628 674411 Fax: 01628 771055 Website: www.introphoto.co.uk

Tamron UK Ltd 4 Millfield House Croxley Business Park Watford WD1 8YX Tel: 01923 212241 Fax: 01923 212215 E-mail: tamron@tamron.co.uk Website: www.tamron.co.uk

Vivitar Europe Ltd Westmead, Swindon Wiltshire SN5 7YT Tel: 01793 526211 Fax: 01793 544814 E-mail: vivitaruk@compuserve.com Website: www.vivitar.co.uk

FILM

Agfa Gevaert Ltd 27 Great West Road Brentford Middlesex TW8 9AX Tel: 020 8231 4903 Fax: 020 8231 4948 E-mail: agfa.brentford@agfa.co.uk

Fuji Photo Film UK Ltd 125 Finchley Road London NW3 6JH Tel: 020 7586 5900 Fax: 020 7722 5630 Website: www.fujifilm.co.uk

Ilford Imaging UK Ltd Town Lane Mobberley Cheshire WA16 7JL Tel: 01565 684000 Fax: 01565 872791 E-mail: uksales.ilford@ilford.com Website: www.ilford.com Kodak Ltd Kodak House PO Box 66, Station Road Hemel Hempstead Herts HP1 1JU Tel: 01442 261122 Fax: 01442 844352 Website: www.kodak.co.uk

Polaroid UK Ltd Wheathampstead House Wheathampstead, Herts AL4 8SF Tel: 01582 632000 Fax: 01582 632012 Website: www.polaroid.com

TRIPODS

Benbo Impress Group 1 Stafford Park Telford, Shropshire TF3 3BT Tel: 01952 423300 Fax: 01952 423342 Website: www.paterson-intl.com

Centon The Jessop Group Ltd Jessop House, 98 Scudamore Road Leicester LE3 1TZ Tel: 0116 232 0033 Fax: 0116 232 0060 E-mail: sales@jessops.co.uk

Cobra Cobra Europe Ltd 5 Capstan Centre Thurrock Park Way Tilbury, Essex RM18 7HH Tel: 01375 840540 Fax: 01375 840534 E-mail: cobraeurope@btinternet.com

Cullmann Newpro UK Ltd Old Sawmills Road Faringdon, Oxfordshire SN7 7DS Tel: 01367 242411 Fax: 01367 241124

Gitzo Hasselblad UK Ltd York House Empire Way Wembley, Middlesex HA9 0QQ Tel: 020 8903 3435 Fax: 020 8902 2565 E-mail: hasselblad.uk@hasselblad.com Website: www.hasselblad.co.uk Manfrotto KJP Promandis House Bradbourne Drive Tilbrook, Milton Keynes MK7 8AJ Tel: 01908 366344 Fax: 01908 366322 Website: www.calumetphoto.com

Velbon Introphoto Ltd Priors Way Maidenhead, Berkshire SL6 2HR Tel: 01628 674411 Fax: 01628 771055 Website: www.introphoto.co.uk

FILTERS

B+W and Cokin Johnsons Photopia Ltd Hempstalls Lane Newcastle-under-Lyme Staffordshire ST5 0SW Tel: 01782 753344 Fax: 01782 753340 E-mail: info@johnsons-photopia.co.uk Website: www.johnsons-photopia.co.uk

Cromatek Lastolite 8 Vulcan Court Hermitage Industrial Estate Coalville, Leicestershire LE67 3FW Tel: 01530 813381 Fax: 01530 830408

Heliopan and Hi-tech Teamwork Photographic 41-42 Foley Street London W1P 7LD Tel: 020 7323 6455 Fax: 020 7436 5212 E-mail: all@teamworkphoto.co.uk Website: www.teamworkphoto.co.uk

Hoya Introphoto Ltd Priors Way Maidenhead, Berkshire SL6 2HR Tel: 01628 674411 Fax: 01628 771055 Website: www.introphoto.co.uk

Lee Filters Central Way Walworth Industrial Estate Andover, Hampshire SP10 5AN Tel: 01264 366245 Fax: 01264 355058 Website: www.leefilters.com

Wratten Kodak Ltd Kodak House PO Box 66, Station Road Hemel Hempstead, Herts HP1 1JU Tel: 01442 261122 Fax: 01442 844352 Website: www.kodak.co.uk

PORTABLE AND STUDIO FLASH

Bowens Calumet Trading PO Box 3128 Tilbrook, Milton Keynes MK7 8JB Tel: 01908 646444 Fax: 01908 646434

Broncolor The Studio Workshop 20-22 The Brunswick Centre Bernard Street London WC1N 1AE Tel: 020 7278 7633 Fax: 020 7278 7340 E-mail: info@tsw-lon.demon.co.uk

Cobra Cobra Europe Ltd 5 Capstan Centre Thurrock Park Way Tilbury, Essex RM18 7HH Tel: 01375 840540 Fax: 01375 840534 E-mail: cobraeurope@btinternet.com

Courtenay The Impress Group Stafford Park 1 Telford, Shropshire TF3 3BT Tel: 01952 423300 Fax: 01952 423342

Elinchrom 54 The Brunswick Centre Bernard Street, London WC1N 1AE Tel: 020 7837 6163 Fax: 020 7833 4737

Metz Hasselblad UK Ltd York House, Empire Way Wembley Middlesex HA9 0QQ Tel: 020 8903 3435 Fax: 020 8902 2565 E-mail: hasselblad.uk@hasselblad.com Website: www.hasselblad.co.uk

Sunpak Introphoto Ltd Priors Way Maidenhead Berkshire SL6 2HR Tel: 01628 674411 Fax: 01628 771055 Website: www.introphoto.co.uk

ASSOCIATIONS

Arts Council of England 14 Great Peter Steet London SW1P 3NQ Tel: 020 7333 0100 Fax: 020 7973 6590 E-mail: enquiries@artscouncil.org.uk Website: www.artscouncil.org.uk British Copyright Council 29-33 Berners Steet London W1P 4AA Tel: 01986 788122 Fax: 01986 788847 E-mail: copyright@bcc2.demon.co.uk

Bureau of Freelance Photographers Focus House 497 Green Lanes London N13 4BP Tel: 020 8882 3315 Fax: 020 8886 5174

The Photographic Alliance of Great Britain Website: www.amphot.co.uk

Royal Photographic Society The Octagon, Milsom Street Bath BA1 1DN Tel: 01225 462841 Fax: 01225 448688 E-mail: rps@rps.org Website: www.rps.org

Scottish Arts Council 12 Manor Place Edinburgh EH3 7DD Tel: 0131 226 6051 Fax: 0131 225 9833 E-mail: administrator.sac@artsfb.org.uk Website: www.sac.org.uk

DARKROOM EQUIPMENT

Agfa Gevaert Ltd 27 Great West Road Brentford Middlesex TW8 9AX Tel: 020 8231 4903 Fax: 020 8231 4948 E-mail: agfa.brentford@agfa.co.uk

Durst UK Ltd Longmead Industrial Estate Epsom Surrey KT19 9AR Tel: 01372 726262 Fax: 01372 740761

Fotospeed Fiveways House Westwells Road Rudloe, Corsham Wiltshire SN13 9RG Tel: 01225 810596 Fax: 01225 811801 E-mail: sales@fotospeed.com Website: www.fotospeed.com

Ilford Imaging UK Ltd Town Lane Mobberley, Cheshire WA16 7JL Tel: 01565 684000 Fax: 01565 872791 E-mail: uksales.ilford@ilford.com Website: www.ilford.com Impress Group 1 Stafford Park Telford Shropshire TF3 3BT Tel: 01952 423300 Fax: 01952 423342 Website: www.paterson-intl.com

Jobo Introphoto Ltd Priors Way Maidenhead Berkshire SL6 2HR Tel: 01628 674411 Fax: 01628 771055 Website: www.introphoto.co.uk

Kaiser Fotolynx Ltd CCS Centre Vale Lane Bedminster Bristol BS3 5RU Tel: 0117 963 5263 Fax: 0117 963 6362

Kodak Ltd Kodak House PO Box 66 Station Road Hemel Hempstead Herts HP1 1JU Tel: 01442 261122 Fax: 01442 844352 Website: www.kodak.co.uk

LPL Introphoto Ltd Priors Way Maidenhead, Berkshire SL6 2HR Tel: 01628 674411 Fax: 01628 771055 Website: www.introphoto.co.uk

Nova Darkroom Equipment Ltd 1A Harris Road Wedgnock Industrial Estate Warwick CV34 5JU Tel: 01926 403090 Fax: 01926 493992 E-mail: sales@novadarkroom.com Website: www.novadarkroom.com

Speedibrews Calumet Trading PO Box 3128 Tilbrook, Milton Keynes MK7 8JB Tel: 01908 646444 Fax: 01908 646434

Tetenal Tetenal House Centurion Way Meridian Industrial Estate Leicester LE3 2WH Tel: 0116 263 0306 Fax: 0116 263 0087 E-mail: uk@tetenal.com Website: www.tetenal.com

INDEX

Accessories 27-28 Adams, Ansel 16 Animal photography 70-75 Aperture 30, 32–35 'B' setting 210-212 Backlighting 100-101 Black and white processing 187-208 Contact prints 195-196 Creative printing techniques 202-208 Borders 202-203 Diffusing 207-208 Handcolouring 206-207 Toning 204-205 Developing equipment 188-189 Dodging and burning 199-201 Lightproofing 194 Making a print 198-201 Paper 193-194, 197 Printing equipment 189-193 Test strips 196-197 Bracketing 42 Cable release 28 Camera, choice of 10 Camera formats 11-16 Camera shake 35 Camouflage 75 Cartier-Bresson, Henri 20 CCD 168-169 CD-ROM 165, 173, 182 Close-up photography See Macro photography Colour cast 93 Colour temperature 92-94 Composition 61-84 Computers 163-166 Contrast range, Exposing for 40-42 Creative techniques 209-218 Cross-processing 212-213 Darkroom See Black and white processing Daylight photography 85–104 Depth of field 32-34 Depth-of-field preview 142 Digital cameras 168-170, 173 Digital imaging 161–186 DX coding system 10

E-mail 183–184 Exposure 39–46 Exposure compensation 42 Exposure latitude 24 Fairgrounds 211 Film 22-26 Brand 22-23 Infrared 25-26 Negative 23 Processing 26 Speed 23–24 Transparency 23 Tungsten-balanced 25 Uprating 25 Filters 47-60 Colour-correction 55, 94 Graduated 52-53 Green and blue 60 In black and white photography 58-60 In infrared photography 60 Intensifiers 56 Metering with filters 60 Neutral density 51-52 Polarisers 50-51 Red 58 Skylight 55 Soft-focus 54-55 Special-effects 57 Split-screen 57 Últra-violet 49–50 Warm-up 55-56 Yellow and orange 58 Fireworks 211–212 Fish-eve lens 19 Flare 28, 101 Flash photography 105–138 Autofocus 112 Bounce flash 109, 122-124 Built-in flash 125-127 Catchlights 125 Daylight 116-118 Diffusers 124 Exposure 113-115 Fill-in flash 116-117, 125 Flashguns 109-112 Automatic 112, 114-115 Dedicated 112, 115 Guide number 111, 115 Hammerhead 109 Hot-shoe-mounted 109 In macro photography 157-159 Movement 126 Non-dedicated fill-in flash 118 Portraits 126 Reflector cards 123–124 Ringflash 110 Second-curtain sync 121 Slave flash 111 Slow-sync flash 119-121 Studio flash 130–138 Dish reflectors 134 Focusing spots 135

Monoblocs 131–132 Snoots 135 Softboxes 133 Stands 135 Umbrellas 133 Sync speed 113–114, 117 When not to use 128 Zoom head 112

Grey card 46

Hyperfocal focusing 35

Incident and reflected light 42 Internet 185–186 ISO rating See Film speed

Landscape photography 62–69 Large format cameras 16 Lens hoods 28, 101 Lenses 17–21 Focal length 34 Light, Shooting into 99–101 Light and shade, Exposing for 40 Lightmeter 28 Long exposures 210–212 Low-light photography 95–98

Macro photography 110, 139–160 Accessories 144-147 Background 152-154 Bellows 145 Close-up dioptre lenses 144 Composition 150-152 Equipment 142 Extension tubes 144 Flash 157-159 Indoor photography 154, 156–157 Lighting and exposure 155-160 Macro lenses 145 Reproduction ratios 143 Reversing rings 146-147 Stacking rings 147 Subjects 150 Supports 154 Technical challenges 148–149 Teleconverters 146 Magnifying lenses 57 Microphotography 141 Microprocessors 164-166 Mid-tone, Exposing for 40 Monopods 27 Moonlight 216 Motor drive 10 Multiple exposures 215-216

Natural light 85-104

Nature photography 70–75

Optical disks 183

Panning 74 Parr, Martin 126 Photomicrography 141 Pixels 162, 163, 166 Polaroid emulsion lifts 213-215 Polaroid transfers 213-215 Portraiture 76-81 Previsualization 36-38 Printing from digital images 179-182, 186 Dye-sublimation printers 182 Inkjet printers 180-181 Micro-dry printers 181 Pictrography 182 Thermal autochrome printers 181 Prism attachments 57 Prism finders 13

Reciprocity law failure 97–98 Reflectors 102–104 Rule of Thirds 35, 63

Scanners Film 171–173 Flatbed 171–173 Seasons 90 Shift-lenses 19 Shutter speed 30–32 Silhouettes 99 Slide sandwiching 217–218 Software for digital imaging 174–178 Spirit level 28 Still-life photography 82–84

Teleconverters 21 Telephoto lenses 20 Time of day 91–94 Traffic trails 210 Tripods 27 TTL metering 43–46

Ultra telephoto lenses 21 Ultra wideangle lenses 19

Viewfinder 10

Waite, Charlie 68 Weather 88–90 Wideangle lenses 19 World-wide web 173, 184

Zip disks 183 Zoom lenses 17

PICTURE CREDITS

The publishers would like to thank the following sources for their kind permission to reproduce the pictures in this book:

Adobe Photodeluxe (trademarks of Adobe Systems Incorporated) 174 Adobe Photoshop (trademarks of Adobe Systems Incorporated) 162, 163, 164, 176, 177 Allsport 1701/Adam Pretty 105/Al

Bello 107/Julian Herbert 170r Nigel Atherton 16, 17cr, 18br, 29t, 30l, 39br, 63tl, 74, 85b, 91b, 99tl, 117, 121, 125, 203br, 207 Steve Austin 20l, 20r, 21l, 21r, 38, 44, 52, 60, 63tr, 69tr, 87t, 88, 91t, 97bl, 98tl, 139bl, 217 Richard Bailey 195, 201, 203bl, 203tl, 203tr, 208 www.niallbenvie.com 6b, 10tl, 33t, 69b, 70, 71, 78br, 148tl, 161, 165b, 179, 184 Broncolor/courtesy of Bron Elektronik AG 131 Bronica/Introphoto 11bl Michael Busselle 4, 8, 10l, 27, 35t, 36, 37, 39bl, 41, 42/43, 53, 59, 64b, 65, 66t, 76r, 79br, 79bl, 83, 87b, 90, 206

Rosemary Calvert 81bl, 82 Laurie Campbell 19bl, 72, 73tr, 86 Canon/Robert Scott Associates 17bcr, 17cl, 19br, 112 Corbis/George Lepp 17tl/Ed Young 78t Joe Cornish 11br, 13c, 14br, 30r, 35b, 63bl, 64t, 66c, 67l, 67b, 68, 94, 98br, 99br, 211t

Steve Day 34, 50b, 50t, 209 Damien Demolder 12tl, 132 Elinchrom/Flash Centre 135b, 135t, 138 Epson (UK) Ltd 171r, 172, 180, 181, 186

Fuji Photo Film (UK) Ltd 13tl, 13tr/courtesy of Charles Barker BSMG Worldwide 168

Tim Gartside 23, 24, 89, 93, 210, 211b, 212, 214b, 215, 216, 218 Getty One Stone 7

Halesway Ltd/Lee Filters 47tl, 48 Angela Hampton 6t, 21b, 54, 56, 57, 61cl, 75b, 77c, 79tl, 79tr, 79bc, 84t Hasselblad (UK) Ltd 32 Hewlett Packard/courtesy of Beattie Media165t

Image Bank 173b Introphoto 47tr, 47br

Kevin Keatley/Wildlife Watching Supplies 73bl, 73tl, 73br Mike Kipling 29b, 39t, 61tr, 61bl, 61tr, 62, 66b, 69tl, 84br, 85t, 88t, 95, 97tr, 102, 119, 129b, 151t Kodak 169

Lastolite/photography: Clare Arni 124, 133, 134

Mamiya/Johnsons Photopia Ltd10br, 12c Manfrotto/Robert Wyatt Photography/courtesy of KJP 25 Ailsa McWhinnie 22, 26t, 31, 33b, 40, 59, 127 Nick Meers 67tr, 214t Screen shots reprinted by permission from Microsoft Corporation 183, 184 Millennium 75t, 77t, 80, 187 Minolta (UK) Ltd 3, 26b

NHPA/Stephen Dalton 106, 121t Nikon UK Ltd 15tl, 18t, 19t Nova Darkroom Equipment Ltd 188, 189, 190, 191, 192, 193 Martin Part/Magnum Photos 126 Pentax 9br, 109, 111

Getty One Photodisc 173t

Den Reader 81tl, 81tr Chris Rout 76l, 77b, 78bl, 101, 110b, 113, 118, 122, 136, 137

Science Photo Library 139b Sigma/Jenoptik (UK) Ltd 18bl SIN 129t Sinar/The Studio Workshop 14tl Andrew Stevens 139t, 142, 143, 149b, 157 Sunpak/Introphoto/courtesy of Tocad Co. Ltd. 109l, 110t Screen shot showing the Umax MagicScan/VistaScan Interface 1711

Colin Varndell 96, 100, 138, 139tr, 141, 144, 145, 146, 148r, 149t, 150, 151br, 151bl, 151bc, 153, 154, 156, 158

Andrew Wing 196, 197, 198, 199, 200, 203tc, 203bc, 204

Every effort has been made to acknowledge correctly and contact the source and/or copyright holder of each picture, and Carlton Books Limited apologises for any unintentional errors or omissions which will be corrected in future editions of this book.